A Cold War
Tourist and
His Camera

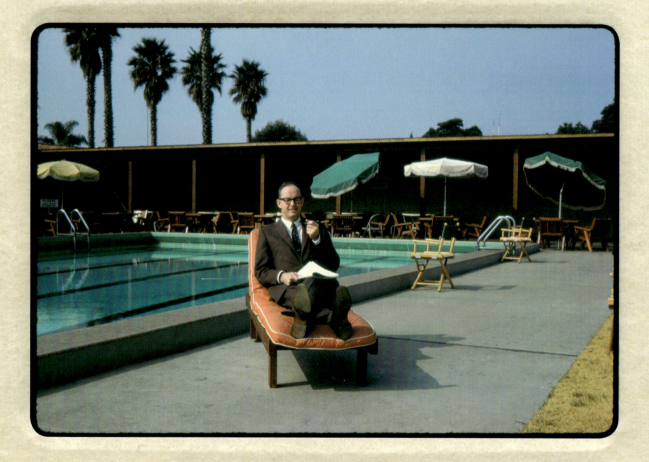

McGill-Queen's University Press | Montreal & Kingston | London | Ithaca

A COLD WAR TOURIST and HIS CAMERA

Martha Langford and John Langford

© McGill-Queen's University Press 2011
ISBN 978-0-7735-3821-4

Legal deposit first quarter 2011
Bibliothèque nationale du Québec

Printed in Canada on acid-free paper.

This book has been published with the help of a grant
from the Canadian Federation for the Humanities
and Social Sciences, through the Aid to Scholarly
Publications Programme, usings funds provided
by the Social Sciences and Humanities Research
Council of Canada. Funding has also been received
from Concordia University's Aid to Research program
(ARRE), and the Gail and Stephen A. Jarislowsky
Institute for Studies in Canadian Art, Concordia
University.

McGill-Queen's University Press acknowledges
the support of the Canada Council for the Arts for
our publishing program. We also acknowledge the
financial support of the Government of Canada
through the Canada Book Fund for our publishing
activities.

LIBRARY AND ARCHIVES CANADA
CATALOGUING IN PUBLICATION

Langford, Martha
A Cold War tourist and his camera / Martha Langford
and John Langford.

Includes bibliographical references and index.
ISBN 978-0-7735-3821-4

1. Langford, James Warren, 1919–1997 – Travel –
Europe. 2. Langford, James Warren, 1919–1997 –
Travel – Africa. 3. Cold War – Pictorial works.
4. Military bases, American – Europe – Pictorial
works. 5. Military bases, American – Africa –
Pictorial works. 6. Photography, Military.
7. Vernacular photography. 8. Canada – Military
relations – United States. 9. United States – Military
relations – Canada. I. Langford, John W. II. Title.

UG476.L36 2011 778.9'9355 C2010-906213-2

Set in 11.5/14.5 Bulmer MT Standard with
Berthold Akzidenz Grotesk

Book design and typesetting by Garet Markvoort
of zijn digital

Contents

Acknowledgments

Situating the photographs in *A Cold War Tourist and His Camera* has drawn on the knowledge, memories, and archives of many individuals and institutions, near and far. We especially thank Beth Davis, Hanae El-Alfy, Soad El-Alfy, Tammer El-Sheikh, Michael Goodyear, Helmut Klier, Ludmilla Lebedinskaia, Malgorzata Majorek-Klier, Malcolm McCrow, Rita McCreadie, Brian S. Osborne, Sandra Paikowsky, Amr Sabbour, and Allan Tupper. The project is greatly indebted to Lieutenant General Richard Stovel and Dr Iyorwuese Hagher, Nigerian high commissioner to Canada, for according us interviews and to Mrs Nancy Hagher and Ms Rita Iorbo of the Nigeria High Commission for their knowledge and insights. At Library and Archives Canada we were kindly assisted by Barry Stead, Lisa Perry, and many of their colleagues behind the scenes. During our many research trips to Ottawa, Stuart Langford catered to our every need. For permissions to reproduce related photographic works, we thank the Richard Harrington Estate and Stephen Bulger Gallery, Toronto; *LIFE*; and the *National Geographic*.

Erin Silver helped with the scanning of the slides and preparation of the image files – patient, painstaking work – followed by Donigan Cumming, whose tender ministrations drew everything possible from this fifty-year-old colour material. Katy Chan kindly prepared the black and white file. Research assistance came from Gwen Baddeley, Natalia Lebedinskaia, Julia Lum, Jennifer Roberts, and Laura Schneider.

An early, much abbreviated version of this book was delivered at a scholarly workshop organized by Carol Payne, Andrea Kunard, and Nancy Yakimoski, which was held at the National Gallery of Canada and Carleton University in Ottawa. We thank the organizers, participants, and funders for their generosity, and especially Carol Payne and Andrea Kunard for their helpful comments. Martha Langford also presented aspects of this research at the Centre for Oral History and Digital Storytelling, Concordia University. Useful and encouraging feedback on these presentations and drafts of the work came from Steven High, Jeanne Langford, Suzanne Morrison, Sharon Murray, John O'Brian, Aurèle Parisien, Kate Seaborne, Zoë Tousignant, and Reg Whitaker, for which we thank them very much.

At McGill-Queen's University Press, acquisitions editor Jonathan Crago understood our vision of the book, brought it into the house, and furthered its development by having it appraised by two anonymous reviewers, whose comments on the manuscript were much appreciated. As always, MQUP coordinating editor Joan McGilvray and production and design manager Susanne McAdam embraced the project. The careful copy-editing of Elizabeth Hulse brought two writers' styles into closer harmony. Those writers were delighted with Garet Markvoort's sensitive book design and are forever grateful for her great attention to detail.

Publication grants from the Visual Arts section of the Canada Council for the Arts, the Aid to Scholarly Publications Program of the Canadian Federation for the Humanities and Social Sciences, and Concordia University's Aid to Research Related Events, Publication, Exhibition and Dissemination Activities Program (ARRE) helped bring a full carousel of colour slides into print. The book was also supported by grants from the Gail and Stephen A. Jarislowsky Institute for Studies in Canadian Art, Concordia University. The book is a partial fulfillment of Martha Langford's program as a Concordia University Research Chair and was also partially funded by a Social Sciences and Humanities Research Council of Canada grant to investigate Canadian vernacular photography.

Of course, the man who made all this possible, in both public and private ways, was the Cold War tourist himself, Warren Langford. His pictures, carefully preserved by our mother, Lucille Langford, sparked our curiosity and sent us on an extraordinary journey. We dedicate our book to his memory.

ML and JL

A Cold War
Tourist and
His Camera

Setting Up the Screen

INTRODUCTION

For almost fifty years, between the end of World War II and 1991, the United States and the Soviet Union, together with their allies and client states, engaged in a 'cold war.' This term describes a protracted confrontation in which both sides use the threat of armed and nuclear attack, economic power, diplomacy, and a variety of unconventional warfare techniques ("propaganda, economic warfare, sabotage, espionage, subversion, strikes, civil disturbances, terrorism, political warfare, and guerilla warfare").[1] Collective memories of this era are sparked by iconic media images of tanks moving into cities, mushroom clouds, schoolchildren ducking under their desks, shopping carts loaded for fallout shelters, reconnaissance photographs of Soviet missile sites in Cuba, political leaders arguing in a kitchen, aging party girls, and a bizarrely disguised defector.[2] These are the high photographic moments of the period, unforgettably capturing its contained violence, sexual intrigue, and simmering collective psychosis.

Recent cultural histories – studies of art and architecture; world's fairs and touring exhibitions; mainstream cinema, documentary film, and home movies; radio and television; graphic, industrial, and fashion design – are less about concentration, more about saturation. They underscore the ubiquity and plasticity of Cold War culture, its insinuation by osmosis of signs, symbols, and shapes into every aspect of the public realm.[3]

North American Cold War culture presents schematically as a binary system: East and West, encirclement and containment, international communism and democratic capitalism, patriotism and contagion, escalation and détente.[4] Symbolized in the black and white figures of the cartoon strip *Spy vs. Spy*, Cold War culture can be narrated as a struggle to the death between light and shadow, between the familiar, visible world and fearsome invisibilities: enemies who lurk in the shadows or pose as friends, only to exploit the target's hidden weakness.[5]

The snapshooters of the Cold War period seem to inhabit another, more colourful world, made up of close-knit families and their pets, sun-drenched vacations, shiny new automobiles, and labour-saving devices for the home. The amateur slide show is both product and producer of the North American dream, a set of images teetering between the nuclear family and nuclear annihilation, neither construct mistakable for the *ideal*. Any photographic collection, amateur or professional, from the Cold War era can be interpreted contextually and imaginatively to shine light on the rhetoric and preoccupations of those times. This particular collection, occasioned by Cold War tourism, addresses its themes rather more directly: as a study of observation and infiltration, showing how global conditions and apprehensions of history can photographically in-form a local community of memory.

In 1962–63, at the height of the Cold War, James Warren Langford (1919–1997), World War II veteran of the Royal Canadian Air Force (RCAF), career federal public servant, devout Roman Catholic, and our father, attended the National Defence College (NDC) in Kingston, Ontario. The NDC was then in its sixteenth year of operation, having been founded in 1947. American Cold Warriors were already in training at the National War College in Washington, started a year earlier. The Canadian NDC modelled its first course on the curriculum developed by the more established Imperial Defence College in London (started in 1927).

By 1962 the NDC was part of a growing network of defence colleges, with campuses located in global metropolises such as London, Washington, Paris (1949), Tokyo (1954), and New Delhi (1960).[6] Its location at Kingston, in small-town Canada, was rather less glamorous though saturated with military history. Fort Frontenac stood on the site of a post established by the Comte de Frontenac in 1673 on lands wrested from the Iroquois.[7] Captured by the British in 1758, the fort fell into disuse until the Loyalist emigration of 1783 formed the settlement that would become Kingston. The British were then formalizing relations with the Mississaugas through the Crawford Treaty of that year. With Fort Frontenac at the heart of the settlement, Kingston maintained its defensive position as a naval base, a barracks, and the home of the Royal Military College, established in 1876.[8]

NDC was never a military college; rather, it was a national security training centre whose teaching philosophy was based on "a recognition of the need for greater common understanding between senior officers of the armed forces and between senior military officers and civilian officials."[9] The express mission of the college was to equip a select group of students with "the necessary background of knowledge and understanding of those military, economic, scientific, political and organizational aspects of national security, to enable them to take their places effectively in the senior levels of military and departmental appointments."[10] Another memorandum on selection states that "the prime purpose of the training is to provide highly qualified individuals competent to take their places in planning and directing the national effort in both peace and war."[11] Qualities of the ideal candidate were "mental alertness, initiative, good judgment, facility in learning and ease of expression," with the "essential criterion" of "a demonstrated capacity for advancement to positions of major responsibility."[12]

Eighteen of the thirty participants in Course Sixteen were serving military officers, including single representatives from each of the three services in the United States and Britain. Nine of the twelve civilians came from Canadian government organizations directly related to foreign affairs and defence; one participant was from the US State Department and another from the British Foreign Office.

Competition for the Canadian civilian spots on the course was stiff: public servants were nominated by their deputy ministers or agency heads and evaluated by a committee composed of the undersecretary of state for External Affairs, the deputy minister of National Defence, and the secretary to the Cabinet, who was also the head of the public service.[13] Warren Langford's cohort contained an interesting mix of civilians. The departments of National Defence and External Affairs sent single representatives. The Defence Research Board and the Department of Transport landed not one but two of their employees. Defence Construction Limited, Atomic Energy of Canada Limited, and the National Research Council each sent a single representative. Of the twelve civilians on Course Sixteen, six had no military background whatsoever. Defence know-how and career potential seem therefore to have trumped military experience.

The twelfth civilian was Warren Langford, whose presence at the NDC still seems something of a mystery, since he was then the senior staff officer advising the deputy minister for Customs and Excise in the Department of National Revenue on policy and operations, a position with no obvious connection to Canada's defence or foreign relations. Nor was there much likelihood at the time that he would move into one of the "defence" area departments, the preferred policy sector for course

candidates and graduates. His hopes, privately expressed, were that he would continue to rise up through the ranks at Customs and Excise. When instead he left the department, he did not go on to positions even remotely connected to national security, but moved via a secondment to the Program Branch at Treasury Board Secretariat, then to the Department of the Secretary of State, and finally to the Department of Communications, where he ended his career as director-general of Arts and Culture, supporting and funding cultural activities across the country. The department's responsibilities for nation-building, UNESCO, world's fairs, and the promotion of Canadian culture abroad were the closest he came to international relations.[14] While another NDC participant described Langford as a "breath of fresh air bringing different ideas to the table,"[15] it is not clear what made him so attractive, in the first instance, to the NDC recruiters and, later, to the college directing staff, who made him the civilian syndicate leader of the Afro-European Section.[16] What he was exposed to during his NDC training is less open to speculation.

The college's raison d'être and curriculum were dominated by the Cold War, the seemingly never-ending struggle between the Western alliance and the Communist bloc that started after World War II. The program was designed to sensitize thirty participants to the bipolar global context within which they were employed, creating stronger working relationships among the three military services and non-military departments and agencies. The overall focus was on the "military, economic, scientific, political and organizational aspects of national security."[17]

The course was divided into 'problems' lasting two to four weeks, with participants formed into 'syndicates' of seven or eight students for study and report-writing purposes. The specific problems emerged from the flow of the curriculum, which focused first on Canadian government and defence organization and then went on to look at the Canadian economy, the Western alliance, the Communist bloc, modern weapons and methods of warfare, countries of Asia, Africa, and Latin America, East-West conflict, and then, finally, Canadian foreign and defence policies. The college leadership claimed that the curriculum was regularly revised in response to changing geopolitical conditions, but in fact the topics, the pedagogy, and the mountainous reading lists appear to have altered little from year to year.

Travel was an integral part of the candidates' training. In November 1962, shortly after the end of the Cuban Missile Crisis, the entire cohort made a quick trip to New York and the United Nations, where briefings were marked by expressions of relief that this dramatic Soviet attempt to change the balance of power between the Soviet Union and the United States had not turned the Cold War hot. On their return,

students prepared for a three-week North American tour of military installations. After further academic preparation and report writing, the group was then divided for the Overseas Tours, half going to Africa and Europe and the other half to the Middle East and Asia; they joined together at the end in Brussels, London, and Paris. For eight weeks they were led to "study on the spot," enabling them "to confirm or modify" impressions gained from their studies.[18] All of this experience was consolidated in a last session on Canadian foreign and defence policies at Kingston, before the graduates dispersed to resume their careers.

Our father, never before much interested in photography, bought an Aires Viscount M 2.8 single reflex 35 mm camera and produced some two hundred Anscochrome and Kodachrome slides of his domestic and foreign tours.[19] He also posed for other people and accepted their duplicate slides as gifts, incorporating them into his collection. On occasional weekends home and after the long Overseas Tour, he set up the screen and projected the slides in the living room. These slides reflect both the dream of world travel and the nightmare of nuclear confrontation. Both inside and outside these largely touristic frames are potential theatres of war and sites of ideological conditioning. And the witness/photographer is no less complex a construction: family man and public official; an apprentice snapshooter with an itinerary of photographic opportunities; a professional tourist "seeing through the lens" of iconic Cold War photographs and popular photo essays and posing in similar frames to be seen by himself and others.

Reviewing our father's slide shows forty-five years later, we have grown interested in their representation of the Cold War, as structured by the curriculum of the NDC and especially its program of exposing trainees to particular North American, African, and European sites. As none of the slides was labelled, the first stage of our research was to identify the photographed sites and fill in the story behind the pictures, including facts that would not have been shared with us at that time and some that are just now coming to public attention. It is worth noting that obtaining the files of the National Defence College, now held by Library and Archives Canada, involved some Access to Information requests and that some of the information, still considered sensitive, might have been withheld. The 1962–63 course files to which we were granted access contained no in-country itineraries or briefing books prepared by the embassies, consulates, and bases on the Overseas Tour; in some cases, photographic evidence led us to question the official record. To solve these puzzles, we consulted files from Courses Fifteen and Seventeen, where available. We also looked for living members of Course Sixteen and were able to interview

retired Lieutenant General Richard Stovel, who had been with Warren Langford at Fort Frontenac, in New York, and on the North American tour. He himself had made 8 mm films from his experiences – films buried in a military lifetime of moving boxes – and he mused about the photographic culture of the college, remembering one member who said, "I'm the only happy person here because I don't fuss about pictures."[20]

Our fussing has continued, resulting in this bookish reconstruction of our father's slide shows, an interdisciplinary photographic study conducted close to home by the children of an amateur photographer whose apprenticeship took place in very interesting times. The two unifying themes of the book are vernacular photography, performatively defined as everyday photographic experience gained through the making and seeing of images, and the Cold War, as remembered and recorded and as re-examined through a geopolitical lens that focuses on Canadian participation through retrospective, contextual analysis and cultural theory. Simply put, Warren Langford's photographs document his attempt to see for himself, through the Cold War lens of Western militarism and colonialism, and to position both himself and his audience – his family – within that optic. As members of that family, we are hardly detached; we find ourselves reliving episodes of Cold War photographic experience, as they formed our impressions then and generate our inquiry now.

In photographic studies, such systematic use of the vernacular builds on interdisciplinary contributions from anthropology, art history, communications, folklore, geopolitics, history, geography, literature, and psychology.[21] Photography's relatively short life in the academy has seen the rise and fall of a number of critical trends that pertain to our study – formalism, Marxism, psychoanalysis, feminism, post-colonialism, the linguistic turn, with its structural and post-structural readings, memory as an organizing principle, and so forth – each focusing on a particular aspect of photographic practice and reception.[22] In the early 1960s, when Warren Langford's images were being produced, cultural theorists such as Marshall McLuhan and Daniel J. Boorstin had already pulled back the curtains on North American advertising and "pseudo-events" – if not curbing the appetites of consumers, at least shaming them for their addictions to flattering messages, vulgarizing copies, and outright deceptions.[23] The college's modest hopes for the Overseas Tour – confirmation or modification of impressions formed in the classroom – reverberate in Boorstin's cynicism: "The tourist's appetite for strangeness thus seems best satisfied when the pictures in his own mind are verified in some far country."[24] The sources of those images – visual media and, especially for people of our father's

generation, literature – can be plotted on a "circle of representation."[25] But, as we will show, this is neither a vicious circle nor a closed system.

Warren Langford's photographic attempts at verification are, *because of their visible shortcomings*, instructive tellings of Cold War history. We have attended to what the photographs show us, accepting that this reading might deviate considerably from the photographer's intentions or "focal themes."[26] Ulrich Baer stresses "photography's ability to confront the viewer with a moment that had the potential to be experienced but perhaps was not … a mechanically recorded instant that was not necessarily registered by the subject's own consciousness."[27] This phenomenon occurs with modernity's traumatic events, as Baer argues, but it also applies to photographic representation as a whole. A detail or a gesture, overlooked at the time, may hold a kernel story or an inconvenient truth. Looking at tourist photographs, some ethnographers warn against photographic "'noise' – appearances which have no significance to the outcome of the research."[28] This study of Cold War tourism opts instead to turn up the volume.

In the early twenty-first century everyone is a *new* historian, though, as historiographer Peter Burke points out, the twentieth century's affection for "new" approaches, such as "total history" or "cultural history," is not itself new. Rethinking the task of historical writing has always been part of the process.[29] Amateurism – doing things for the love of it – predates the invention of photography, which was immediately understood and eagerly seized upon as a means of making one's own visual documents, of picturing "history from below," whether below the skill set of a trained draughtsman or history painter or below the notice of disciplinary game wardens.[30] Vernacular photography, as we are considering it here, is photography whose lack of scientific or artistic pretensions has become its very claim on scholarly interest, as both document and barometer of modern life. From this perspective, photographic evidence and photographic experience are equally meaningful, as are reconstructions of photographic opportunity. Much of what we call vernacular photography has been generated by explorers, prospectors, settlers, travellers, and tourists – people with inquisitive and acquisitive predispositions.[31]

Other photographic vernaculars have arisen in response to these photographic visitations, and they continue to be produced as contemporary artists and emerging scholars engage with the afterlife of the photographic image as a vehicle of memory and imagination.[32] Contemporary art in all media is increasingly based on vernacular photographs found in private or public collections, in flea markets, or on eBay, which are applied to constructions of personal and collective identity. In

post-colonial critical practice, appropriations or performances by indigenous artists serve to repossess the products of a colonizing gaze.[33] Transcultural exhibitions with thermodynamic titles such as *Archive Fever* exemplify twenty-first-century fascination with the vernacular, especially its characteristic form of copious representation: many pictures, many voices intertwining.[34]

From a geopolitical perspective, the analysis is informed in part by ideas expressed by what are now called "traditional" or "orthodox" Western Cold War scholars and practitioners, largely from the late 1950s and early 1960s, whose writings and teaching dominated the curriculum of the NDC course and provided the lens through which Warren Langford and his colleagues saw the world that Canada inhabited.[35] In this view, the Soviet Union, for a variety or combination of reasons (national security, ideology-driven expansionism, paranoid leadership, traditional great-power behaviour), was largely responsible for provoking and sustaining the conflict with the West.[36] This Soviet-focused view of the Cold War began to be widely challenged by "revisionist" scholarship in the 1960s, which reflected an increasing appreciation of the inadequacy of a stark bipolar vision of the world to explain or justify US engagement in the Vietnam War and went on to seek more nuanced analysis of the origins and causes of the Cold War, the motivations, interests, and actions of key protagonists, foreign and military policy options that Cold Warriors might have pursued, and developments in the so-called third world.[37] What is often labelled "post-revisionist" scholarship has attempted to modulate what was seen as overdrawn criticism of the United States' role in the creation and conduct of the Cold War by "revisionists."[38] Western triumphalism resulting from the collapse of the Soviet Union in the early 1990s and the opening of Soviet archives have generated a further round of post–Cold War writing, including the simplistic "end of history" rhetoric of Francis Fukuyama, a renewed focus on the roles of competing ideologies, and the synthetic efforts of long-time Cold War scholars such as John Lewis Gaddis.[39] We have used post-1963 scholarship extensively to help clarify the realities of the world that the Course Sixteen participants experienced in their travels. But we have tried to resist its use for second-guessing their perspectives.

The dialogical structure of two scholars working with a personal archive extends Martha Langford's research on photographic albums (1860–1960) to a highly popular mid-twentieth-century photographic form: the domestic slide show. From a geopolitical perspective, John Langford has reconstructed some of the backstory to the photographs, seeking to understand how the various participants might have experienced the visual evidence of the Cold War, as well as how this evidence was

framed by and staged for the camera. Martha Langford's role has been to situate this private photographic travelogue in relation to public photographies in the mass media and to reflexively consider the function and value of such a particular collection. These disciplinary perspectives are preserved in the body of the text, disguising somewhat the degree to which the authors' voices have mingled.[40]

The Cold War Context

For people of Warren Langford's generation, the Cold War was the constant background music to their lives. If a member of this generation died in the 1990s, as our father did, then the Cold War had dominated almost their entire postwar adult life. John Langford worked briefly in the early 1990s in what was then Czechoslovakia, just after the collapse of the Warsaw Pact and the Soviet Union and the liberation of Communist Europe. He observed how the Cold War had starkly affected the world view of people so thoroughly that they were literally incapable of seeing the freedom of choice that was now available to them. They could simply not reframe their world and instead sat patiently waiting for orders from bureaucrats and party bosses that were not forthcoming. Learning to reframe Western experience has been no more rapid. It has taken many years and much digging in the archives to develop a comprehensive understanding of the cultural formations of the Cold War and its psychological impact on our parents' generation and ourselves. Our father had very few years to reflect on the Cold War from a distance and look at it through a different lens, though he came to regret some of its excesses, notably the Vietnam War.[41]

Warren Langford attended a college founded in 1947, the same year as the American Cold War concept of 'containment' was born. This geopolitical strategy had been elaborated by State Department official George Kennan in a "long telegram" from Moscow in 1946 and then in an article published in *Foreign Affairs* under the pseudonym X.[42] Kennan's article was widely circulated in Ottawa and other Western capitals, and it catalyzed huge changes in foreign and defence policy for governments on both sides of the Atlantic.[43] The article's containment strategy appealed to those in Western capitals who were becoming increasingly anxious about the apparent expansionist intentions of the Soviet Union and the increasing strength of Communist political parties in postwar Europe and Asia. Acceptance of this view of Soviet behaviour led to the pronouncement by the American president in 1947 of the Truman Doctrine, endorsing containment and proclaiming the US intention to react strongly to Soviet attempts to destabilize democratic regimes. This doctrine

was manifest in a number of specific measures, such as support for the Greek royalist military regime in the civil war with the Communists, pushback against Soviet involvement in Turkey and Iran, establishment of the Marshall Plan for European economic recovery, creation of the National Security Council and the CIA in Washington, formation of a new US-led Western alliance – the North Atlantic Treaty Organization (NATO) – and a huge airlift in support of West Berlin when it was blockaded by the Soviet Union. From the Soviet perspective, the strategy of containment was in fact 'capitalist encirclement': an attempt to defeat legitimate initiatives intended to enhance its regional security and international influence.

By 1950 the structure of the Cold War was well-established. The Soviet Union had its own atomic bomb (developed, in part, from the proceeds of espionage),[44] Mao Zedong's Communist Party had taken control in China, and the Korean War had begun, pitting the north and south against each other with support from the Soviet Union and China on one side and the US-led United Nations coalition on the other. As positions hardened, containment increasingly relied on military strategy, including psychological warfare, rather than economic or diplomatic methods.[45] In addition, in the United States and Canada particularly, the Cold War took on a domestic character, focusing on espionage, loyalty, and internal political enemies. The culture of guilt by association, which cast suspicion on all forms of difference and dissent, was embodied in Senator Joseph McCarthy's Communist witch hunts, the "lavender scare," and the characterization of social activists as pawns or agents of Communist intent.[46] The earlier defection of Igor Gouzenko, a cipher clerk at the Soviet embassy in Ottawa, forever after pictured in his white "pillowcase" hood, launched numerous espionage investigations, resulting in tremendous collateral damage for smaller players in North American public affairs. Prison terms were imposed on Canadian labour organizers, a member of Parliament, scientific researchers, and lowly clerks, some having passed on secrets out of firm political conviction, others simply moved by their sympathy for Canada's wartime ally, the Soviet Union.[47] Promising careers were shattered, inexplicably stalled, or simply never allowed to begin.

It was in these circumstances that Warren Langford restarted his public service career after returning to civilian life following almost five years in the Royal Canadian Air Force. The Cold War deepened while his career progressed through the 1950s. The United States and the USSR accelerated the arms race, developing the H-bomb, intercontinental ballistic missiles (ICBMs), and nuclear-missile-armed atomic submarines. The two camps used violence, subversion, military assistance,

economic aid, and propaganda to maintain and expand their control or influence in states such as Poland, Hungary, Iran, Guatemala, Cuba, and Egypt. There were occasional glimmers of what would in the late 1960s come to be known as détente, an easing of tension between the two sides. Opportunistic proposals to reduce the size of armies, allow mutual aerial surveillance of military forces, and limit both nuclear bomb tests and nuclear weapons proliferation were tabled.[48] In 1959 Soviet premier Nikita Khrushchev visited the United States and American vice-president Richard Nixon travelled to Russia. Pope John XXIII discreetly attempted to soften the anti-Communist hard line of his predecessor, Pius XII, by opening communications between the Curia and the Kremlin.[49] But these gestures were few, and they pale in significance when compared with the dangers created by such events as the Cuban Missile Crisis, which brought the two superpowers to the brink of nuclear war over the Soviet attempt to place medium- and short-range ballistic missiles with nuclear warheads on Cuban soil, ninety miles from the coast of Florida.

Taken in this atmosphere of confrontation and suspicion and influenced by the NDC course material and lectures, many of Warren Langford's photographs are most easily understood from a Western Cold War perspective. Those images feature the bleak outposts of North American air defence in Canada's north, the military might of the United States, post-colonial Africa, NATO forces in Europe, and finally the iconic isolated outpost of freedom, Berlin.

But what did a "Cold War perspective" mean in the early 1960s for a well-educated, thoughtful, Ottawa-based federal public servant, subscriber to the conservative *Encounter* magazine, regular reader of the Sunday *New York Times*, and "earmarked for advancement"?[50] First, it ensured that the Soviet Union was seen as an opportunistic and aggressive enemy and the greatest threat to world peace and the security of Canada.[51] A paper written by Warren Langford and his Syndicate 5 colleagues on the Western alliance provides a classic statement about the Soviet Union's total and ongoing responsibility for the Cold War. This essay is replete with assertions such as the following: "The list of Soviet expansionist moves since the end of World War II is long. While the Western nations were disarming, Russia maintained her military strength virtually intact; the absorption of Albania, Bulgaria, Roumania, Eastern Germany, Poland and Hungary constituted steps in the realization of her dream of world domination."[52]

Reflecting this perspective, a very significant, if declining, portion of the federal government's budget was devoted to deterrence and preparing for a hot war with the Soviet Union and its allies.[53] Canada was deeply enmeshed in military alliance

arrangements with the United States, which were focused on the defence of North America from attacks from the north by Soviet bombers and intercontinental ballistic missiles. In addition, Canada was an active participant in the defence of Europe, with an Army brigade and eight Air Force squadrons stationed in West Germany (where, it was thought, a Soviet ground attack on Europe would most likely occur) and anti-submarine forces patrolling the North Atlantic approaches. After the Gouzenko affair, Soviet espionage was widely feared, and considerable intelligence and police resources were devoted to countering this threat.[54]

Secondly, in bureaucratic Ottawa, because of the perceived Soviet threat and despite the confusing and contradictory utterances of the Diefenbaker government between 1961 and 1963, a high premium was placed on building and maintaining a close relationship with the United States.[55] In addition to connecting with its southern neighbour through military alliances, Canada during the 1950s cooperated in the construction of the Distant Early Warning (DEW), Mid-Canada, and Pinetree radar lines and the provision of training facilities to the United States. It also purchased American surface-to-surface missiles, fighter aircraft, the Semi-Automatic Ground Environment (SAGE) system for tracking and intercepting Soviet bombers, and the Bomarc B anti-aircraft missile system, while at the same time cancelling the development of the all-Canadian Avro Arrow.[56] Much scientific research and technological development in this period was defence-oriented and often carried out in partnership with US military research organizations and industries. By the early 1960s this alignment was not limited to defence relationships. On the economic front as well, there was a steady shift toward tighter ties with the United States. American investment in Canada was allowed to increase dramatically in the 1950s, despite the warnings of the Gordon Commission that this development threatened Canadian economic sovereignty. Cross-border trade grew proportionately. Well before the US-Canada Auto Pact was signed in 1965, proposals were put forward by the business community, government officials, academics, and even some unions to further integrate the two economies through the reduction of tariffs and the elimination of other trade and investment barriers.[57]

Thirdly, the Cold War was viewed within the Ottawa bureaucratic community as a legitimate and significant factor to be considered across the widest spectrum of government policy-making and activity. Cold War–related concerns about Arctic sovereignty contributed to the Liberal government's decision to forcibly relocate Inuit communities from northern Quebec to unfamiliar territories in the High Arctic, which could then be said to be inhabited by Canadians.[58] Foreign aid was used primarily as an instrument of Cold War politics.[59] The federal government

secretly fell in line with the US government's policy toward gays and other individuals in the public service with "character weaknesses," portraying them as security risks open to blackmail by agents of the Soviet Union.[60] Every member of Course Sixteen had to have top security clearance, with all the nervous self-examination and ultimate satisfaction that such a thorough and secretive vetting produced.

Finally – and closely related to the last point – any questioning of Cold War orthodoxy, political dissent, and social activism was suspect and therefore to be avoided. From the early 1950s through the mid-1960s, our family home was in Sandy Hill in Ottawa. Irene Norman, the widow of Herbert Norman, Canada's ambassador to Egypt, who committed suicide in 1957 after being openly accused by a US Senate committee of being a Communist, had a residence not far away. John recalls that Norman's persecution and death were subjects of considerable conversation among grown-ups in the neighbourhood, an object lesson about the dangers of youthful flirting with Communism.

Our house was just three blocks from the Soviet embassy, beside Strathcona Park and the Rideau River, magnets for neighbourhood kids. Soviet personnel took walks (always in twos, it seemed) in the area in the evening, and as children, we were often warned by our father to avoid contact with them. John once brought home a Soviet magazine given to him on a summer evening in the park by an embassy official; he was told never to accept such a gift again. As Reg Whitaker argues, what had started legitimately as spy hunting became, under the influence of the United States, witch hunting, creating anxiety that even a minor display of curiosity about the Soviet Union, for instance, might be interpreted as a sign of unreliability or worse.[61] John learned his lesson well and soon found the opportunity to prove his loyalty as a junior Cold Warrior.

In January 1956 the Soviet embassy, a repurposed Sandy Hill lumber baron's mansion, was completely destroyed by fire. The event dramatized Cold War paranoia because firefighters were initially prevented by Soviet personnel from entering the embassy grounds while they worked to remove sensitive documents and equipment. On the morning after, John, aged eleven, accompanied by his brother Stuart and a friend, snuck onto the property and recovered three canisters of film from a storage cabinet that must have been thrown out the back of the building into the snow. They took them to the friend's home across the street from the embassy and called the RCMP, who arrived almost immediately in two unmarked cars. The agents chastised John and his accomplices, asked them if they had looked at the films, which they denied doing, and swore them to secrecy before taking the canisters away. In the end, it seems unlikely that any USSR state secrets were comprom-

ised since the films, which naturally had been unspooled and examined before the agents arrived, appeared to be Russian cartoons and physical-fitness instruction.

When Warren Langford arrived at Kingston to join the NDC program in August 1962, he was a solid, career federal public servant who seemed comfortable with this orthodox Cold War perspective, lived within its rules, and imparted them to his children. The perspective would be reinforced by the views of other course participants, the conservative college staff, the course topics, the resource materials, and the ideas of the many distinguished academics and senior public officials encountered during the program.

Most of the participants in each NDC course were drawn from the senior ranks of the Canadian, American, and British military services. These men (and at this time they were all men) owed their career success in the postwar period at least in part to the expansion in military activity that the Cold War had stimulated. In a report on the college written in 1961 for the undersecretary of state for External Affairs, John Watkins, a former Canadian ambassador to Moscow, commented on the declining quality of the service participants and their inability to think creatively. "The military mind tends to be costive and conformist and to see things in blacks and whites. They are impatient of attempts to look at a problem from all sides and with the slow process of negotiating step by step. They like action and are readier than the rest of us to imagine that things can be settled once and for all by the use of force."[62]

Complaints were also expressed by some participants from the early 1960s and in a later (1967), more formal evaluation that the college directing staff (one from each military service and the fourth from the Department of External Affairs) held narrow views of the world which were reflected in the choice of course problems, speakers, and reading materials, as well as the framing of debates on major foreign and defence policy issues and the assumptions on which they were based. The 1967 evaluation argued, "The result is that the general approach of the College remains that of the mid-nineteen fifties, which does not adequately relate to the needs of senior Canadian military and government officers who will be facing Canadian national and international defence problems of the 1970s."[63]

Such may have been the case, but the reality is that in the early 1960s few senior public servants, industrial leaders, or even academic experts openly questioned Cold War orthodoxy.[64] They might argue about strategies and methods (e.g., massive nuclear retaliation in the event of a Soviet attack versus a flexible response starting with conventional weapons, or the open denunciation of public officials with left leanings versus secret gathering of evidence on such individuals and their quiet

exclusion from sensitive positions), but the need to contain and even push back the expansionist Soviet Union by maintaining a strong relationship with allies, especially the United States, and guarding against espionage and subversion was not yet seriously contested in the academic literature, the executive suites of Canadian big business, or the corridors of government departments.[65] Listen to the voice of Peyton Lyon, a well-regarded Canadian foreign policy expert, taking on Canadians who espoused more foreign, military, and economic policy independence:

> Are they blind to the facts of contemporary existence which imperiously demand greater interdependence? On the economic front, the trend is to larger, more highly integrated blocs; militarily, the possibility of independent defence vanished years ago; politically the western Alliance may go under unless its members are prepared to pool more of their sovereignty in the common cause … What, in 1961, could be more anachronistic than the cry of "national independence."[66]

It should not be surprising, then, that there is also little evidence that this orthodoxy was much challenged by the many experts and public servants who addressed NDC course participants in the early 1960s. The archives contain very few lecture notes, but in the case of most academics and senior officials, it is possible to extrapolate the messages they would have communicated to participants from their roles, contemporary writings, or later memoirs. It is hard to imagine either Major General Sir Rohan Delacombe, the recently retired commandant of the British Sector in Berlin and the lecturer on "The Berlin Situation," or Major General Creighton Abrams, future US commander in the Vietnam War and lecturer on "Land Weaponry and Methods of Warfare in the Nuclear Age," straying far from the orthodox Cold War script. Walt Rostow addressed the course on "The Role of Diplomacy and Force in International Relations." He was a senior adviser to President John F. Kennedy on national security and a hawkish Cold Warrior, who based his strategic thinking on the premise that "the impulse in Moscow to seek the expansion of Communist power is so deeply rooted and institutionalized that Soviet leaders will feel almost an historical duty to exploit gaps in the capacity, unity and will of the West."[67] William Kintner, who lectured on "Western Foreign Strategy," was a former American army officer and an adviser on nuclear and defence strategy to the US Department of Defense, the National Security Council, the CIA, and Richard Nixon's transition team. He was described, with perhaps a touch of understatement, in his *New York Times* obituary as a "political conservative."[68] Harold D. Lasswell, who, "almost

singlehandedly, introduced the disturbing world of the unconscious into Cold War behavioural sciences," laying the groundwork for such military think tanks as the Rand Corporation, was the NDC's invited lecturer on "Psychological Warfare."[69]

Closer to home, James Eayrs spoke on "Communist Theory and Practice." Eayrs was a prominent Canadian defence policy scholar who wrote perceptively about major strategic debates, but saw little merit at that time – his views changed later in the 1960s – in Canada moving away from its Cold War alliances and policies.[70] Professor Adam Bromke (the international relations specialist at Carleton University when John Langford was a student there) was the NDC lecturer on "Communist States of Eastern Europe." A wartime Polish underground fighter and émigré, he was an ardent anti-Communist, famous at Carleton for his espousal of *realpolitik* strategies for enhancing the status of Poland and other Warsaw Pact satellites.[71] The lecturer on "An Alternate to Nuclear Weapons" was General Charles Foulkes, the retired chairman of the Chiefs of Staff Committee. Robert Sutherland, the "Disarmament" speaker, was – curiously enough – one of Canada's foremost strategic thinkers and a strong advocate of the need to maintain a robust defence relationship with the United States.[72] Perhaps no lecturer represented the traditional view more thoroughly than Royal Canadian Mounted Police deputy commissioner George McClellan, who had been director of security and intelligence in the early years of the Cold War and when he addressed the NDC participants was in charge of all phases of the policing, security, and investigative work of the RCMP.

The course reading lists were all daunting in their length and lack of direction. Some were extremely comprehensive, drawing widely on contemporary academic books and journals. Others were dominated by official, classified (restricted or confidential), and very narrowly focused briefing documents provided by government agencies, such as the Department of External Affairs, its embassies and high commissions, the Department of National Defence, the three branches of the Canadian and US military, and NATO. Still others were almost laughably inadequate, featuring curiously titled articles from obscure journals and books that might sell well in airport shops. For example, items from in-house journals such as the US Air Force's *Air Intelligence Digest* (e.g., "Are Reds Brewing Fantastic Weapons?") were a notable feature of the "Modern Weapons and Methods of Warfare" module list. These lengthy reading lists appear to have been distributed to the participants at the beginning of each problem without any directions regarding key readings or the location of contending viewpoints. Speakers were not asked to make connections between their lectures and the reading lists. In such circumstances, it would have

been extremely difficult for course participants, especially those long removed from the classroom, to use these resources to test preconceived notions about the Cold War and Canada's approach to it. Syndicate papers did not require footnotes, and the papers to which we had access betrayed little sign of participants wrestling with different interpretations of events, policies, or motivations.

And if there is any doubt that orthodoxy held sway, we need to pay attention to the views of John Holmes, an influential Canadian foreign policy analyst who ran one of the final course sessions on Canadian foreign and defence policy in the early 1960s. His encounter with the class of 1961 was observed by John Watkins, who reports that Holmes commented to the class members "on the refreshingness of the orthodoxy he found in contrast to the spate of unorthodoxy to which he had been exposed in speaking to lay groups throughout the country."[73] Apparently, the irony was lost on the participants. Watkins further notes, "By the end of the session it was plain that he (Holmes) would have been very grateful for more evidence of fresh thinking in the group and more willingness to confront realistically and imaginatively some of the problems before us in the world as it is at present constituted. Frankly he was disappointed and discouraged and told me he had the feeling that they were living at least half a century behind."[74]

Cold War orthodoxy is perhaps even manifest in the photographs Warren Langford did not take. His colleague on the North American tour recalled no photographic restrictions; still, Langford's activity was curiously sporadic.[75] For the overseas tours, the college requested embassies and local authorities to produce "Personal Information Brochures," including "Photography Information: Availability of photographic materials and any special restrictions on photography."[76] Without access to these brochures, we can only speculate on the basis of Langford's own pictures and those in which he appears. Rules aimed at tourists or visitors to military installations might have been guiding him in some instances.[77] Elsewhere, his failure to record Cold War hot spots may have reflected his own risk assessments, since his colleagues were snapping away.

The Photographic Context

We make no claims for our father as a photographer. Warren Langford was a snapshooter with no greater ambition than putting together a slide show, a projected album. A photographic album is difficult to decode; a slide collection presents additional challenges, as slides are not compiled in the same way. Some people

organized their shows and kept them together in slide trays or binders. These slides came to us in boxes supplied by the processor, and while most of the mounts are numbered and can be restored pretty well to the sequence in which the pictures were taken, this does not necessarily correspond to the order in which they were shown. There are no captions or lists, nor can we remember what our father chose to include in his slide shows, though certain key images stick in Martha's mind – the missiles at North Bay, for example. "There were lots of them and my brothers started shouting, 'No more!'" Generally, we recall that our father's slides shows were quite long and somewhat repetitive, so we would venture to say that he showed us everything he took, pretty well following his itineraries.[78] The results are sometimes episodic (short cinematic vignettes that narrate a walk or a visit), sometimes descriptive (whether from a single-point perspective or in a series of shots across the horizon), and sometimes expressive (responding to the photogenic qualities of a setting or a view).

The slides restored to their original sequence also preserve something of the photographic impulse, which is quite intriguing. Warren Langford appears to have gone into a photographic frenzy under certain circumstances, while he took not a shot in other situations that we might find pretty interesting today – nothing in Belgrade, for example. His photographic travelogue starts, stops, stutters; the narrative is full of gaps. What we are left with are moments that he took to be photographic opportunities: situations in which he felt licensed, encouraged, or even compelled to photograph. For a photographic theorist, the first question might be: Where did those impulses come from, and what were their governors?

We are looking, one might say, at a productive meeting of opposites: a hybrid form of what John Urry has called "the tourist gaze."[79] Criticism of Urry's widely travelled phrase has questioned his understanding of the gaze, specifically whether his use of the concept retains the complexity of its French intellectual roots to express more than mastery, or the naive desire for mastery, of the scopic field.[80] Urry himself, in collaboration with Carol Crawshaw, has unpacked more facets of "the tourist gaze" in relation to seeing, perception, anticipation, and memory. Tourists who might aspire to visual mastery of strange surroundings are equally liable to be seen and stage-managed by the objects of their gaze. Tourist photography can be considered "as mirror, as ritual, as language, as dominant ideology, and as resistance."[81]

Uses of the word 'tourism' are on the whole less contested. Most studies recognize its roots in "the Greek word for a tool used in describing a circle ... tourism

intrinsically involves a circular itinerary in that tourists return to their point of origin, home."[82] Along this circle route, tourism is construed as a leisure activity, recreation, sometimes an escape: as Urry writes, "The places gazed upon are for purposes not directly connected with paid work and they normally offer some distinctive contrasts with work (both paid and unpaid)."[83] Tourism is a break from the workaday world, which is not to say that work itself is not gazed upon or created by the presence of the tourist. On the contrary, Dean MacCannell's Marxist theory of "alienated leisure" – "a perversion of the aim of leisure" – describes the modern tourist's fascination with the working lives of others, whether willingly presented in the form of "staged authenticity" or seized from the shy, or the unwilling, by adventurous tourists who leave the beaten paths in search of *real* authenticity.[84] The trick is to recognize it when they see it: according to Jonathan Culler, "tourists are the agents of semiotics: all over the world they are engaged in reading cities, landscapes and cultures as sign systems." But they seek confirmation, or what MacCannell calls "markers," that what they have found is the real McCoy.[85]

Such adventures are marketed as totally transformative, leaving theorists such as Edward Bruner countering that "the tourist self is modified very little while the native self experiences profound change."[86] The mirroring of tourists' desires and expectations – the provision of good photographic opportunities, for example – modifies both the cultural products and the values of the host culture.[87] Postcards are often held up as examples.[88] But whether tourists with cameras are engaged in a photographic form of social interaction or trophy hunting, they are supposed to be at leisure – that is, released from the daily grind to enjoy touristic experience.[89]

Our Cold War tourist's photographs strain that convention by attaching to both labour and leisure, each latent in the other, and by blurring distinctions between public and private, history and memory.[90] Much depends on the tourist's understanding of what he is about and what he is projecting – an image that flickers, depending on the location. In decolonizing countries, negotiations for a souvenir at a roadside market might put him in a class of "special access tourism," with privileges previously enjoyed by colonial administrators, missionaries, and businessmen.[91] On a spring evening in Europe, rubbing elbows with diplomats might turn his thoughts to the romance of espionage, while luxury hotels and picturesque ruins prompt cultural memories of another era's Grand Tour.[92]

The case study is doubly interesting, because we are also faced in the tourist with something of a split personality. He may have been our father, but as a member of the sixteenth cohort of the National Defence College, Warren Langford was a

public person, with a number of symbolic functions of which he was constantly aware. He was, for example, a civilian, rather than a military man, though he had served with two nations' air forces: as a radar operator in the RCAF during World War II, he had been assigned to Royal Air Force Coastal Command in Scotland. Still, he wore a lounge suit, not a uniform, at social functions, of which there were many at Fort Frontenac and over the course of his travels.

Outside Canada, he became a Canadian, part of a group representing the Canadian government. A certain level of deportment was required, as reflected in one of his recorded comments about an unspecified event on the Afro-European trip: "I

Figure 1
Warren Langford,
San Diego, California,
January 1963

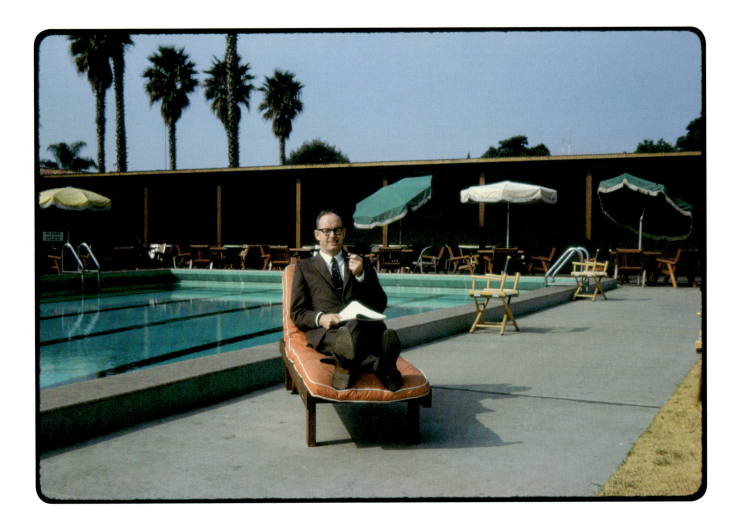

have never been without my pipe in more enjoyable circumstances."[93] Never? Consider how his wife, and bed partner, might have responded to that little quip – probably just as he meant it, as an expression of his public persona. At the same time, he was taking photographs for personal interest and to show his family where he had been during these long absences, holidays from family life to which he was entitled by virtue of his professional status. There is a whiff of domestic pleading in this function that also fits nicely with Edgar Morin's understanding of the hard-working tourist.[94] Many of our father's photographs were taken on rest days; they prove that he was not resting but taking very long walks to survey the terrain. He was, on

Figure 2
San Diego, California,
January 1963

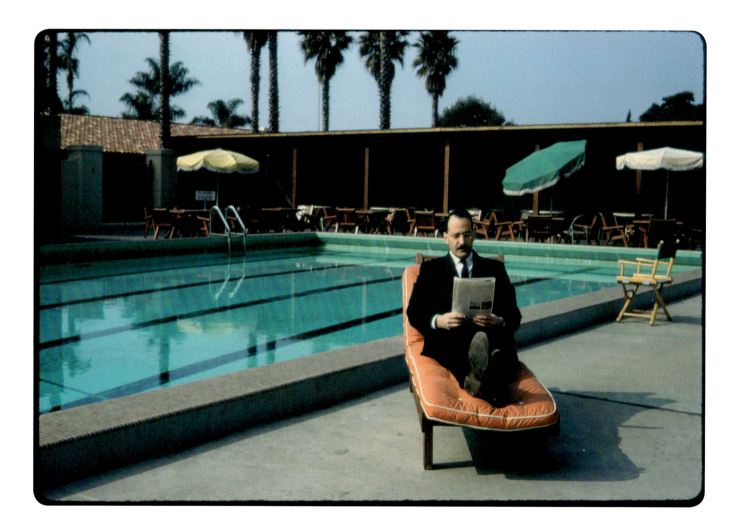

these occasions, a Sunday photographer, an amateur par excellence, in a role that assumed unexpected power when the group made its visit to Berlin.

Warren Langford's slides are illustrative of his photographic experience on a number of levels. Already a willing photographic subject, he was also learning how to photograph others, both colleagues and perfect strangers, some of whom are manifestly camera-shy. This photographic *Bildungsroman* is also a primer on the intricacies of the "tourist gaze," conceptualized as the expression of encounters between self and others, both inside and outside the frame.[95] To borrow an image from the Cold War, the watchers are also being watched, or they feel they are. His first photographic choices can be seen as emulative; some of these are plainly staged, and quite playfully, as repositories of camaraderie and special moments. The silliness of this double portrait, made in San Diego, strikes us now as it would have struck viewers then – as an amusing image of incongruity (figs. 1 and 2). Placing the slides in numerical order confirms that the portrait of our father was taken first, using his camera. Was he in fact waiting by the pool for transport, sunbathing in his brown suit, when a colleague happened along and saw how funny he looked? Warren having been outed as a clown, did he then propose that the other man imitate him ("Let me get one of you!")? This short photographic lesson, and its bonding effect, seems to have held some importance for our father, since he kept both images, while an earlier, stiffer portrait of him before the same hotel stands alone, following a one-slide gap in the roll. The missing image has to have been a more decorous portrait of his colleague, given to him as a more appropriate keepsake of himself as a man on a serious mission.

Others slides offer different kinds of proof. They are forms of witnessing that relate more directly to the college's objectives, to the formation of the public man: a forty-three-year-old, mid-level Canadian civil servant.[96] The broad requirements of the Overseas Tour were articulated as follows: "to supplement the work done at the College by seeing something of the countries that are of concern to Canada in her international relations and by hearing at first hand from personages, officials and experts something of their national problems and to gain some insight into their characteristics, outlook and attitudes."[97] The NDC hoped to *hear* from speakers of the highest calibre and position.

Seeing, however, was another matter, and the memorandum continues: "It is important that the members of the College be allowed some time to see something, not only of the cities, but of the local countryside, in order to gain a better understanding of social developments and to supplement the briefings which they have had as well as general discussions which take place during social engagements."[98] The

word "supplement" can be taken as encompassing the possibilities of confirmation and modification – the power of *seeing for oneself,* as distinct from other ways of gathering information, though never quite *correcting* them for two somewhat contradictory reasons.

First, the ways of seeing were in a sense pre-framed by exposure to images from the mass media that were embedded in ideological constructions. Second, the photographic opportunities that presented themselves were eventless – that is, devoid of journalistic interest. There are mass-media precedents for those kinds of everyday images as well – Warren Langford would not otherwise have taken them – but their taking within the context of a Cold War tour gives them a particular quality, affording us a look behind the curtain of mass-media photographic propaganda.

Pictures of people in their everyday lives are the basic product of social documentary photography: influential European and American models, such as Mass-Observation, the Farm Security Administration, and the Photo League. Our father had a vivid recollection of seeing the Museum of Modern Art's famous travelling exhibition *The Family of Man* when it was exhibited at the National Gallery of Canada in February 1957.[99] This exhibition, with its implicit messages of universal brotherhood and explicit cautions about nuclear escalation, may have been demolished by French critic Roland Barthes, but its dazzling effect on Western audiences was undiminished.[100]

The photo essay, well-established in mass-market magazines since the 1930s, also traded in the ordinary made interesting. In the early 1960s Canadian readers of English-language newspapers received an illustrated magazine every week; photo essays, many of them generated by the National Film Board Still Photography Division, were published in newspapers across Canada. If you went to the doctor or dentist, you saw *LIFE, Look,* or sometimes *Paris-Match.* Our family subscribed to the American magazine *National Geographic* and the Canadian edition of *Time.* Martha's earliest memory of puzzling over a news photograph belongs to *Time*'s coverage of the Cold War and to this project, since she sought an explanation for pictures of a wall in Germany and the pain it was inflicting from her older brother, John.

A survey of these popular magazines has turned up striking similarities to Warren Langford's photographs, as well as some important differences. *National Geographic,* situated by Catherine A. Lutz and Jane L. Collins "between science and entertainment," secured its first generation of readers by publishing "technically adequate, though naive, prints from travellers." Adopting the Modernist style of straight photography, "*National Geographic* photographers … were asked to

The horn remained balanced, and the initiate continued to smile as if nothing had happened. Girls on the side lines ran up to him, cheering and laughing to indicate their approval of his courage. Again the person with the stick danced up and struck another blow.

After the third blow, other young men gathered round the initiate and pressed coins against his forehead to test whether or not the blows had brought sweat to his skin. The coins fell off and the girls cheered.

The boy was still calm. He then was marched before his elders and, after bowing, retired from the circle. He had proved he was able to take punishment without flinching. One after the other, all the initiates went through the ordeal.

Most young Fulani men successfully brave these floggings, but sometimes one fails and has to go through the ordeal again or else be considered a weakling. A few have died from the severe blows they receive. Though many Fulani youths of delicate features appear almost effeminate, they certainly do not lack stamina and courage. The great majority proudly display scars on their chests.

A British District Officer, with whom I talked later, told me that Hausa menfolk often asked him if there were any Fulani in England. When informed there were none, they asked in surprise, "Then how do you get meat and milk if you have no cattle herders?"

On another side trip from Jos I rode down the steep southern slopes of the plateau to Pankshin and Shendam. In village markets I saw numerous tribal folk come to shop.

"Within the 3,600 square miles of this district," the British A.D.O. at Pankshin told me, "there are at least 20 tribes, each speaking a different language."

Many of these tribal groups live in the hills, impoverished and isolated. Now the British are aiding some of them to abandon their rocky hill refuges and unproductive fields and resettle on richer lands below.

I visited one resettlement area near Shendam. Four years before, no one had lived there; now the area is occupied by 300 families—some 2,000 individuals. One of the farm villages was so new that men were still mixing mud to build walls and were bringing in poles and thatch for the roofs. On newly cleared fields the people were growing corn, rice, sesame, peanuts, and Guinea corn, and were harvesting more food than they had ever known before (page 363).

Magic of the Printed Word Holds West African Youngsters Spellbound

Only one in five Nigerian children attends classes. The rest have no school close by, or receive purely religious education. Literacy programs in the villages attack the problem by teaching apt pupils, who in turn pass the knowledge on to neighbors. This boy reads the *Nigeria Review* to friends in Onitsha.

Camera Press-Pix

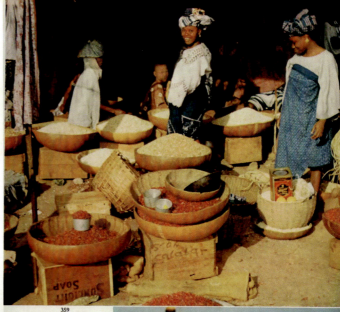

359

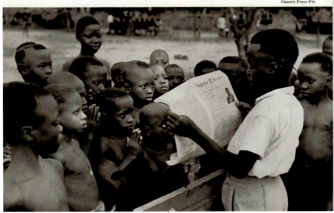

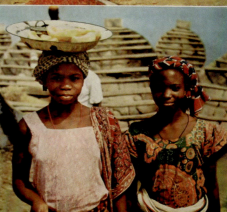

↑ Sidewalk Supermarket Draws Ibadan Wives

Halved calabashes display dried foods in the central market place of Nigeria's largest city.

Foreground tray holds red peppers, so widely used in cooking that Europeans can hardly swallow the food. Corn, sorghum, and peas fill other containers.

Indigo colors the wraparound skirts and carefully folded turbans of these Yoruba women.

→ Scars mark the cheeks of these girls near Asaba, on the Niger River. Enamelware basin holds papaya slices. Fishing boats crowd the riverbank.

© National Geographic Society

Figure 3

W. Robert Moore, "Progress and Pageantry in Changing Nigeria," *National Geographic*, September 1956, 358–9. Reprinted with permission.

make literal transcription their goal."[101] Lutz and Collins contrast the magazine's style with photojournalism's "decisive" moments. They find an editorial bias for the "random" or "incisive" moment: "a lull between peak actions." Effects of "timeless-ness, inherence, and enduring family values" are prized and expressly connected by the editors to *The Family of Man*.[102] Lutz and Collins's observations are confirmed when we compare *National Geographic*'s and *LIFE*'s representations of Nigeria, a place also visited by NDC students on their Afro-European Tour.

Published in September 1956, the *National Geographic* story "Progress and Pageantry in Changing Nigeria" combines snapshots taken by the writer, W. Robert Moore, with photojournalism and stock images from the agencies (fig. 3).[103] The overall effect of this editorial amalgam is something between diary and scrapbook. The professional photographs are deskilled by the amateur company they are keeping and drained of visual drama by the compressed layout.[104]

By contrast, "The Hopeful Launching of a Proud and Free Nigeria," published in *LIFE* on 26 September 1960, offers a coherent, 'signature' look at Nigeria: seasoned photojournalist and African old hand Eliot Elisofon supplies a lead picture that is a study in cultural syncretism and Cold War technocratization.[105] A group of Nigerian villagers, masked as "ancient juju gods," includes one person wearing an "antique" gas mask, while the text exults that Nigeria, a "new nation," is moving "eagerly from a primitive past toward a modern world" (fig. 4).

A photograph so showcased in *LIFE* carries the authority of Western technical superiority. With point and symbolic weight, it is on its way to the canon as a summary statement of rapidly changing conditions. The average reader is struck dumb with admiration; the amateur photographer cannot compete. This is another form of photographic experience: a viewer's memorable encounter with a spectacular photographic image. As Robert Hariman and John Louis Lucaites argue, the encounter with an "iconic photograph" is destined to be repeated, the image much reproduced and frequently translated into non-photographic forms, doing various jobs in public life.[106] For the amateur, drawing on this cultural memory through performative emulation reproduces both the impressive image and the excitement of first seeing it – a mediated form of first contact.

In *National Geographic*, with many more words and images relating the story, the cumulative effect is patient: travel as a way of life, seeping down from the leisure class to the middlebrow consumer. The places of tourism correspond to a paternalistic educational program: not too strong on social or political expression, just enough to keep pace with the appetites and tolerances of the readership. As Lutz

THE HOPEFUL LAUNCHING
OF A PROUD AND FREE NIGERIA

Model of preparation in a turbulent continent, the new nation
moves eagerly from a primitive past toward the modern world

Photographed for LIFE by ELIOT ELISOFON

From behind its centuries-old masks of savagery and primitivism, the most populous nation in Africa looks out eagerly on a world it is about to join as an independent nation. On Oct. 1, Nigeria and its 36 million black inhabitants gain freedom from Britain. Like the other new nations of Africa, it is ambitious and proud. "We want independence," said a Nigerian civil servant, "because we want to be accepted on our own terms—and to be able to turn our backs on those who won't accept us."

The free world, with the worrisome Congo on its mind, can temper its anxiety over Nigeria—because of farsighted British colonial policies. The Congo plunged into catastrophe when Belgium thrust independence on an unready people. In Nigeria, Britain has encouraged and trained a native leadership. The dangerous black vs. white antipathy which is wounding such lands as Rhodesia is absent from Nigeria where Britain barred whites from owning land. Besides, killing heat and disease, which gave Nigeria the name "the white man's grave," has kept the white population down to 27,000.

It is an exotic, variegated land and the handsome photographs on the following pages show the diversity in its many moods and colors. But diversity could make it difficult to preserve the country's unity. There are some 400 tribes whose local chieftains, dressed in the splendid trappings of their office, may be swayed by tribal loyalties. There are rival religions—white-robed Moslems who make obeisance to Allah, Christian converts led by foreign missionaries, pagans dancing to their juju gods.

NIGERIA, a three-region federation, is 360,000 square miles—California, Nevada, Oregon combined.

There are fundamental antagonisms between its three regions. The north, made up of mountains and arid plains and three times larger than the rest of Nigeria, is mainly a Moslem land of minareted cities and feudal emirs. It fears the liberalism of the Christian south. The south, a region of swamps, rain forests and grassland, fears the autocratic conservatism of the north and is itself split. The comparatively urbanized west, run by the Yoruba tribe, is the hustling center of education and bold government. In the east, where oil has been discovered, the dominant Ibo live in small farming villages.

In a nation where 250 languages are spoken, political parties must graft themselves onto a multicellular tribal system. A modern economy must be built where most commerce is by "mammy traders" who deal on the level of one lump of sugar and one cigaret. And the human sinews of government, the civil servants, must be strung in large part with men of bare high school education. But Nigerians, with intense British help, are driving ahead, compressing into a few years decades of normal maturing. In a land where mud hut villages are common, an ultra-up-to-date university is rising up. A Nigerian cabinet and prime minister already virtually run domestic affairs and the three regions are self-governing.

This embryonic democracy is oriented toward the West and will stay that way unless, says one Nigerian, "the West is stupid." "I am an African," he goes on. "When a Belgian in the Congo slaps Lumumba, he slaps me and the whole African race. So we acquire bad feelings secondhand."

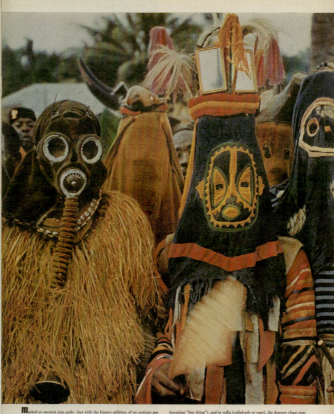

Masked as ancient juju gods—but with the bizarre addition of an antique gas mask—Ibo masquerade dancers assemble for the annual *Onwuate* or yam festival in the eastern village of Ugwueke. In wildly colored costumes called *iyafo* (meaning "fine thing"), and in raffia (called *ada* or *rope*), the dancers chase noncostumed men with mock ferocity, hitting them with switches and blowing horns from under the masks. The chased men act mortally afraid, then laugh wildly.

CONTINUED

Figure 4

"The Hopeful Launching of a Proud and Free Nigeria," *LIFE*,
26 September 1960, 54–5. Photos by Eliot Elisofon.
Text reprinted with permission of Life Inc.
Copyright 1960 Life Inc. All rights reserved.

and Collins explain, *National Geographic* was a private organization with strong ties to the American government.[107] Chronicling the magazine's evolution through the Cold War and anti-colonial struggles, they rehearse many of the themes and motifs that can be found in Warren Langford's photographs, not just in Africa but also in the Canadian North.

The ideological pattern of *National Geographic* can be fuzzy when its cameras are turned on the Other. It comes into sharp focus when the spotlight turns on You. In 1947 another article that must have circulated widely in Canada's capital was "Exploring Ottawa," a lengthy feature whose first two photographs feature Canadian prime minister Mackenzie King with British field marshal Viscount Montgomery in one and with US president Harry S. Truman in the other. Ottawa is introduced as "the capital of the United States' northern neighbor and its close military ally." Mounties are featured in six of the twenty-three photographs; the rest of the article is dominated by views of Parliament and the Ottawa River, the latter helpfully compared to the Potomac and the Thames.[108] In its pedagogical strategy of building on its readers' knowledge and beliefs, in its fusion of the exotic and the familiar, *National Geographic* style comes close to what we are here calling 'Cold War tourism.'

But two additional aspects need to be taken into account. First, the explicit and determinate context of the Cold War: however touristic the photographic report, the intended audience knows, and the reader cannot forget, that these images all relate *somehow* to Canadian defence strategies and foreign policy. Our Cold War tourist would otherwise not be there to take them. Second, the slide show presentation of the images – one after the other, projected on a screen – is not at all like the fixed combination of image and text offered by *National Geographic*. A slide show is fluid, durational, and improvisational, in the sense that its performance invites participation from the audience. A single image, filling the screen, is immersive and therefore potentially memorable, though, like speech, the experience is evanescent. Returning to us through both history and memory, these photographs are shot through with conflicting temporalities.

Timing was certainly a factor in Berlin: almost two years after the erection of the Wall, the situation in spring 1963 remained volatile. Whether the visit would actually happen was always open to question, and its precarious place on the schedule was regularly mentioned. On 30 April a memorandum from the Canadian Military Mission, Berlin, made the point that the NDC visit to the city had to be understood as occurring at the invitation of one of the four Berlin Sector commandants, in this

case the British. "The presence of service personnel in West Berlin, other than those of the three Western occupying powers [Britain, France, and the United States], is not strongly encouraged." Interestingly, the 1944 Allied Protocol had specified that commandants be allowed to invite "representatives of the armed forces of other Allied countries which [had] participated in military operations against Germany." But for the forthcoming NDC visit, it was stressed that there could be no "question of publicity."[109] Canadians were there on sufferance; they needed to keep a low profile. To be crashing the Berlin party can only have raised expectations for the Canadian members of Course Sixteen regarding their visit, whose itinerary, suspensefully, was not circulated until 10 May, well after they had hit the road. Warren Langford's pictures of Berlin and photographs taken there of him are nevertheless oddly laconic. For reasons we will explore, they take on the cast of "dark tourism," or "thanatourism," as situated on the battlefields of two tragic conflicts: World War II, in which the Soviets and Canadians were allies, and the ongoing ideological and economic struggle over Berlin, in which East and West Berlin were divided by a wall.[110]

Malcolm Foley and J. John Lennon connect modern "dark tourism" to moving pictures produced and transmitted by the mass media: they are never static but, rather, "dynamic images experienced ostensibly first-hand and committed to memory by reinforcement."[111] Television or the Internet is what they mean, but we would argue that such dynamism may also be generated by a family slide show, in which touristic images become screen memories and vehicles of intergenerational transmission based on first-hand experience. Personal memories become collective memories through photographic storytelling. Children of the Cold War era, we had already consumed many of its mass-media representations of fear and family, but our storehouses of Cold War memories were considerably enlarged when the portable screen went up, the projector bulb was lit, and the photographer, who was also our father, said: "Turn out the lights."

Northern Outposts and the Heart of Empire

THE NORTH AMERICAN TOUR

Course Sixteen's North American tour, carried out between 14 January and 2 February 1963, was designed "to gain knowledge of the military strength and potential of Canada and the United States."[1] It was a circuit of military and strategic installations and followed directly on the heels of the group's completion of the "Modern Weapons and Methods of Warfare" problem, served up in two parts because of the Christmas break.

The Weapons and Warfare problem seemed to spark the holiday mood. Canadian army colonel R.T. Bennett's introduction to Colonel W.R. Sawyer's series of lectures on "The Theory of Nuclear Energy and General Principles of Nuclear Explosions, Together with the Effects of Nuclear Explosions, Blast, Thermal Radiation, Nuclear Radiation, Fallout, and Further Aspects of Fallout" was a parody of the 1823 poem "'Twas the Night before Christmas."[2] Course Sixteen had already been enjoying some family entertainment, courtesy of Walt Disney. A classic of American Cold War propaganda, *Our Friend the Atom* (1953) features stunning visual parallels between a nuclear-level explosion on an island and "The Fisherman and the Genie," in which the genie's escape from the bottle fairly replicates a mushroom cloud.[3] More sober projections of Tomorrowland came from reading the

Canadian Army's civil defence plan, "The Role of the Army in National Survival," which listed the nine likeliest target cities and methodically explained how Canada would dig itself out of a nuclear winter.[4] The problem was heavy sledding, and a certain level of stupefaction is evident in participants' comments following a lecture on "Biological and Chemical Weapons in the Nuclear Age." British army colonel R.D. Wilson's somewhat tortured pursuit of precision is recorded as "I am talking about *potential* – how far can you *not* go," while his countryman, Royal Navy Captain D.V.M. Macleod, presses the speaker with a supplementary "I wasn't asking for the rational answer, Colonel. I was asking for the American political feeling."[5]

Modest Efforts

Appropriately, our Cold War tourist begins his travels in the cold. The North American tour started in Halifax with a visit to Canadian naval installations, including Integrated Maritime Headquarters, the Joint Maritime Warfare School, the Maritime Reconnaissance Squadron, the Naval Research Establishment of the Defence Research Board, and the Bedford Institute of Oceanography. The briefings focused in part on the role of Allied Command Atlantic (ACLANT), responsible for protecting the deployment of NATO's sea-based nuclear deterrent and maintaining the sea lanes from North America to Europe and North Africa.[6] Canada played a relatively minor role in these activities, which were largely under the control of US surface and submarine forces stationed in Norfolk, Virginia.

From there the tour moved on to North Bay, Ontario, and the 'hardened' underground Northern Region HQ Combat Centre of the North American Air Defense Command (NORAD).[7] The centre had been built, but the SAGE computer control systems would not be operational for another eight months.[8] The first of Warren Langford's photographs was taken at RCAF Station North Bay, where the group visited the newly acquired CF-101B Voodoo interceptors of the Royal Canadian Air Force's 414 Squadron and the Bomarc-B anti-aircraft missiles of the 446 SAM Squadron (fig. 5). By 1962 both the Voodoo fighter and the Bomarc, under the control of the commander-in-chief of NORAD, had become symbols of Canada's ambivalent engagement in the air defence of the continent.

Throughout the Cold War, Canada was under constant pressure from the United States to be a more proactive partner in the defence of North America from air attacks by the Soviet Union. Despite Canada's secret agreement with the US government in 1957 to adopt five nuclear weapons systems, the Conservative government

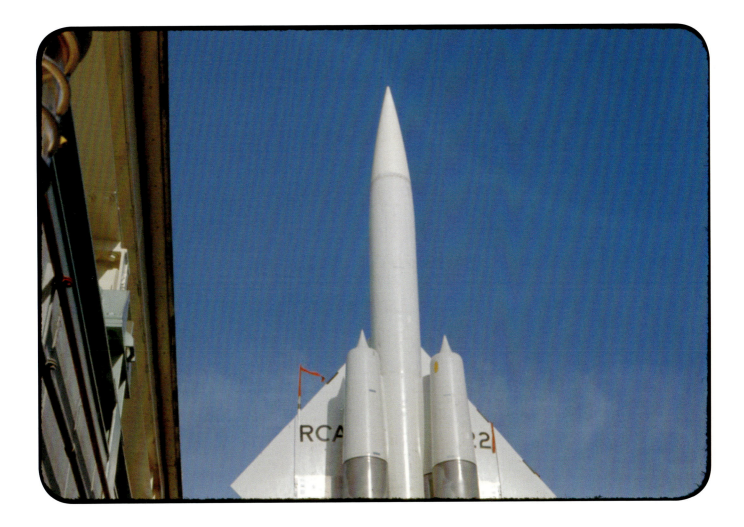

under John Diefenbaker balked after the agreement became public in 1960. When Warren Langford took these pictures, the Bomarcs and the Voodoos were still many months away from being fitted with nuclear weapons, a process only begun after a change of government in Ottawa in 1963.[9] In a paper written prior to the trip, Langford's NDC syndicate noted that "Canada's refusal, on very weak and illogical grounds, to allow her NORAD forces to be armed with nuclear warheads creates a serious hole in the defence of North America which could be disastrous in an all-out war."[10] This is strong criticism of the Diefenbaker government's waffling by a syn-

Figure 5
North Bay, Ontario,
January 1963

dicate made up largely of hand-picked, loyal Canadian public servants and military officers.

The demonstration of the Bomarc appears to have consisted solely in raising the roof of one of the missile shelters and elevating the missile vertically into firing position. In most of Langford's photographs we see the upright weapon, gleaming white against a clear blue sky. The third picture in the Bomarc set depicts two colleagues standing beside the missile. Their heights establish the impressive scale of the object; their less-than-rapturous attitudes are also captured. One man (not in uniform) smiles jocularly at the camera, his right hand on his hip, his left reaching

Figure 6
North Bay, Ontario,
January 1963

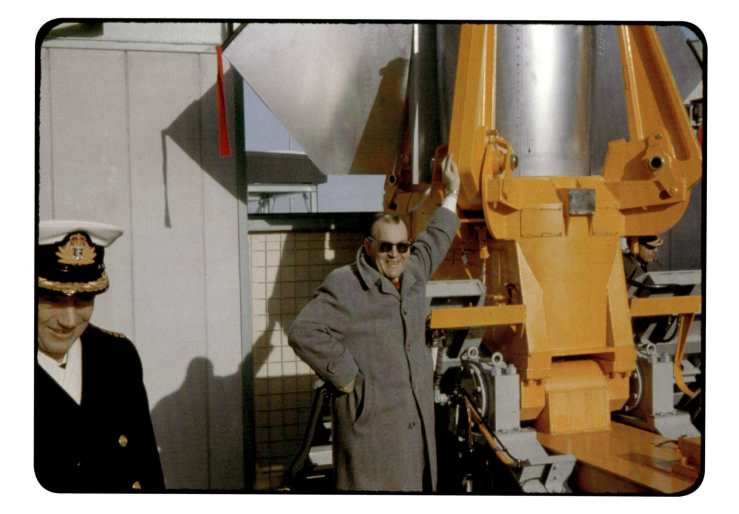

up to touch the erector (fig. 6). Would a picture like this have been allowed if this missile had been nuclear-tipped? On one hand, when it is viewed from a contemporary vantage point, there is something incredibly casual about all of this. On the other, we cannot forget the quip of one tour member as he left the Bomarc site: "Now I've seen my first eunuch!"[11]

The journey continues northward marked by two images of the group's departure from North Bay. The first slide features the visiting 'suits' and 'uniforms' sporting those infamously ineffective toe rubbers walking across a freezing tarmac to the tour aircraft. Their attention has been caught by the lonely fighter aircraft in the background. This is one of Canada's great Cold War defence production successes: the CF-100 Canuck, an all-weather fighter that saw service in a number of models from the early 1950s until the late 1960s (fig. 7).[12]

In the next photograph, our Cold War tourists are converging on the North America tour aircraft, one of the two de Havilland Comet jets operated by the RCAF's 412 Air Transport Command from 1953 until they were phased out in late 1963. Lagging behind with our photographer-father is Captain R.H. Chicken of the Royal Canadian Navy (fig. 8). They are about to board the Comet, a British designed and built aircraft that had become the first commercial passenger jet in 1949; it suffered a series of fatal crashes in the early 1950s before certain design problems were corrected. These mishaps did nothing to build public confidence. So, while the Comet enjoyed a long career as a military aircraft, it had been displaced in commercial jet travel by the Douglas DC-8 and Boeing 707 by the late 1950s.[13] One cannot help but imagine that the more knowledgeable travellers might have been a tad fretful each time they climbed aboard.

The tour was headed for two days in the Arctic, stopping first at Fort Churchill, on Hudson Bay in northern Manitoba. After World War II, because of existing rail, airport, and military infrastructure, Fort Churchill became an important Canadian-US joint military testing facility. The focus was first on cold-weather warfare testing and training, then short-range surface-to-air missile testing, and, from 1954 to 1964, upper-atmosphere rocket research, driven in large part by the problem of designing ballistic missile guidance systems capable of dealing with the geomagnetic and auroral influences of the upper atmosphere over the Arctic. This problem was obliquely referenced in a postcard home in which our father bemoans the lack of landmarks in the north but notes the possibility of "travel by dry compass once you learn how to cope with the problem of magnetic effects."[14] After 1959 the Churchill Research Range also became the main test and launch site for the

Figures 7 and 8
North Bay, Ontario,
January 1963

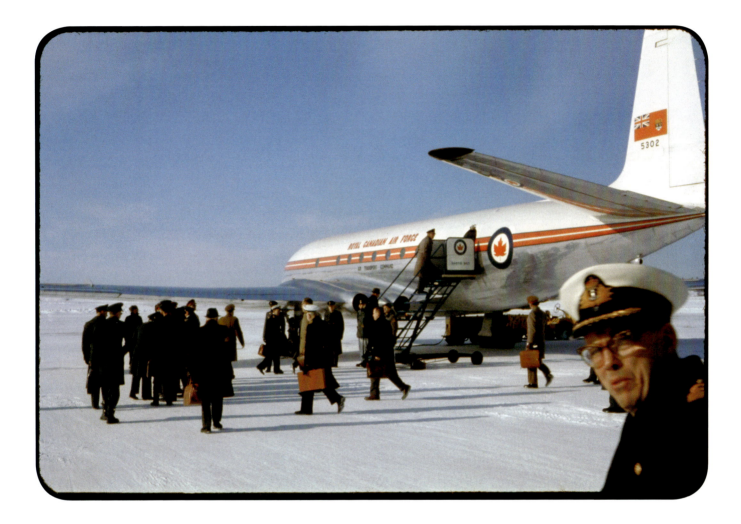

Canadian-designed Black Brant rockets. In January 1963, when the tour arrived, the Rocket Research Facility had just reopened after a significant redevelopment by the US Air Force, made necessary by a fire in early 1961 that shut down the launch facilities for almost a year.[15] By 1963, between rocket launches and the refuelling of Strategic Air Command bombers, the US Air Force had become "the major user of Fort Churchill."[16]

The three photographs taken in the area by our father are winter landscapes marked by signs of human presence, though nearly devoid of people. Expressions of power, which in other representations of the landscape might require some decoding, are rather more explicit in terms of function and meaning. These are "imperial landscapes," hosting the imaginations of those who would possess these places through the gaze, and military landscapes, whose location, expanse, topography, weather, and populations have been enlisted in Canadian defence strategies.[17] An "extraordinary and desolate country," wrote Glenn Gould in 1965, after riding the Muskeg Express to its northernmost station, Fort Churchill, to see "a small part" of the Arctic for himself.[18] Partial, indeed: no military voices would be heard in Gould's polyphonic "The Idea of North." In 1963 these were the very informants sought by our Cold War tourists: how to navigate the unmarked terrain; how to survive "lost in the Barrens"; how, in effect, to be Canadian, as defined by the country's northern frontier.[19] This mythic concept of Canadian-ness, a strain of nordicity cultivated in the south, was then, as it remains, abstract and unfinished. Sherrill E. Grace calls it a "process," unconsciously echoing W.J.T. Mitchell's advice that landscape be thought of as strictly a verb.[20] Landscaping the North photographically projects the photographer onto northern experience. For the Cold War tourist, seeing for himself in the North is also feeling or *experiencing* the conditions of nordicity though short bursts of mimicry.[21]

Upon their arrival at Fort Churchill, the NDC visitors were given a Cold Weather briefing in preparation for their taste of winter warfare training as conducted for Canada and other NATO countries by the Canadian Army. Each member of the course had been issued an Arctic kit, including mukluks that were given close critical scrutiny by our father in that same postcard home. Banter recorded in Course Sixteen's "Trip Lines" suggests that not everyone took part in the exercise; Warren Langford opted in. A black and white photograph (taken, it would appear, by an official photographer) portrays him (far right) and two colleagues (one apparently somewhat more apprehensive than the others) as they prepare mentally for their rite of initiation, a chilly January night under canvas, "sleeping out on the barrens" (fig. 9).

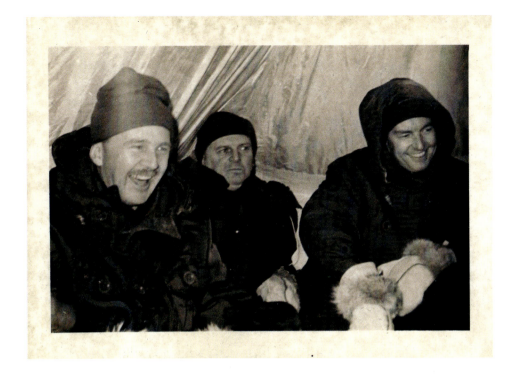

The first photograph of Fort Churchill taken by our Cold War tourist shows the Aerobee Rocket Launch Tower (right) and blockhouse, from which the launch was controlled (fig. 10).[22] Because of the cold temperatures, "the launching pads were enclosed by corrugated steel walls that allowed the rockets to be kept warm. Moments prior to blast off, doors at the base of the launch building would be opened so that the shock of the blast would be quickly dissipated."[23] The Anscochrome gives a subtle rendering of what is virtually a monochromatic image of flat, uneven terrain with installations silhouetted against the horizon.[24] In the picturing of landscape, such openness is disorienting; distance and scale are difficult to determine (the Launch Tower was 53 metres high).

The second landscape catches a figure with a dogsled and team manoeuvring along the ubiquitous snow fencing that cluttered the Churchill landscape at that time (fig. 11). Cree, Chipewyan Dene, and Inuit people lived in communities close to Churchill, and many families had dog teams in the 1950s and early 1960s. Briefing notes on the settlement include mention of a Northern Service officer of the Department of Northern Affairs and National Resources, "who is responsible for

Eskimo affairs in this district."[25] The bibliography on the Canadian North, though dominated by defence matters, included some background material on the region's inhabitants: "Northern Indians" and "The Changing Eskimo." In the second article, based on a study conducted at Frobisher Bay, Warren Langford would have learned that wage employment – construction and maintenance work offered by the Canadian government departments of Northern Affairs and Transport, as well as by the US Air Force – was systematically destroying the Inuit way of life by limiting their freedom to hunt, raise their families, and let their dogs off the leash.[26]

Figures 10 and 11
Fort Churchill, Manitoba,
January 1963

The interest for the taker of this second landscape is clearly the presence of a dog team and driver. But from a Western landscape perspective, the snow fence is of equal importance. Functioning like a road or a river in a Dutch landscape view, it holds the middle ground in two ways. Formally, it provides a means of measuring and containing the space occupied by photographer and spectator; in this part of the picture, at least, the North's hallucinatory recession to infinity is controlled; the eye is allowed to meander in the middle distance and given something to cling to while doing so. Psychologically, the fence becomes a source of comfort to the south-

ern spectator; the dog team and driver appear to be guided by it, so perfectly are they underlined by its curve. The background participates in this ordering, though it is indistinct, including some scattered low buildings and two striped communication towers. Cast into the frame lower right is an amorphous shadow that can be read, perhaps fancifully, as part of the technological apparatus of the base. The overall effect of the photograph is as Lutz and Collins describe dualities found in the *National Geographic*: encounters between old and new, expressed in juxtapositions of tradition and modern technology.[27] Such stark contrasts feed beliefs in the indigenous populations' inevitable cultural extinction, which tended to dominate everything from ethnographic reports to children's literature of the day.[28]

Our father's postcard home might well have inspired the picture just described. This photographic object represents both resistance to and collusion in the disappearance of the northern peoples (fig. 12). The photograph was taken by Richard Harrington, renowned Canadian documentarian whose images of the Arctic had been included in *The Family of Man*. Harrington made a number of trips to the

Arctic, beginning in 1947, with increasing concern for the loss of traditional ways.[29] These visits brought him into contact with Christian missionaries, whom he also photographed. The title on the postcard is "Esquimaux – Eskimos : Missionnaire en voyage sur sa traine à chiens." There is no mention of the child sharing the ride. The publisher of the card was Pôle et tropiques, Lyon, which in 1947 became the title of a journal covering "the missionary activities of the French Oblates and the Sisters of the Holy Family of Bordeaux literally from the Poles to the Tropics."[30] The Oblates had been active in the North since the beginnings of photography, having been invited to Canada by the bishop of Montreal, Ignace Bourget, in the 1840s.[31] Harrington's memoir includes an account of visiting "the most remote mission in the world," where Father Vandevelde, suddenly realizing who his guest is, shows him a well-thumbed Belgian paper with a four-page spread of Harrington's Coppermine pictures from 1949.[32] A similar journey has been taken by Harrington's photograph of the missionary, which has travelled to Lyon and then returned to the Canadian North in the form of a postcard to be purchased by our Catholic father and sent home, while being replicated in his own Fort Churchill landscape.

Warren Langford's third Fort Churchill photograph shows a dredger and other vessels iced into their winter moorage near a shed at the port (fig. 13). Framed as an approach along a ploughed road, with trace shadows streaming across the way, the ships are almost illegible. The interest of this view is a bit hard to fathom, until we remember the photographer's earlier responsibility for the administration of customs functions at Canadian ports. As a group, the three images meet one of the secondary objectives of the Arctic tour: to gain "an appreciation of immense distances, variety of terrain and weather encompassed in North America."[33] Hardly incidental, the North's challenging conditions had at one point constituted a modest proposal for defence strategy. Putting nothing there, meaning no installations in the North, would give an invading Soviet force nothing to cling to; in 1953 this had been Lester Pearson's "scorched ice" approach.[34] From a southern perspective, combining nothing with forced relocation constituted a plan. Accordingly, the unifying impression of the three Churchill slides is of cold and unfathomably deep space, the horizon consistently cutting the frame in two.

These are Warren Langford's contributions to the northern sublime, for there are no photographs of the flying visit by Hercules aircraft to the Distant Early Warning (DEW) Line site at Cambridge Bay, on the south side of Victoria Island in the Northwest Passage, three hundred miles within the Arctic Circle. It was quick: they were on the ground for less than four hours and took no meals. But the visitors all

Figure 13
Fort Churchill, Manitoba,
January 1963

received impressive certificates signed by the chief of the Federal Electric Corporation DEW Line Project (fig. 14), "Dewliners, Explorers, Uranium Prospectors, Transients and Roustabouts" thereby welcoming "Mr. J.W. Langford, BA" to the "Order of the Sea Gulls." The certificate exhorts "Sourdoughs, Eskimos, Cheechakos, and Igloo Dwellers" to share their hospitality. Thus honoured, the Sea Gulls had taken flight on their Hercules to RCAF Station Namao near Edmonton. The air base was used at this point in the Cold War by the RCAF and by the US Strategic Air Command to service nuclear bombers and air tankers. A day of rest, a morning of briefings, and the Sea Gulls were reunited with their Comet jet, heading south.

Order of the Sea Gulls

DEW LINE
ARCTIC CIRCLE

To all men greetings

Know Ye by these presents that on the 19TH day of JANUARY 1963 in latitude 70° with the wind gusting at 42 knots there suddenly appeared a whiteout from within whose bosom emitted upon our Arctic shores an honored guest, namely

MR. J.W. LANGFORD, BA

who is hereby awarded this:

Certificate of Membership

Harken Ye All DEWLINERS, Explorers, Uranium Prospectors Transients and Roustabouts Wherever you may be, respond to the clarion call of the Polar Echoes, and join with me to honor and welcome into the ORDER OF THE SEA GULLS this new member who is the most worthy, and who has graced us with his presence here,

And Further That Ye with dispatch summon all Sourdoughs, Eskimos, Cheechakos, and Igloo Dwellers to also welcome our honored guest and to share with him the hospitality of our eminent domain, and to suffice his needs and desires whilst among us.

AND AS FURTHER TESTIMONY OF HIS PRESENCE HERE I affix my hand and seal,

Ursus Polaris Rex Borealis
Ruler of all the Arctic Domains

CHIEF

Federal Electric Corporation — DEWLINE PROJECT

ITT
SERVICE

Figure 14
Federal Electric Corporation,
DEW Line Project,
Order of the Seagulls,
19 January 1963

Figure 15
Colorado Springs, Colorado,
January 1963

Military Muscle

The southerly portion of the North American tour took our travellers first to NORAD headquarters at Colorado Springs, also in the grip of winter. A moody sunrise, looking east toward the open prairies, has been taken from the newly constructed South Tower of the Broadmoor Hotel (fig. 15). This is not the spectacular view of the nearby mountains but the backyard view of snow-covered grounds and a large home with smoke – a whiff of homesickness – curling up from the chimney. The city of Colorado Springs lies grey in the distance.[35]

NORAD was a joint Canadian-American air defence operation started in 1957. Six years later the now famous underground facility in Cheyenne Mountain was still under construction, so briefings were held above ground at Ent Air Force Base. The Air Force Academy tennis courts and nearby ski slopes were lauded in a postcard home. On the Cold War front, our father notes, "A busy day at NORAD. Continental defence system so intricate as to be almost unimaginable until seen in actual operation."[36]

The group left Colorado Springs and flew to Vandenberg Air Force Base in California for briefings at the headquarters of the First Missile Division of the Strategic Air Command. The following day visits were made to Atlas, Titan, and Minuteman intercontinental ballistic missile test-launch sites on the base. Not surprisingly, since these weapons were replacing bombers as the lynchpin of the US nuclear weapons strategy, there are no photographs.

Then the tour moved on to the US Naval Station, San Diego, the largest naval base on the West Coast. Here Warren Langford's slides provide a solid feeling for the Cold War military might of the United States. Instead of pictures of a solitary missile and one fighter aircraft on the snowy apron of a Canadian air base, we are treated to pictures of multiple war machines. There is a view of four US submarines rafted to their sub tender, the USS *Sperry* (fig. 16). The *Sperry*, a veteran of World War II and the Korean War, had been modernized two years before to support the Navy's growing nuclear weapons capability. Another photograph provides a parallel picture of four destroyers and their mother ship (fig. 17). These marine photographs, taken from the water, keep a very respectful distance. The reasons may seem practical – getting the whole floating raft of warships in – but the remoteness of these vessels is also the measure of their power.

The same hierarchical relationship is preserved when the group visits the USS *Oriskany*, an aircraft carrier built late in World War II and a participant, like the *Sperry*, in the Korean War. The first sighting, taken on the approach, is of a warship stem to stern, from the perspective of a humbler vessel on the water. A photograph taken on the vast flight deck reinforces the message (fig. 18). A friendly handshake – the photographic standard 'grip and grin' – might have been staged as a photo opportunity, so neatly has it been executed by our novice photographer. The protagonists clasp hands beneath an enormous warning sign: "BEWARE OF JET BLAST AND PROPELLERS." A glance around the flight deck suggests that none of that is about to occur. Two sailors, one actually reclining, are taking a break in the background, above skids loaded with buckets. A cord or hose snakes across the

Figures 16 and 17
San Diego, California,
January 1963

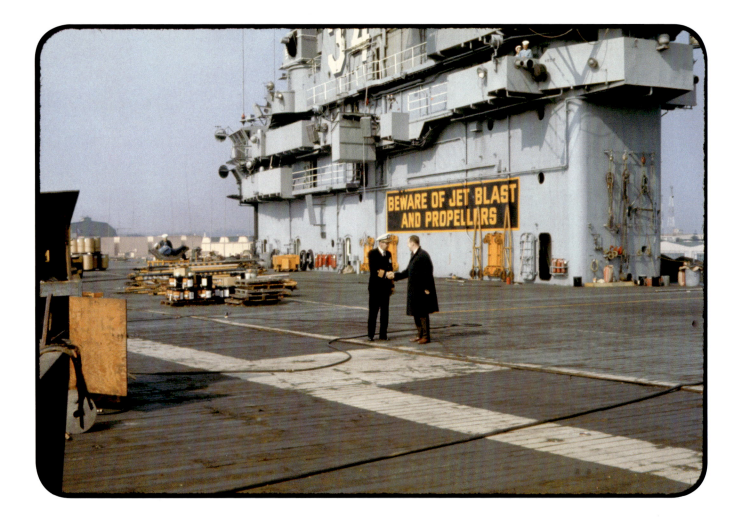

Figure 18
San Diego, California,
January 1963

deck under the protagonists' feet. Things are not shipshape, in other words, and the sailor in work shirt looking down from above seems to be counting the minutes until the visitors leave. The *Oriskany* had come into San Diego in mid-December and was taking part in operational training exercises: enter Course Sixteen. But even at this random, in-between moment, the sheer scale of the warship is impressive, and the dwarfed NDC visitors are on their best behaviour: no horsing around as in North Bay. If Warren Langford was able to record this ceremonial handshake, so, one might surmise, were his companions, who are not in the picture but well off to the side, looking on.

A few months after these pictures were taken, the *Oriskany* had its first contact with the Vietnam War. It went on to launch thousands of bombing missions during the war and suffer an onboard fire that killed forty-four crewmen. The ship was decommissioned in 1976, but it came to public attention again during the 2008 American presidential election as the carrier base of navy pilot, become Republican presidential candidate, John McCain, when he was shot down over North Vietnam in October 1967 and imprisoned until early 1973.

The tour enjoyed the second of its rest days at San Diego: a number of its members went to the zoo. In keeping with the theme of containment, as well as introducing a number of species that some members would soon re-encounter in Africa, the day at the zoo was a photographic workshop for Warren Langford. He switched to Kodachrome, which fanned out its peacock tail across flamingos, black panthers, tigers, camels, seals, and a lone polar bear. The Cold Warriors are also recorded, along with their fellow visitors, a curiously adult crowd for a Saturday. In terms of Langford's photographic experience, the site offered a breakthrough. As the contemporaneous work of American photographer Garry Winogrand repeatedly proves, places designed for the display of animals are also good spots in which to observe human interaction; they encourage public performances by their paying customers. The shy amateur need only pivot slightly or step back from the animal subject to become a candid camera in the human zoo. At San Diego in the early sixties, types express themselves clearly through costume and behaviour. The seals gaze up from their pond at a line of human subjects that includes a monk, a nun, a sailor, a snapshooter in formal business attire, middle-class Americans in their bright Perry Como cardigans, and their blissfully smoking wives (fig. 19). Photographing his fellow traveller edging up on a flamingo prepares Warren Langford for Africa's indecisive moments (fig. 20).

The North American tour continued with visits to the Strategic Air Command base in Barksdale, Louisiana. In 1962 this huge air base (then the largest in the world) was the home of operational wings of B-52 bombers and KC-135 air tankers. It was also the central training facility for the crews of both aircraft. After their introduction in 1958, these aircraft became key elements in the strategic nuclear bombing program initiated by General Curtis "Bombs Away" LeMay in 1948. Our tourists then moved on to a 'fire power' demonstration by the Strategic Army Corps (STRAC) at Fort Benning, Georgia. This was the location of the US Army Infantry School, the Airborne School, and, later, the infamous School of the Americas, whose international military officer graduates (including Manuel Noriega, dictator of Panama in the 1980s) were implicated in a host of human rights abuses in Latin

American countries during the Cold War. The demonstration would have been noisy, showing how tanks and artillery would be used to provide fire support for STRAC units that could be quickly deployed worldwide in an emergency. Among officers, STRAC stood for "skilled, tough, ready around the clock," but among enlisted men, it meant "Shit, the Russians are coming." The final stop was Washington, where the group received briefings by Canadian embassy and US State Department officials. Not surprisingly, there are no photographs from any of these locations.

What impressions might Warren Langford and his colleagues have formed from this four-week fact-finding tour of military and strategic installations? The overwhelming insight would have to have been the degree to which Canada was a very junior military and strategic partner of the United States. In fact, the term 'partnership' could hardly be said to apply in circumstances in which Canada brought well-trained people and territory but so few modern military and technological resources to the table. The non-military participants, in particular, would now have a clear sense of the degree to which Canada depended on US military power and spending for the defence of North America and Canadian interests elsewhere. A series of comparisons between conventionally armed Bomarc missiles and nuclear-tipped ICBMs, recycled and aging Voodoo fighter aircraft[37] and the newer American F-4 Phantom jet, NORAD activities at North Bay and at Cheyenne Mountain, and Canadian and US military programs in the Canadian North would leave no doubt that Canada was a policy 'taker' with very limited capacity to influence the development of defence policy for the continent. The Diefenbaker government's half-hearted support for the United States during the Cuban Missile Crisis and its clumsy efforts

to maintain its 'nuclear virginity' in the face of clear Canada-US agreements about atomic armaments would only have added weight to this assessment of Canada's limited clout in Washington in early 1963.[38]

For those participants less familiar with Cold War nuclear strategy, the trip may also have brought home the fact that not only was Canada a junior partner but as a northern neighbour it was the battleground on and above which a nuclear war would be fought. Accepting the risks inherent in this close cooperation with American defence plans was the price the country paid to avoid the more aggressive 'help' the United States might feel required to provide if Canada did not join enthusiastically in this lopsided partnership.[39] Six months later, toward the end of the course, this issue would surface again in lectures by nuclear strategist Robert Sutherland, who drew attention to what he saw as the necessary costs of being the owner of the airspace in which a nuclear attack against US strategic targets and cities would be repelled.[40]

The oral history of the tour, its "Trip Lines," confirms this relational dynamic, as well as the eternal competition between branches of the military, though the social context of this bantering needs to be borne in mind. Informal exchanges of views conducted in the officers' mess and out on the town seem to have occurred with regularity – there is less yearning for home than praying for swift recovery. US army colonel Boyd Branson gets off two good cracks at his fellow Americans. The first might have been heard after a night on the town in San Diego: "I've seen more bedraggled sea captains in my time, but only in the middle of a hurricane." The second, more caustic still, burst out at Vandenberg: "You guys in the Air Force are going to be just like wealthy farmers: silo commanders!" His countryman Matt Looram, of the US State Department, plays the Canadian hick for the benefit of a San Diego cab driver: "Take me to the Gananoque Club."[41]

Unwilling Cold War Players

THE AFRICAN TOUR

The much heralded Overseas Tours took place in the last quarter of the college year. NDC directing staff divided the students into two groups, one syndicate destined for Africa and Europe, the other covering the Middle East and Asia, and also appointed their military and civilian leaders. The Afro-European section left Canada on 15 April and was slated to return home on 7 June. Departure and return dates had been fixed since the beginning of the course, but the itinerary for the five-week tour was never quite certain. Berlin, it has been noted, might be struck off any time if the East Berlin authorities got cranky. NDC files suggest that visits to the African countries were just as liable to be cancelled, though for different reasons.

In September 1962 the Joint Chiefs of Staff had been advised that, because of a lack of suitable aircraft for two concurrent tours, the trips might be combined into a single world tour on one of the RCAF's new 66-passenger Yukon VIP turboprop transport aircraft. The speed and range of the Yukon would have allowed an expansion of the trip to include Tokyo, Hong Kong, and other Pacific areas never before part of an Overseas Tour. Africa would have to be scratched, however, and easing this regretted decision was the information that "Kenya would be or was about to be independent at the time the College would normally have visited."[1] This warning, elsewhere attributed to "acting Governor —— Jones" (E.N. Griffith-Jones), had been given directly to members of Course Fifteen. Other intelligence came from

military authorities in Kenya, who "expressed the view that it was highly unlikely that a visit to Kenya during the difficult period of independence would be rewarding and suggested that the whole area in East Africa would react to these unstable conditions by a greater instability in the whole area."[2] For the 1963 tour planners, this disruption in the flow of diplomatics would have made their visit "decidedly inadvisable."[3]

In the event, the consolidation plan failed to be approved. Over a flurry of phone calls, appearances were considered: a round-the-world tour seemed rather showy in a period of government budgetary restraint. The cumbersome size of the group, the difficulty of finding hotels – such practical matters also militated against this break in NDC tradition.[4] Reverting to the old plan was judged more prudent, with some minor shifts within countries and between Paris and London. An RCAF plane, the outdated and slow Canadair C-5, would be the travellers' magic carpet.[5] Africa was reinstated, and with value added: Rabat, richly present in our father's photographs, was a last-minute decision "because of the increasing Canadian interest in Morocco"[6] and, more pragmatically, because a sporting event had claimed all the hotel rooms in Dakar. The tour made its first overseas stop at Lajes Field on the island of Terceira in the Azores, where the United States had established an important refuelling point for transatlantic flights to its air bases in Europe.[7] The passengers stretched their legs and looked around. Warren Langford was sufficiently awake to take his first photographs of the trip: two views of the base, aligned to construct an almost perfect panorama (fig. 21). The pleasure was in the act and the anticipation – a curiosity, because paired images were beyond the technology of his slide shows and never in his lifetime materialized in print. From Lajes Field, the group headed off to Rabat for a two-day recovery. The real business of the tour was slated to begin in Nigeria, followed by Kenya and the United Arab Republic, or Egypt, as it was more commonly known.

What did Africa represent to a visiting Canadian public servant at this point in time? The course syndicate studying "Black Africa" was instructed to focus on African nationalism, colonial policies, white settler populations, and the degree of Communist penetration. The syndicate concentrating on the "Arab World" was directed to pay attention to the struggle for Arab unity and the "rampant anti-western feeling in the Arab world or at best an ambivalence." It was posed the question "Why hasn't Communism made any noticeable gain in the area?"[8] The briefings and business on the ground were all about the challenges of cementing loyalties to Western values and economic interests in an ostensibly post-colonial setting.

Figure 21
Lajes Field,
Terceira Island,
Portugal,
April 1963

By spring 1963, Morocco, Nigeria, and Egypt had secured their freedom from formal colonial control; Kenya would follow suit by the end of the year. All, to varying degrees, embraced non-alignment, anti-colonialism, pan-Africanism, and, in the case of Egypt, pan-Arabism. Building strong alliances with these nations in such circumstances would have been difficult without any further complicating factors. But with the Cold War increasingly stabilized and institutionalized in Europe and its domestic economy growing, the Soviet Union had begun in the 1950s to show more interest in contesting its relationship with the West in these newly independent states. This shift raised significant concerns for Western nations, especially where their continuing economic interests might be affected by new competition for raw materials, Soviet-supported national liberation movements, or the Communist-inspired nationalization of private-sector mining, forestry companies, and landholdings of white settlers.

Such concerns led the United States and its formerly imperial allies to make gestures toward the support of representative governments set up or endorsed by the colonial powers as they left, while turning a blind eye to (or actively backing) the evisceration of these governments by 'strong man' leaders who would protect Western economic interests and suppress indigenous or Moscow-supported Communist movements.

In 1963 Canada was not a significant player in Africa. In fact, except for its continuing support of United Nations aid activities and peacekeeping initiatives in the

Congo, a program of diplomatic representation that strained to keep up with the emergence of new states, and a very modest aid program focused largely on a few new Commonwealth countries (Ghana and Nigeria, most prominently), it had no official and only modest commercial presence on the continent, especially outside South Africa. The Canadian government still saw its interests in Africa primarily in terms of its Commonwealth relationships and Cold War alliances, with the pull of the former colonial powers and NATO partners generally perceived as being more important than its sympathy for the goals of the newly emerging African nations.[9] This position often put Canada at odds with African aspirations over issues such as the Algerian struggle for freedom from France, Southern Rhodesia's unilateral declaration of independence, and apartheid in South Africa.[10] These tensions would undoubtedly have been brought to the NDC participants' attention by Arnold Rivkin, one of the more unorthodox lecturers to take part in the program. A specialist on the emerging relationship between the West and the new African states, Rivkin was a prominent critic of the United States' willingness to sacrifice defensible, progressive policy goals to "the pressures of the moment, the putting out of fires, the special concern for 'bad boys,' 'problem children' and the crisis-prone, the needs of 'containment,' the special interests of allies, the U.S. dollar drain, etc."[11]

While the most prominent cases of Cold War confrontation in Africa are eventually to be found in countries such as Angola, Mozambique, Congo, Somalia, and Ethiopia,[12] our African tour provides some evidence of these developments. But photographs taken on the trip also suggest that the course participants were having trouble maintaining their Cold War focus, at least until they reached the United Arab Republic (UAR). The novelty of the African experience and the pure spectacle of new, artificially constructed states trying to kick-start governments and economies in the face of overwhelming economic, political, and ethnic challenges seem to have displaced some of the focus on the continent as an ideological battleground. As we shall see, our travellers became increasingly caught up in the people and landscapes they briefly encountered, manifesting signs of "imperialist nostalgia" in their attraction to, and their desire to preserve in pictures, threatened ways of life.[13]

Moroccan Prelude

In Morocco the constitutional monarchy based in a democratic government that had been established with independence in 1956 was being transformed into a ruthless monarchical dictatorship under King Hassan II which retained strong ties to

France. Fortuitously, our Cold War tourists visited Rabat just after a referendum that promised – but eventually failed – to restore democracy.[14] Since Morocco had not featured in the college's pre-tour briefings, it figured in the travellers' imaginations primarily as a former French colony where, as Ottawa had noted, "French cultural and linguistic influence is strong."[15]

This observation is contained in a memorandum sent to the closest Canadian embassy, Madrid, requesting an informal briefing and a not-too-strenuous program "of the sight-seeing variety."[16] Ambassador Jean Bruchési took up the assignment, breathlessly arriving minutes before the NDC plane touched down at Rabat-Salé

Figure 22
Rabat, Morocco,
April 1963

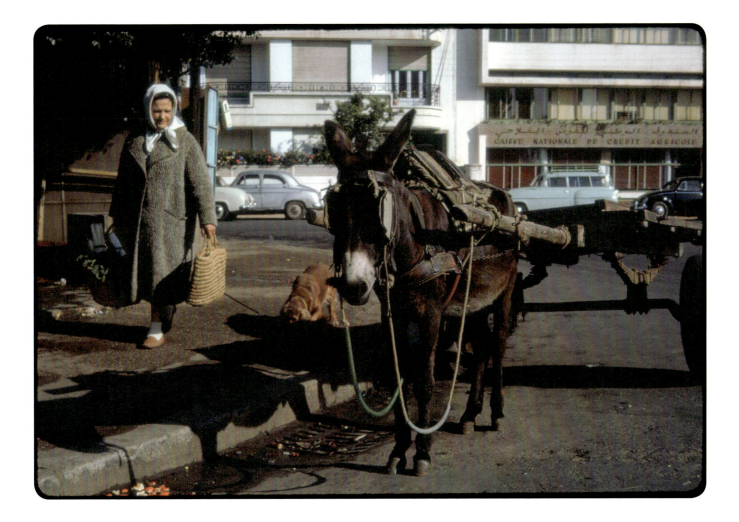

Figures 23 and 24
Rabat, Morocco,
April 1963

and leaving us with a priceless report on matters as they stood between Morocco and Canada, the United States, and Britain; Morocco as a former French colony; and Morocco and its internal troubles leading up to the election.[17]

A recurrent theme of the ambassador's report is Canada's dependence on the British embassy at Rabat: to handle problems at the airport (none of the Canadair crew members spoke French); to organize a VIP tour of the royal palace; to host a reception for diplomats, US and French military attachés, one Moroccan functionary, and a few Canadian expatriates; and for the British ambassador to brief the college on "Morocco, yesterday and today." On that very day, Ambassador Bruchési had skipped the morning tour to meet with senior Moroccan officials, who taxed him on the lack of a Canadian consulate or even a commercial mission at Rabat and chided him on the necessity of going through the British to make any diplomatic connection between their two countries. They talked about the upcoming election and its potential for "verbal" violence as a result of worker unrest; the "thorny question" of American military bases in Morocco, a question they had *not* raised during the recent visit of Adlai Stevenson, then American ambassador to the United Nations; and the importance of Morocco's participation in the upcoming world's fair at Montreal, *if only* the commercial benefits could be made clear, a hard sell to Moroccan officials without that Canadian presence at Rabat. Fresh from these illuminating discussions, Bruchési stood by while the British ambassador gave his "brilliant" potted lecture to the NDC. Following a lengthy question period, and with local guests on the point of arriving, Bruchési was called upon to survey relations between Canada and Morocco: "For obvious reasons, brevity was essential."[18]

The dreamlike quality of Warren Langford's touristic report on Morocco makes sense under these ludic diplomatic conditions. He begins his study with an evening walk around the neighbourhood of his hotel, picturing the picturesque: veiled Muslim women, the Cathédrale St Pierre, a market stall, and a donkey with a cart (fig. 22). His curiosity is overcoming his shyness, though not entirely, as his street photography is sly, catching his human subjects unaware, from the side. On the following day, as the official sightseeing begins, Langford takes his first photograph of a stranger staring back at him. This leap in his photographic apprenticeship happens between two frames. In the first photograph of the day, taken in an interior courtyard of the royal palace, members of his group are seen walking ahead of him, one stopping to photograph a member of the Royal Guard, while the others wind their cameras (fig. 23). The next photograph on the roll is Langford's portrait of the same guard (fig. 24). His emulative gesture, a visitor's *politesse*, looks for all the

world like a one-on-one Kodachrome encounter, but it is really the mirror image of a scrum. The rest of the photographs capture "Morocco yesterday" – its ancient walls and minarets, the basin of Chellah (fig. 25) – and "Morocco today" – storks nesting in the Roman ruins, uniformed workers maintaining the formal gardens, the tiled pool, and the clay tennis courts (fig. 26). The sightseeing tour of Rabat ends with the Cold Warriors looking over the river Bou Regreg and the casbah of the Oudayas in the distance (fig. 27). A longing look at waves and sand, a rather beautiful seascape, ends the first African roll (fig. 28).

Figure 25
Rabat, Morocco,
April 1963

Figures 26 and 27
Rabat, Morocco,
April 1963

Figure 28
Rabat, Morocco,
April 1963

Nigeria secured its independence from Britain in 1960. Canada established diplomatic relations with its new Commonwealth partner shortly before the declaration of independence and then upgraded the representation to a High Commission. In 1963, when our Cold War tourists passed through, Nigeria still held out considerable promise as one of only two federal states in Africa.

But clouds could already be seen on the horizon. A briefing note prepared by the African and Middle Eastern Division of External Affairs provides hints of the problems plaguing the federal arrangements, most specifically, the inability of Nigeria's three regions to capture the wide variety of tribal and religious differences across the society and the consequent pressures to increase the number of regions or states. An appended report on "Recent Political Developments in Nigeria" underscored the point that tribal and regional divisions were endangering efforts to create viable national political parties and a stable national government.[19] By 1965 the country would be well on its way to centralized military rule and a terrible civil war in which Britain (for oil) and the Soviet Union (for influence) competed to support the federal military regime.

The NDC students had also been prepped to pay attention to other key issues. Nigeria's internal troubles notwithstanding, Course Sixteen's study guide differed only slightly from Fifteen's; both were Janus-like, looking forward to the Niger Dam Project (still one year away from approval by the World Bank) and backward to Canadian export figures (unrevised since 1960).[20] Likewise, the itinerary was to be a repetition of the 1961–62 program, including a meeting with federal prime minister Sir Abubakar Tafawa Balewa in Lagos. This event was attended by at least one foreign journalist, giving Balewa a platform from which to condemn the propaganda war between East and West, to praise the United Nations, and to ruminate publicly on the likelihood of an African union.[21]

The rest of the Nigerian itinerary was supposed to be "less crowded" than the previous year's, allowing time for participants to meet "Canadians associated with Canadian aid programmes."[22] Rounding out a quorum from this population must have proved something of a challenge. There were forty Canadian schoolteachers in Nigeria at the time and a few technicians. No schools, clinics, or missions appear to have been visited. Canadian technical aid was somewhat difficult to estimate on the ground, since the main contribution was flowing through the Special Commonwealth African Assistance Programme (SCAAP), to be used to conduct an aerial

mapping survey.[23] Nigeria's political non-alignment was normally disassociated from its economic needs, except, it has been argued, in relation to the Commonwealth, where it sometimes appeared that financial aid from Britain and other more developed members was the only reason to join.[24]

Downplaying such base motivations, British prime minister Harold Macmillan had played up the Commonwealth family (and familial dynamics) when reporting on his own four-country African tour: "In our present stage of development [in 1960], the relationship between each Commonwealth country and Britain is generally closer than the relationship between themselves. Yet this is changing – and I am glad of it." And focusing more specifically on Africa, he expressed yet more pride and joy: "We are glad to see the development of the nations in the world to which we already stand in the relationship of parents."[25] To experience this relationship first-hand – to see for themselves – the NDC visitors did just what the British prime minister reported having done on his African mission: they went to the markets, which they found, unsurprisingly, both photogenic and photo-generative.

Their excursion took place in the predominantly Muslim Northern Region, in and around Nigeria's second largest city, Kano. For students of governance, Kano should have presented a fascinating case study. The terminus of the trade route through the Sudan, Kano had developed under the Emirate into a plural society. In 1963 there were over 200,000 inhabitants – traders and farmers – divided by claims of belonging, which the recently departed colonial authorities had succeeded in hardening and then controlling through strict segregation of "natives" (Hausa Muslims) and "non-natives" or "settlers" (Igbo or Yoruba non-Hausa Muslims or Christians) in residential districts. For the visitor, these divisions might seem always to have existed, demarcated by picturesque city walls, behind which ruled the emir, and the suburbs of Tudun Wada (for northern immigrants) and Sabon Gari (for southerners). Sabon Gari, the "strangers' quarters," had begun to prosper under colonial rule.[26] When Course Sixteen visited, segregation was still in place, accented by the religious differences that were also dividing Nigeria as a whole. After the orderliness and relative modernity of Lagos, Kano offered the Cold War tourists a window into bewildering otherness.[27] They could only connect through what Boorstin had figuratively described as "a chink in that wall of prearrangements which separates [the tourist] from the country he visits": shopping.[28] With only one day and many markets to choose from, the group visited at least two locations, the first selling a wide range of goods, from food to souvenirs, and the second catering to a local community's basic and social needs.

The more prosperous market is described from various angles as a sprawling conglomerate of regular stalls, set more or less permanently within a built environment of one- to four-storey block, cement, and concrete buildings, with 'pitches' trailing out along adjacent streets. The area seems to have been explored on foot, and since the colonial hotels in Kano were first built in Sabon Gari, a market or *the* market in this area seems likely.[29] The population is ethnically diverse; the roads are paved; the buildings are electrified; commerce is conducted under shade trees or canopies improvised from cardboard boxes. Wares are displayed on racks, in

Figure 29
Kano, Nigeria,
April 1963

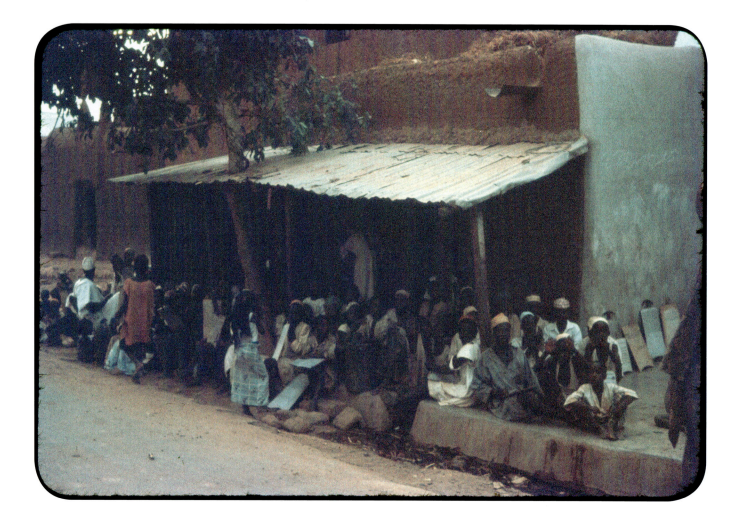

Figure 30
Kano, Nigeria,
April 1963

the branches of trees, on the heads of children, and on the ground. There are dyed and printed fabrics, goatskin bags and moroccos, and tourist carvings, as well as foodstuffs and services on offer (fig. 29). One photograph at this location depicts an Almajiri Muslim school, or Koranic 'tablet school,' sheltered against a high mud wall and shaded by a corrugated tin roof (fig. 30).

The village or suburban market is set up along a roadside – a meeting place for "exchange, banter, rumour," as well as trade.[30] It offers a glimpse of Hausa tradition and vernacular architecture: the boundary walls of the settlement are constructed

of raffia palm, which is also the screening material used within family compounds for gendered segregation, or purdah; the market stands have thatched roofs topped off at a centre point, also typical of houses in this region. Wares cater to the needs of local people: firewood and foodstuffs, including cheese and fruits such as mangoes, guavas, and tangerines. Human and animal tracks lead away from the main road that has brought the Cold War tourists in their chauffeured vehicle, as well as local travellers squeezed into a British-made bus. A blind beggar, carrying a water can for his ritual ablutions, appeals to the passengers for alms. The environment is hot and dry.[31] Donkeys graze freely on nothing that is visible to the camera eye (fig. 31).

Figure 31
Near Kano, Nigeria,
April 1963

This limited exposure to Nigerian dailiness seems to have awakened Warren Langford's *Family of Man* humanism, leading him to focus on people within the established binaries of colonial representation.[32] He was not alone, by which we suggest two things: first, that he approached his subjects as part of a group of avid snapshooters and, second, that his Nigerian subjects, especially those found at the urban market, could see him coming, as another white man in a colonial conga line of "special access" photographers dancing forward to take their pictures.

Their responses to the photographers cue us immediately to this group dynamic (fig. 32). In the first picture the visible subjects, mostly children and adolescents,

Figures 32 and 33
Kano, Nigeria,
April 1963

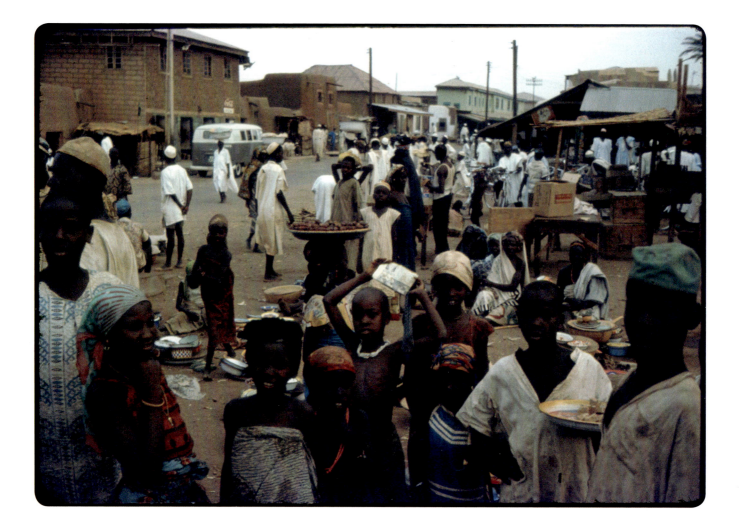

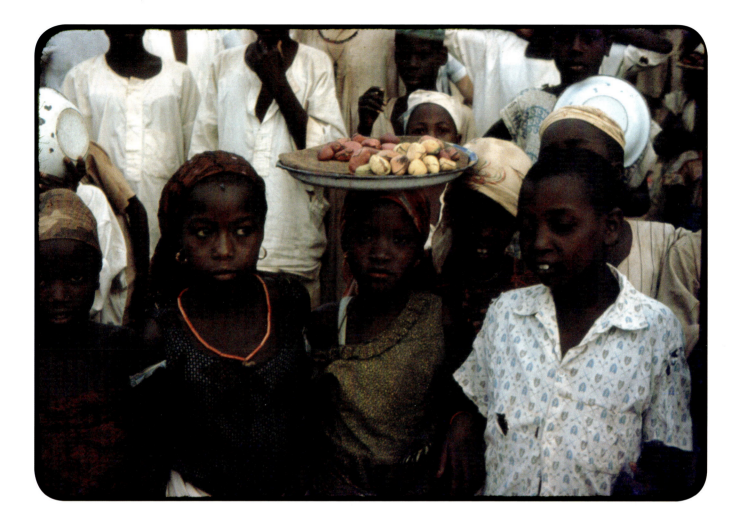

are staring at different cameras. To achieve the effect of an intimate photographic encounter – a portrait – this group needs to coalesce and the photographers need to work cooperatively. So the children are organized into a line by height, putting the younger ones in the front, thus raising their status above their older siblings, who are shunted into the background. Even then, their gazes need to be trained on one photographer at a time, and this alignment does not occur in perfect synchronicity, though Warren Langford, shooting from the centre of his group, comes away with a memorable portrait of the little girl at the centre of hers, a bowl of kola nuts expertly

balanced on her head. As she gazes back at the camera, theirs is the exchange by which all others are measured – and found wanting (fig. 33).

The presence of the photographers hardly ever goes unnoticed or unrecorded. How could it? Travelling in packs, they converge on their subjects, and the extras who are trailing after them cooperate, parting like curtains when the object of curiosity becomes clear: a tea hawker, his kettle and cups set down beside him on the ground, patronizing a barber who is both photogenic in his flowing pink robe and turquoise kufi cap and exotic in the plying of his trade, which includes haircuts, shaves, manicures, pedicures, and the removal of tonsils (fig. 34). The tension that

Figures 34 and 35
Kano, Nigeria,
April 1963

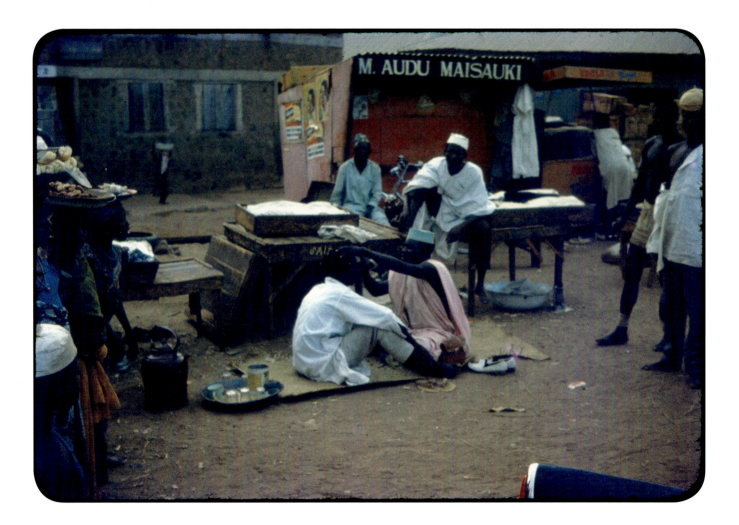

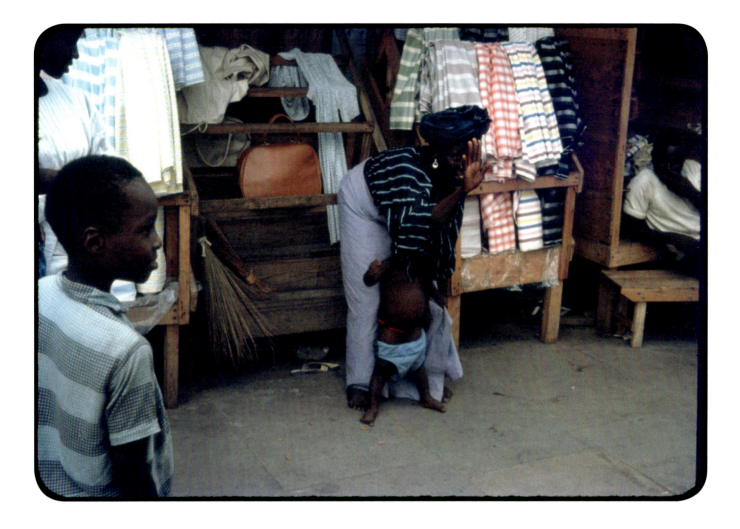

our tourists' attention is creating comes through in a number of pictures: photographed from the side, a Yoruba woman trader gestures "no" at another snapshooter as she hastens to dress her half-naked child (fig. 35). Her embarrassment only adds to the irresistible mix of innocence and authenticity; the visiting photographers leap at the image from two directions at once. Unbeknownst to them, their naked African child picture awaits them at the suburban market, to be taken by our father with his own mix of fascination and nervous discretion (fig. 36).

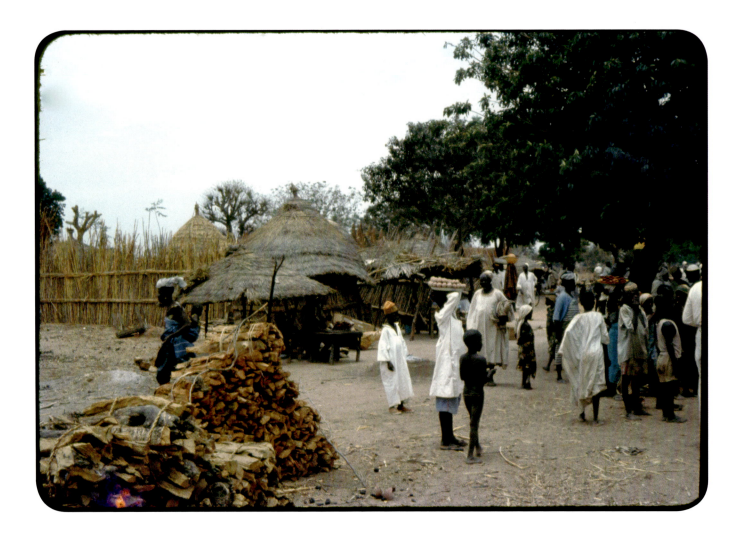

Figure 36
Near Kano, Nigeria,
April 1963

Warren Langford's oblique shot of the smiling woman's futile gesture and his prudish picture of the naked child form cracks in the *National Geographic* photographic mould. Such 'bad shots' preserve more of the total photographic experience by featuring an aspect that any professional photographer or editor would have suppressed: the reluctance of people to be photographed. Likewise, the photographer is seen to be *not wanted* at the tablet school: some of the boys make faces; the adults simply look severe. More in the *National Geographic* mould is the frontal portrait of the smiling bicyclist in his blue kaftan suit (fig. 37). Perfectly centred in

the frame and with an electrical pole rising directly behind his head, this man is the very picture of a junior member of the Commonwealth of Nations: modern in his openness to foreign presence and technology, while traditional in the cultural expression of dress.

To see this man pausing for the camera at an unmarked crossing is to realize how little written language and few graphic elements have been recorded. There are no street signs. A catalogue of letters includes one hand-painted sign ("M. Audu Mai-sauki" advertising cheap prices at his stand), one illustrated placard, some printing

Figure 37
Kano, Nigeria,
April 1963

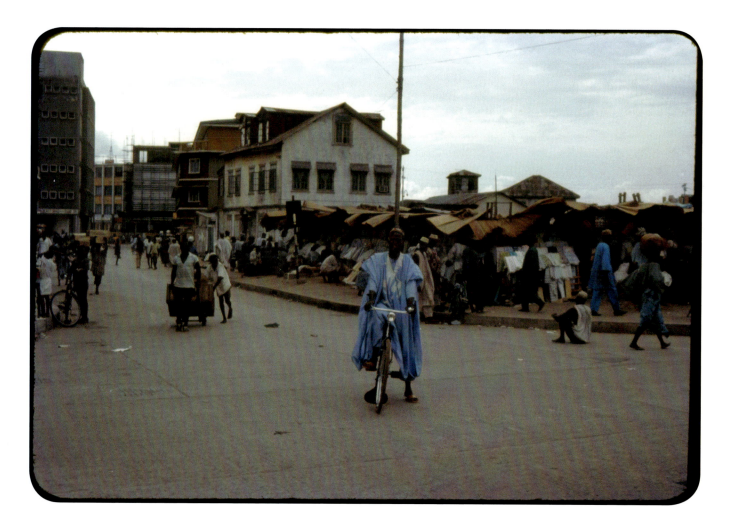

on cardboard boxes, a couple of peeling posters, and a few logos. The two that appear can be fit nicely into the NDC tourists' political frame: the soft drink Tango, a British import from the colonial days, is being sold from a well-used trolley; the Coca-Cola logo, stuck up over a shop door, looks a little fresher. The issue here is not literacy; reading is being taught by rote at the tablet school. But this amateur photographer does not catch, and is unable to stage, the kind of picture also sought by W. Robert Moore to illustrate "Progress and Pageantry in Changing Nigeria" for *National Geographic*. Returning to that spread, we find that Moore himself failed to get *the* picture: one of illiterate children "spellbound" as an older villager reads to them from the newspaper *Nigeria Review*. This image looked forward to independence, when English, the colonial tongue, would be declared Nigeria's official language, as "one way of downplaying regionalism and ethnic tensions in the legislative process."[33] For Moore's article, this vision of pan-Nigerian nation-building "progress" had to be supplied by Camera Press-Pix, a British agency founded in 1947[34] (see fig. 3). In Warren Langford's market report, print culture, in the form of an illustrated magazine, newspaper, bulletin, or brochure apparently being used as wrapping paper, makes just one appearance, held up over the head of a little boy in that disorganized first shot (see fig. 32).

Other aspects of Warren Langford's market pictures are similar to Moore's report and in general conform to *National Geographic* style. Within the magazine's structure of dualities and motifs, Lutz and Collins consistently find representations of traditional divisions of labour by gender. Likewise, Langford photographs women performing a "toilsome"[35] task, pounding millet or corn (fig. 38). Indeed, he seeks them out. The two women in his photograph appear somewhat uncomfortable, their unease likely having less to do with the habitual intensity of their labours than with the photographer's breaching of Muslim laws and physical boundaries by entering their segregated courtyard. The two Hausa women, the younger plainly unnerved, nevertheless stand their ground, suggesting that, as urban dwellers, they have seen this kind of aberrant behaviour in white visitors before.[36]

Hausa men are portrayed as either passive observers or dynamically striding across the frame, coolly indifferent to the photographer (fig. 39). Despite our sure knowledge that purchases were negotiated on this day, there is little recorded interaction between the Nigerian traders and the visitors. Warren Langford's colleagues are either with him, behind their cameras, or discreetly milling in the background of his shots. The one exception, his posing of a colleague with a Nigerian group, follows the *National Geographic* trend of showing Westerners in non-Western settings,

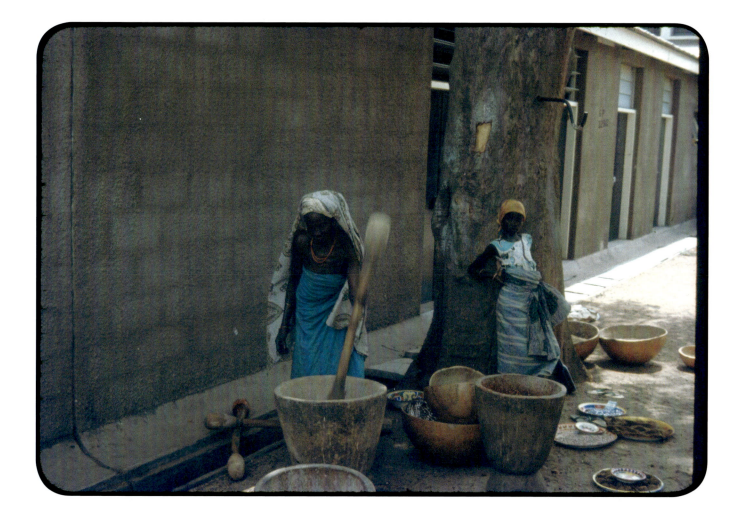

Figure 38
Kano, Nigeria,
April 1963

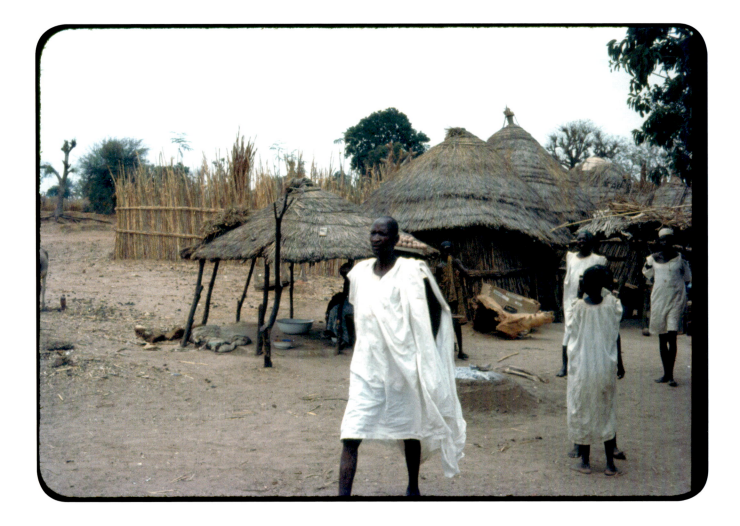

Figures 39 and 40
Near Kano, Nigeria,
April 1963

a postwar tendency that would fall steadily into decline as Americans began to grow anxious about their foreign military adventures.[37] By chance or by design, there are only boys and men in this photograph, whose physical tensions are riveting (fig. 40). The white man towering above the boys, his presence doubly monstrified by tilting head and tilting camera, is boldly stared down by a boy in the foreground, standing in profile with his hand on his hip. Two other boys in the group cup their genitals with their hands, nervous perhaps of the threat to their manhood from this white invader.[38] In the middle ground another boy and at least one man seem to be

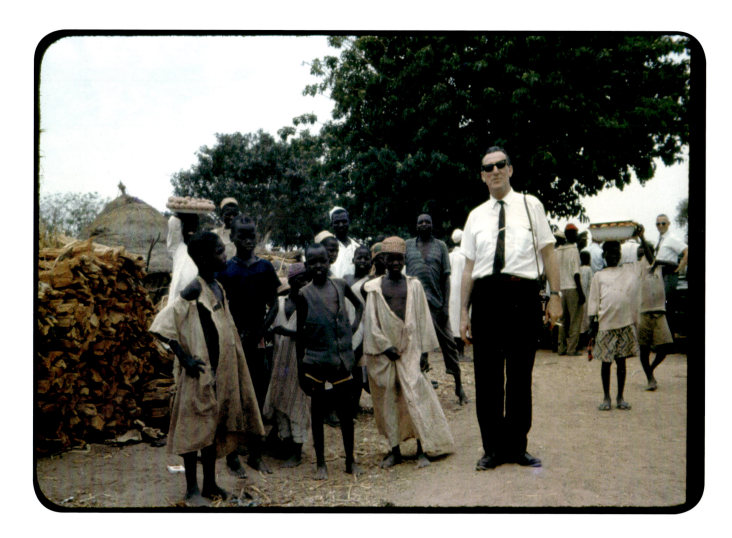

imitating the mannered military posture of the visitor. Almost everyone is attentive to the photographer, or to the photographic act, as something in which they are actively participating. In a last group portrait, an adolescent Hausa girl, traditionally attired, casually leans on the front of the visitors' car: technology is both foreign and familiar at this market, as a facilitator of short-lived encounters.

The third and last series of slides from Nigeria leads the viewer back from the roadside market into the city of Kano, its new mosque on the skyline, behind the Old City walls. On a picturesque stretch of paved road and crumbling walls, the

Figure 41
Kano, Nigeria,
April 1963

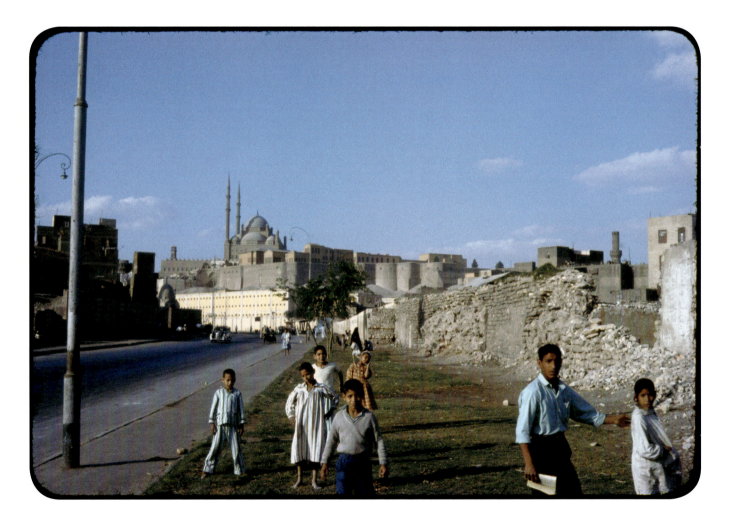

visitors stop to take a picture. They meet a group of children, who act up for the camera, even as some are hustled away by a vigilant young man. These people appear to be Arabs, possibly residents of the Syrian Quarter, certainly more connected by dress and behaviour with these foreign visitors than the children they have just left behind. This brief encounter adds another layer to Kano as a "Sudanese metropolis" (fig. 41).[39]

The visitors' day among the people of Nigeria is drawing to a close, but its narrative in pictures seems strangely to run back in time from the modern market to its more traditional precursor, ending in a vision of the Arabian Nights at the medieval city walls. Contrasts between old and new punctuate the Nigerian series, frame by frame, but the story as a whole (as a sequence in a slide show) also conveys that message, partly by omission.

There are no pictures of modern Lagos, which, as the federal capital, was the tour's first stop in Nigeria. The NDC students were there for several days. If Warren Langford ever saw Nigeria's proud accomplishments – a new university, a new hospital, the Lever Brothers factory, structures documented by Eliot Elisofon for *LIFE* – he was not moved to photograph them.[40] In Kano the Cold War tourist explores the Old City, climbing the 103 spiralled steps of the newly constructed mosque's minaret, which non-Muslims are permitted to climb for the view[41] (fig. 42). His thoughts, after a day among the people, can only be guessed at. The humanist photographer-in-training is also the pragmatic Cold Warrior–in–training who, in a series of brief encounters, has sampled the conditions and attitudes of Northern Nigerians, banking them as picturesque proof of a developing situation. Canadian involvement in Nigeria was never cast as a natural affinity between two former British colonies (despite feeble attempts by politicians and academics in both countries to exploit this theme); rather, it was seen as an inherited white man's burden, a fraternal relationship with benefits. The British were training Nigerian officers, young 'Turks,' at their Royal Military Academy in Sandhurst, for a federal Nigerian military.[42] Canadian engagement was on a more modest scale: the government was providing four officers for navy training in Nigeria, while welcoming a tightly selected number of army and air cadets to military academies at home.[43]

On the economic side, Britain was again leading by example. In July 1963 Brian F. Macdona of the Royal African Society would describe Nigeria as "a country in a hurry ... quickening the speed of industrialisation." His speech bullishly recited British overseas investment, including the recent opening of the Guinness brewery and the rewards beginning to flow for Shell BP.[44] The federation of Nigeria must

Figures 42 and 43
Kano, Nigeria,
April 1963

remain solid for its economic plan to prosper, he said. Or, as Macmillan had earlier put it, "In Nigeria, there are different peoples, to be welded into one nation."[45] Familiar notes for a Canadian, though at no point in these overviews or in the NDC talking points is there any mention of language, ethnicity, religion, or culture, except in the code word 'tolerance.' The Cold War tourist nevertheless cannot help but see its solid forms. His last image of Kano intertwines new and old by setting the believers' minaret against the flat mud roofs of the traditional adobe architecture, with a modern windmill spinning in the middle distance (fig. 43).

Kenya was in the midst of its transition to independence when our visitors arrived in April 1963. From the perspective of the NDC, the Kenyan situation had not much changed since 1961, when Ghana and Kenya had been selected as a tour destination, the latter because "it was still a colony and experiencing considerable difficulty in determining the path it should take to independence." In the spirit of "seeing for oneself," the college had underscored some pedagogical objectives in pseudo-scientific human terms: "the physical characteristics of the Africans in these two countries give rise to important differences in social, political and economic developments in their respective countries." That first visit to Kenya was deemed "very worthwhile. In 1962 the process was repeated, but ... Nigeria was substituted for Ghana. The Kenya programme was slightly disappointing in that no opportunity was afforded the NDC to meet the Africans of the leading political parties."[46] Instead, the group had been "entirely in the hands of the military."[47]

This was, of course, the British military, whose presence in Kenya was fulfilling several not entirely compatible functions: ensuring the safety and prosperity of the settler population, enforcing stability in the country and region for the government-in-waiting of a rehabilitated Jomo Kenyatta, and enhancing Britain's presence in the form of military bases at Gilgil and Kahawa and a safe harbour at Mombasa from which to protect its economic interests in the Middle East and Indian Ocean. As David Percox points out, the strategic significance of Kenya Colony as a military staging point had been under discussion since 1947, as India and Palestine gained independence and the sun began to set on Britain's involvement in Egypt.[48] The possibility of Mombasa as a British-controlled coastal strip was discussed and discarded at the Conference of East Africa Governors at Chequers in 1959.[49] In East Africa, colonial anxieties frequently served to camouflage defence initiatives that really belonged to the Cold War. Memories of the Mau Mau emergency, with its unspeakable horrors, muted the interminable bickering of British colonial and military officials over who was going to pay for what.[50] When the Cold War tourists passed through Kenya in April 1963, the British army base at Kahawa was still a work in progress, to be abandoned unfinished when the last troops left Kenya.[51]

The list of "Country Topics" prepared for Course Sixteen's visit to Kenya is remarkably silent on British aspirations to maintain its military presence east of Suez. Rather, the briefing focuses on the country's post-colonial viability and specifically on the "Ability of new Governor, Mr. Malcolm MacDonald, to bring Kenya to the point of independence." African leaders are surveyed under the heading "Political personalities": Kenyatta is important, Ronald Ngala less so; there are "rivalries in

KANU," the Kenyan African National Union, between Tom Mboya, "moderate pro–United States labour leader," and Oginga Odinga, "pro-communist extreme racialist."[52] Unbeknownst to the Canadian Department of External Affairs, Odinga's Communism had already been dismissed as opportunism by British intelligence, according to which he "regarded the Eastern Bloc as a new and untapped source of financial aid with which to bolster his political prestige."[53] The KANU party platform to confiscate settler estates, end foreign investment, and nationalize industry was a matter of public record, however.[54] External Affairs' briefing notes allocate an entire section to racial problems: the precarious situations of the Asian minority, "tribal rivalries," the "prospects for white setters in independent Kenya," and the "position of Somalis in the Northern Frontier District."[55]

Given that some credence was accorded these reports, it seems remarkable that the 1963 tour went ahead despite worsening conditions, as negotiations between political parties broke down, bloodshed threatened, and "Youth Wings" attracted members. "By March 1963, the British had prepared plans to 'reinforce Kenya for internal security purpose with a Brigade Group of up to three Infantry Battalions.'"[56] But for the purposes of the tour, peace had only to be maintained for two working days and three nights (24–26 April) in carefully selected locations.

The first place pictured by Warren Langford is the entrance to Kilindini Harbour, or the Port of Mombasa, where his party seems to have taken a tour on a launch. A point of interest in one of his photographs has been identified as the Oceanic Hotel, which had been built on the north side of the channel leading into the harbour around 1960. The persons of interest are young men net fishing from a pier. This scene is photographed twice, from two different angles. The first image is taken from the launch, setting the end of the T-shaped pier in the very centre of the image (fig. 44). A young man throws from this position, and the whole composition is organized around his athletic move. Our Cold War tourist, an avid tennis player, must have admired the action for some time to get the shot right. One can imagine him watching quietly, possibly standing alone. The young fishermen seem unaware of, or immune to, his presence. Likewise an African man, dressed for business, one foot on the rail as he gazes down the channel, doubtless enjoying a cigarette: his back is to the photographer. The barefoot fishermen with their ancient technology, the young professional African with his city shoes and British brolly – here is another variation on old and new.

The second photograph is taken from the fishermen's pier, close by the spot, it seems, where the businessman was just standing (fig. 45). Here again the moment

Figures 44 and 45
Kilindini Harbour, Port
of Mombasa, Kenya,
April 1963

has been waited for. There is one figure in this photograph; silhouetted against the water, he leans forward, tensing for the throw. Though taken at close range, this image is not a portrait but a candid shot in the style of photoreportage. It is worth noting, though certainly coincidental, that the only photograph from Kenya in *The Family of Man* also features gleaming African bodies bent to their labours.[57] Differences were more likely on the Cold War tourist's mind – the differences between Kenya's picture possibilities and those he had enjoyed in Nigeria. They are telling, for in Kenya there are no photographic encounters.

Unlike the people of the Nigerian marketplace, these fishermen take no interest in the photographer; they neither solicit his attention nor avoid it. Their reserve or self-containment seems quite natural under the circumstances. Between 1952 and 1959 Kenya had been placed under a state of emergency to stamp out the Mau Mau and quell what had become a civil war; conservative estimates are that "one in four adult Kikuyu males were held in often brutal camps and prisons at some point during the Emergency."[58] Relations across racial and ethnic lines continued to be strained. 'Playing the man' on a Kenyan playing field meant playing for time and

playing it cool. As for our photographer, the sports analogy is fitting here. He would have admired the men's musculature, their concentration. Walking onto the pier, he would have trod softly, minimizing his presence, so as not to distract or interrupt. In short, our tourist is relating respectfully to these men on some level, even as he revels in the otherness of their primitive labours.

An intriguing aspect of this day's photographic catch is the complete absence of NDC business. Organized in-country – in Kenya Colony, as it existed at this point – this trip to Mombasa may reflect the changing priorities of the colonizers as Kenya slipped from their grasp and they refocused on ensuring a naval gateway to the Indian Ocean and a hoped-for oil refinery. Unlike in San Diego, no ships are photographed here. Why? Did the British Navy keep a tighter lid on security? Possibly, in a country where lifting the state of emergency had been endlessly debated and delayed. "Some officials in Nairobi, the Colonial Office and other parts of Whitehall believed from the outset that the Mau Mau rebellion was a Communist plot … The Security Service strongly disagreed."[59] Others, including the colonial settlers in the "White Highlands," likewise knew better. Or perhaps the Cold War tourist had been disappointed by his San Diego pictures: American naval power, remote and dully painted, translated poorly to pictures. His Kodachromes of the human and animal zoo had come off a great deal better.

The world shrinks rapidly into the Cold War tourist's slide show: in January he is photographing tigers at the San Diego Zoo; in April he is shooting a pride of lions in Kenya. The rest of his East African slides are the trophies of a photographic safari, wild animals captured at a distance in the national parks. All human traces are eliminated from these visions of paradise, unspoilt by visitors and their vehicles (fig. 46).[60] Echoes of Joy Adamson's best-selling Kenyan memoir, *Born Free* (1960), especially when we recall that Elsa, the trainable lioness, got to keep her life in Kenya, while her less adaptable siblings were shipped off to the Rotterdam Zoo. Superficially, the Cold War tourist's photographic safari has little to do with the Cold War, though the framing of wildlife is symbolic of other kinds of containment: the Kikuyu Reserves, their twenty-three-hour curfew, 'villagisation' and 'de-villagisation,' the 'cantonment' of British military power on its never-to-be-realized UK Strategic Reserve.

The Cold War tourists fire not a single shot in arrogance or anger, but they leave Kenya with bragging rights for having stayed at the colonial landmark, Nairobi's New Stanley Hotel, where during the Mau Mau crisis "men with ivory-handled six-shooters strode through."[61] They have enjoyed what Renato Rosaldo properly

decries as "imperialist nostalgia," a yearning for the culture as the colonizer first encountered it or, at one remove, tried to possess and, leaving no car tracks, despoil it. "Nostalgia," as Rosaldo writes, "is a particularly appropriate emotion to invoke in attempting to establish one's innocence and at the same time talk about what one has destroyed." As both colonized and colonizer, our Canadian Cold War tourist can be dismissed as an "innocent bystander" in the imperialist scheme of things, a mere snapshooter, a maker of memories. But such is nostalgia's insidious nature: "If most such recollections were not fairly harmless, the imperialist variety would not be nearly as effective as it is."[62] Snapshots of lions are carriers of colonial contagion.

Figure 46
Kenya, April 1963

In May 1963, after our Cold War tourists had departed, the political pendulum in Kenya began to swing in a somewhat more positive direction. The British accepted the election results, which confirmed Jomo Kenyatta as prime minister of the internally self-governed state. This concession accelerated full independence for Kenya, which was celebrated in December of that year. But as in so many of Africa's nascent nations, the democratic momentum could not be sustained in the face of underlying ethnic divisions. By 1969 Kenya had morphed into a one-party state under Kenyatta's tight control. However, even with the end of British rule, it remained a client state of Britain and an important link in the British and American overseas defence system throughout the Cold War.[63]

Public Relations: The United Arab Republic

In 1963 the greatest Cold War concern in Africa was focused on Egypt, then known as the United Arab Republic (UAR), the name all that remained of a short-lived union with Syria. Egypt, under Gamel Abdel Nasser, a rising star among African and Asian nationalist leaders, adopted a strategy of playing the Soviet Union off against the United States in an effort to enhance his country's military and economic power, neutrality, and independence. While the Soviet Union had been politically active in Egypt for many years, from a Western perspective the relationship took a disturbing new direction when Nasser turned to the Eastern bloc in 1955 to obtain weapons and military training after the United States had refused to supply arms without conditions to a bellicose enemy of Israel.

The relationship between Egypt and the Western alliance had already been compromised earlier that year by Nasser's enthusiastic engagement with the leaders of an emerging group of non-aligned nations at the Bandung Conference. It was further damaged in 1956 by his recognition of Communist China and the nationalization of the Suez Canal (with Soviet encouragement), which led to war with Israel, France, and Britain. The United States and Britain withdrew their offers to fund the Aswan High Dam project on the Nile River, and the Soviet Union stepped into the breach with alternative financing.[64]

As guests of the UAR, our Cold War tourists were taken to see the High Dam as one of their last stops on the African tour, and it made a strong impact on them. In a postcard written to John Langford from the tour aircraft on the flight from Cairo to Rome, his father focused specifically on the dam as the high point of the week in Egypt: "Visited the High Aswan dam. A tremendous project of vital importance to this country." The postcard image builds on this theme of progress, show-

ing a modern sculpture, *Egypt Awakening*, which stands at the entrance to Cairo University.[65] From the Western perspective, Soviet infrastructure funding further reinforced its position in Egypt. In the following years, the country deepened its military dependency on the Soviet Union and its Eastern European satellite states. By 1963 the Eastern bloc was supplying modern aircraft, tanks, and anti-aircraft missiles to the Egyptians, further raising anxiety in Western capitals.

As the briefing note prepared for the college by the Department of External Affairs makes clear, this anxiety was heightened by concern that the UAR, under the charismatic Nasser, was becoming a dominant player in the affairs of the region. Questions were raised about UAR intervention in Yemen, its increasing influence and "active U.A.R. subversion" in Saudi Arabia, Jordan, Syria, and Lebanon, and its closer relations with Iraq, newly independent Algeria, and its North African neighbours. The note's overarching concerns are Nasser's capacity to sow social and political revolution among conservative Arab states friendly to the West and encourage unity among those already hostile to Western influence. There is also an awareness of the possibility that the UAR might aspire to a wider leadership role among non-aligned states in Africa and further afield.[66]

It is a curiosity of the briefing note and the travel agenda for this part of the tour that nothing was made of the widely celebrated role that Canada had played in resolving the Suez crisis in 1956 and the continued involvement of Canadian troops in maintaining peace between Israel and Egypt in the Sinai peninsula and the Gaza Strip. The then secretary of state for External Affairs, Lester Pearson (by April 1963 the leader of the official opposition and soon to be prime minister), was awarded a Nobel Peace Prize largely for his work in persuading United Nations members to create an emergency force to police the contested areas, thus allowing the warring parties to stand down. Herbert Norman, Canada's ambassador to Egypt, was instrumental in persuading Nasser to go along with the plan and to accept Canadian military personnel as part of the emergency force.[67] As a result of this initiative, peacekeeping became a mainstay of Canadian foreign policy for decades. Regardless, there is not a word about any of this and no evidence of discussion of the possibility of visiting Canadian peacekeepers in action.

Instead, and because in 1963 Egypt represented the Soviet Union's most successful Cold War venture in Africa, our NDC tourists were encouraged to seek out signs that the Western powers might be able to rebuild their lost influence with the UAR. Relations between the United States and Egypt had warmed somewhat in the wake of American opposition to the British, French, and Israeli attack on Egypt in 1956. But continuing US support for Israel, combined with Nasser's anti-Americanism

and efforts to destabilize US allies in the region, was an ongoing obstacle to serious improvements. Therefore, while signs of change would be hard to find in the traditional realms of foreign, military, and economic relations, there were perhaps more hopeful indicators in what have come to be known as 'soft power' areas, such as culture, tourism, and propaganda.

The construction of the Aswan High Dam displaced scores of Sudanese and Egyptian Nubian villages and precipitated a world heritage crisis that was brought to the attention of politicians and schoolchildren through the popular media.[68] *LIFE* made it a life-and-death situation: "Doom and hope for treasures." Monuments would "drown" unless pleas were heeded, and all this was taking place "where the white and black races first came together" – sacred ground for a still segregated America, to be sure.[69] The crisis crossed disciplinary boundaries, rehearsed in the pages of *Art News* in strikingly political terms as the legacy of "extreme Arab resentment." If the United States and its NATO allies failed to raise the funds to save the antiquities, more blame would ensue.[70] Under the supposedly neutral umbrella of UNESCO, scientists and engineers developed plans to relocate some of the more famous monuments, while some thirty-five projects of salvage archaeology were conducted by scholars and curators from both sides of the Iron Curtain. Heroic efforts indeed, though there were also naysayers. Regarding the most visible project, the relocation of the temple of Ramses II at Abu Simbel, one American classicist saw the multi-million-dollar price tag as a colossal waste; Abu Simbel was already thoroughly documented. This sum could finance "100 new excavations, at 100 new archaeological sites, each one yielding new historical materials."[71] In the event, such critics were dismissed as short-sighted; Abu Simbel was stimulating public enthusiasm for archaeology.[72] The UAR's offer of 50 per cent of excavated antiquities proved irresistible to Western taxpayers, who footed the bill with the usual combination of generosity and self-interest. As US president Kennedy concluded his message to Congress, "By thus contributing to the preservation of past civilizations, we will strengthen and enrich our own."[73] And one of his National Security Council advisers added in a memorandum to the president that "if we don't help Nasser he'll become even more mortgaged to Moscow."[74]

The UAR's public relations team seemed to be operating at the same sophisticated level; similarities were noted between Nasser and the original strongman of Egypt, that master of self-promotion, Ramses II.[75] The NDC itinerary also bespoke public relations savvy. The base of the tour was Cairo, with outings by car and plane to Giza, Aswan, and Luxor. The technological spectacle of the Aswan Dam fit seamlessly with earlier feats of engineering: the Sphinx and the Pyramids. As

Figure 47
United Arab Republic,
April 1963

MacCannell observes, in a reworking of Marx, the pyramids exemplify the transformation of ancient religious sites into modern parables of labour – "abstract, undifferentiated human labour."[76] These wonders of planning and effort were duly photographed by our man on the job: the Sphinx rising from the sand in eternal isolation; a pyramid anchored to the now by three late-model cars pulled up close to the base (figs. 47 and 48).

Western photographic ritual, going back to Maxime Du Camp and Gustave Flaubert's expedition to Egypt in the 1840s, was also honoured, including its unvarying assignment of roles. When photographing monuments, Du Camp liked to include

Figures 48 and 49
United Arab Republic,
April 1963

one of his "sailors, Hadji Ismael, an extremely handsome Nubian," in the shot.[77] This staffing was ostensibly for scale, as well as for visual pleasure.

Old and new fantasies commingle on the Giza Plateau. When a colleague mounts a camel for a picture-perfect ride, Warren Langford records the contrasting expressions of the actors (fig. 49). The Western tourist, neither Lawrence of Arabia nor Peter O'Toole, looks boyish and embarrassed.[78] The Arab guide is scowling; he may be somewhat frustrated because his living depends on leading the mounted camel past the local photographer, who will sell the visitor his prints. These immersions in a storied past are interspersed with more serious exhibitions in the present.

The UAR had requested more time with the college to show the visitors something of its military bases and training. One rather ambiguous photograph seems to derive from this exposure: a view of tents whose pyramidal shapes are somewhat uncanny. Egypt is awakening, or mobilizing, in an ancient form (fig. 50).

The High Dam itself appears in none of Warren Langford's photographs, and we can only speculate on the reasons. Here might be a case of technical failure: it seems likely that the visit took place at night, as would occur in the following year's tour, for which the in-country itinerary has survived. However spectacular from the air, such views of the dam would have been hard for an amateur to capture.[79] Or it might

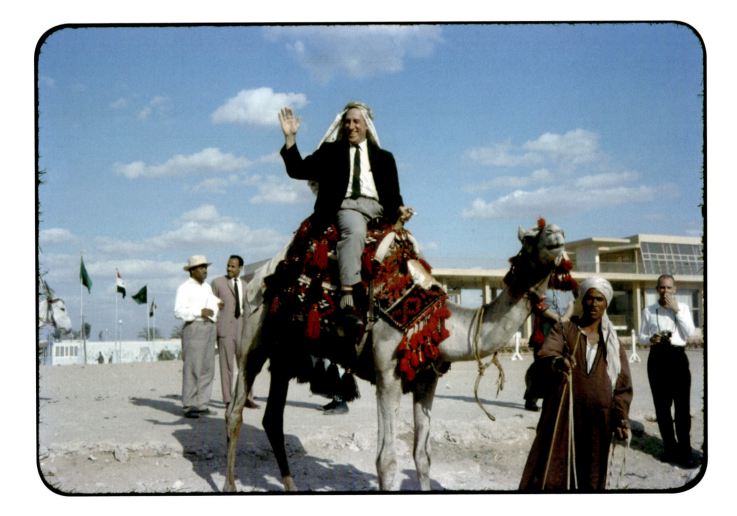

Figure 50
United Arab Republic,
April or May 1963

be that photography was prohibited even to these NDC high flyers. Either way, one senses that Langford somehow knew that he was not coming home with pictures of the Aswan Dam. A pattern can be detected in his postcards: he frequently refers to things that he has not photographed, his writing to his son functioning as another form of *aide-mémoire*. What he does not say is that the Egyptians were nervous about security, as Louis Turner and John Ash would later report: "Tourists would be asked to leave their cameras behind them in their hotels when visiting this attraction, despite the fact that lobbies were filled with brochures bursting with pictures of the dam."[80]

Nasser's UAR is sown with internal contradictions. Another site of competing signs may not have struck members of Course Sixteen with such direct visual force; this was the Nile Hilton, their 'home away from home' in Cairo. Completed in the late 1950s, the Nile Hilton belongs to the first wave of post-colonial hotel building in Europe, Africa, and the Middle East, a campaign led personally by American entrepreneur Conrad Hilton with the express intention of making a profit and winning the propaganda war for the West. With the blessing of the US State Department, Hilton began to stake out his sites in 1949.[81] The commercial Cold Warrior

explained his choices: "in Istanbul and Baghdad, we are pushing close to the Iron Curtain. We are in Cairo because it is the center of the Moslem world and holds the key to Africa and the Middle East ... We are in Berlin because Germany holds the key to the containment of Europe."[82]

In the early 1960s Daniel Boorstin mocked Hilton International for its propagation of "American modernity and antisepsis ... Except for the views from the picture windows, you do not know where you are."[83] MacCannell would later take Boorstin to task for his "nostalgia for an earlier time with more clear-cut divisions between the classes and simpler social values based on a programmatic, back *vs.* front view of the true and the false."[84] Hilton International's prestigious sites, Modernist design principles, and socio-political programs continue to attract scholarly attention. They have been astutely analyzed by architectural historian Annabel Wharton, who pays particular attention to the performative nature of the buildings, especially their systems for shaping experience and directing attention. For a Cold War tourist, Hilton International's Cairo site is almost overwhelming in its implications: the hotel stands on the former location of the British barracks at Qasr al-Nil, installations abandoned well before the occupation forces had left the country but nevertheless still freighted with Britain's reversal of fortune after Suez. Hilton International occupied the site on different terms, no less imperialist, having led the attack through its representatives' flying visits (shuttle development anticipating shuttle diplomacy) and with the carrot, rather than the stick.[85] As guests of the Hilton, the Cold War tourists were also guests of the UAR: the governments of host countries held part ownership in their Hiltons; they had invested, in other words, in the hotels' prolonged success as destinations for tourists seeking the familiar and "local elites" sampling authentic American pleasures. President Tito of Yugoslavia fit comfortably into neither category, though he and Nasser mingled happily as brothers in the non-alignment movement, signing autographs for the American celebrities at the Nile Hilton's gala opening in 1959.[86]

Designed to call attention to itself, the twelve-storey Nile Hilton was then the tallest building in Cairo. Its flat surfaces of glass and concrete snubbed the forms and palette of its neighbourhood. Its site and orientation were highly significant: at the heart of Cairo, between Midan Al-Tahrir (Liberation Square) and the Nile. As Wharton explains, the hotel "turned its back on the medieval, Oriental city to face a safer, more remote Ancient Egypt ... that the West traditionally constructed as the birthplace of Western civilization."[87] It advertised panoramic views to the west, toward the Pyramids, from its guest rooms and rooftop restaurant; its "commoditization of space extended to gaze."[88] This was the full treatment, which was not

given to everyone but only to the privileged occupants of the best rooms and suites. The less expensive rooms might have private baths and broadloom, but their visual appointments were flawed, for they faced in the wrong direction. A perversion of the Hilton program – a cantankerous view of the east – is the sole image of Cairo registered by Warren Langford's camera (fig. 51).

His composition includes Midan Al-Tahrir, with its surrounding buildings, as well as the city beyond. This view is compositionally demarcated as outside the perimeter of the Hilton. The treetops of the hotel's walled garden and an open plaza, yet unfinished, form a line across the bottom of the frame. Then the space opens up to inspection: its famously confusing traffic, rooftop advertising (Air India, CSA, Charleroi, and Rolex inscribed against the sky), mysterious (to our photographer) Arabic advertisements, mismatched architectural styles, and *people* – Lilliputian figures strolling, running, clustering around taxi stands, and queuing for buses around the perimeter of the square. Even the inanimate is in motion. A bus depot under construction arcs into the air above its hoarding. A colossal red granite pillar stands ready for a statue at the centre of a roundabout. This place of memory is collecting itself for the next stage of its history, but the commemorative project is unfinished. No monumental centrepiece instructs or orients the visitor. Indeed, from the floating eye of a Hilton balcony, to dis-orient might seem the aim. The minarets of the Mohammed Ali Pasha Mosque, also called the Alabaster Mosque, rise up on the skyline, but the route to the east seems unplottable, the distance immeasurable in this social landscape of Cairo.

The view is a snapshot of three competing visions for Egypt. The distant mosque represents the controversial legacy of a dynasty that had ruled until 1952; the Turkish patriarch Mohammed Ali Pasha is sometimes honoured as the "father of modern Egypt" because he opened the country culturally and institutionally to the West. His grandson, Khedive Ismail, built the square that temporarily bore his name to a French design. He is perhaps better known for the Suez Canal, which ran Egypt into irreparable debt to European creditors, tipping the country into the arms of British imperial control. Nasser's UAR was another push toward modernization, a heavily subsidized transit system turning Midan Al-Tahrir into a commuter hub for a growing population of urban workers; the bus depot is this period's triumphal arch.[89]

Orientalist romance is restored when the tourists decamp to Aswan, where they bed down for the night at the New Cataract Aswan Hotel. The famous nineteenth-century Old Cataract Aswan Hotel, a port of call along the Nile in the halcyon days of Thomas Cook's Grand Tour, is right next door. Upward mobility continues to

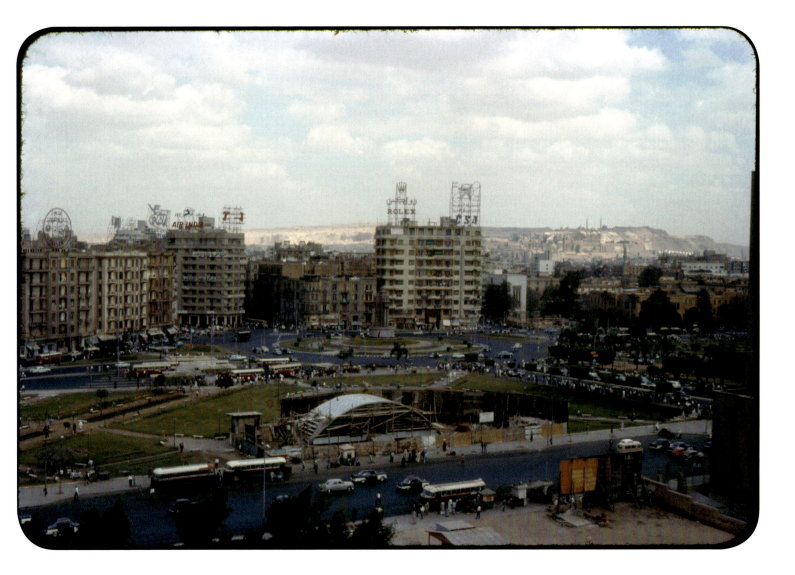

nibble at privilege. As Nelson Graburn's study of waves of tourism would suggest, the aristocrat's Grand Tour of Europe was irrevocably spoiled when the Cookites arrived; the upper classes found themselves "'up against the wall' in having all their styles and locations – apart from private retreats – invaded 'from below.'"[90] Now, in turn, the Cookites are being invaded in Egypt. Warren Langford begins his ex-

Figure 51
Cairo, United Arab Republic,
April or May 1963

Figure 52
Aswan, United Arab Republic,
May 1963

ploration at water's edge, clambering down among the rocks on the shore, but he eventually settles into tourist culture, watching river traffic and surveying the antiquities from the comfort of his hotel balcony (fig. 52). He spots a motorized tour boat; he follows the feluccas. His selective framing and relaxed mood transform the purposeful navigation of these crafts into tales of graceful meandering. He takes thirteen photographs, an extended narrative within his choppy oeuvre, a sequence verging on the cinematic. At Aswan, photography is being used as a pastime, rather than an instrument of record, but as the Cold War tourist's time in Africa winds to a close, the making of such pictures is important. These languid, *timeless* images are restorative. They correct Langford's first impression of Egypt, his view of modern Cairo, which is almost the expression of a shock.

In retrospect, the Soviet Union's initiatives on the African continent in the early 1960s were fairly ineffective. It did establish a strong presence in Egypt, provided military assistance and advisers to other African governments and radical movements, educated many African student leaders, and supported a number of infrastructure projects. But it lacked the economic, political, and military capacity to effectively project its power into the region, and none of the decolonized nations were anxious to take on a new master.[91] Moreover, as Milton Kovner, who lectured at the NDC on "The Sino-Soviet Economic Offensive," would undoubtedly have explained, the Communist bloc faced particular challenges in Africa as it tried to accommodate its desire to win allies with its revulsion over the ideological "shortcomings" of the new states' leaders.[92] Finally, after the Cuban Missile Crisis, there was the concern that destabilizing initiatives in Africa and elsewhere might provoke another nuclear confrontation with the United States.

In 1963 the challenges facing the Soviet Union in Africa and across the Middle East did not seem to be so compelling to Western powers worried about the erosion of their own political, military, and economic power and uncertain about how to deal with nationalist rulers who cleverly played one Cold War protagonist off against the other. The enormous force of American culture and capitalism was beginning to be felt across the developing world, but it had not yet asserted its full influence. Egypt's unique combination of nationalism and socialism – a 'diluted form' of Marxism coexistent with Islamic ideals and European modernities – made the future shape of its 'third way' difficult, if not impossible to predict.[93] On these shifting sands, it would hardly be surprising if the NDC cohort left Cairo sharing the anxieties of the former colonial powers and their new partner, the United States, about the potential influence of the Soviet Union in Egypt and across Africa.

Closing with the Enemy

THE EUROPEAN TOUR

After Egypt, the tour moved on to Europe, where the Soviet Union suffered no power disadvantages relative to its Cold War enemies. The dance card was full – visits to Rome, Verona, Vicenza, Venice, Belgrade, Bonn, Berlin, Brussels, London, and Paris in that order. In the last three capitals, our travellers met up with their colleagues from the Asian tour. By that stage, they were coming down from the intensity of Berlin, the briefings were judged to be repetitive and superficial, and the agenda was full of social activities. Earlier stops in Italy and Berlin had added real value to the group's understanding of the Cold War in Europe, while generating considerable photographic activity. On these destinations, we too lavish almost all of our attention.

On the continent there could be no distancing from the Cold War. Here it was not about missiles fired at targets thousands of miles away or confrontations through proxy states on another continent. Instead, it was about the Western allies' political and military capacity to deter any expansionist or divisive initiatives of the Soviet Union and its Warsaw Pact allies against their immediate European neighbours. The consequences of miscalculation or failure could be a frightening conventional and nuclear war in the heart of Europe less than twenty years after the previous war had devastated the continent.

In 1963 the Cold War confrontation in Europe had the superficial appearance of a nicely balanced and institutionalized Mexican standoff.[1] The chaos surrounding

the economies of Eastern Europe, which were damaged by Soviet interference, misguided central planning, and migration. While, overall, these economies grew in the 1950s and early 1960s under state-planning regimes, they did so at a considerably slower pace than their Western European counterparts. The relative stagnation of Communist economies, food shortages in Eastern Europe, and the public realization that economies in the West were more prosperous did little to build popular support for Eastern European governments.[3]

In 1963 the greatest potential source of misunderstanding and instability between the two Cold War superpowers was still the German situation. The country was divided between East and West, and the Cold War had stymied efforts to reach a peace agreement and reunite it. There were now effectively two Germanys: in the west the Federal Republic of Germany (FRG), a parliamentary democracy governed by a long-standing Christian Democrat–dominated coalition, controversially rearmed since World War II, a member of NATO, and a partner in the European Economic Community; and in the east the German Democratic Republic (GDR), a totalitarian Communist dictatorship exactly modelled on the Soviet Union and under its ultimate control. Just as its Western counterpart formed a component of NATO and the EEC, so East Germany was integrated into the Warsaw Pact and Comecon.

To enhance the instability inherent in a divided Germany, there was the flashpoint of Berlin. The Soviet Union had liberated the city from the Nazis in 1945, entirely on its own and at great cost in human lives. Then Berlin, as the capital of Nazi Germany, had been divided among the Soviet Union, the United States, Britain, and France, with provision for citizens of the city and representatives of the occupying powers to circulate freely across the four zones. It was isolated geographically from West Germany, with extremely vulnerable land and air transportation links to the West, and surrounded by some 400,000 Soviet troops. As an open connection between East and West, it was a hotbed of espionage. It had also become, by the late 1950s, a major source of political and economic embarrassment for the Soviet Union and the GDR because of the seemingly endless flow of East Germans fleeing economic stagnation and political repression by escaping to West Berlin. It was the endgame of this crisis that would capture much of the attention of our Cold War visitors as they made their way through Europe.

But all of this gloomy picture is for later. The European tour began on a much more relaxed note in Rome, where the participants were briefed by senior officials from the Canadian embassy on the always convoluted Italian political situation and the remarkable resurgence of the country's economy since World War II. They then

focused more closely on Italy's foreign and defence policy and its engagement with NATO, on which they were briefed by the Canadian military attaché, as well as by Italian foreign, defence, and space research officials. In previous years the NDC tour organizers had scheduled an audience with Pope John XXIII in the Basilica of St Peter, but interested members of our group (and Warren Langford was certainly one of them) had to settle for a lecture on the Ecumenical Council. This was one of two Roman presentations later judged to be "of doubtful value" by the participants, the other being the offering by the National Research and Space Organisation.[4]

Urbi et Orbi

The Afro-European itinerary had earmarked Sundays in Lagos, Cairo, Rome, Berlin, Paris, and London as the official rest days of the tour, with optional activities for the participants – camel rides at Giza, for example. Participants would later complain that their rest days had been encroached upon by social functions. Warren Langford was having none of that in Rome. He had come prepared for Italy: his Roman Catholicism was one form of training; high school Latin was another; mainstream films, such as *Roman Holiday* (1953), reinforced ideas about where to go and what to see on a lightning visit. On this spiritual and cultural quest, his split personality could be further divided: "A tourist is half a pilgrim, if a pilgrim is half a tourist."[5] The Canadian embassy in Rome laid on a guided tour of the main attractions, which he joined and dutifully photographed. Thus oriented but by no means sated, he was up bright and early on Sunday and spent the day hoofing through the city.

We know something of his feelings from a postcard: "a wonderful stop here but much too short a time to see even a fraction of the things I wanted to see." And the same note evinces some surprise about the city: "You can't imagine what traffic is like in Rome; the streets are crawling with Fiats and they're parked three or four abreast, even up on the sidewalks."[6] This was not the image of Rome that he brought home in a souvenir publication (a fold-out or concertina book), nor was it the message conveyed by his slide show. Rather, these images illustrate a tourist's attempt to ignore modern Italy's occupation of the Eternal City. Photography here operates ahistorically, as a tool of mediated connoisseurship.

Course Sixteen's home base in Rome was the Victoria Hotel on the Corso d'Italia, not far from the Spanish Steps, a site repeatedly recorded: twice in the early afternoon as part of the guided tour and again on the Sunday morning, as

Figures 53 and 54
Rome, Italy,
May 1963

Warren Langford sets out walking. Italians and fellow tourists are like the flowers on display: varied in shapes and sizes, colourful in their mixed seasonal array. A businessman levelling a go-away glare, indifferent weary travellers, and young men exchanging confidences animate his first and best take (fig. 53). In Sunday's wider, more conventional view, adolescent girls, posing in their First Communion dresses, and families are spilling down the Steps. At this Grand Tourist mecca, human subjects play their parts as living anecdotes, giving themselves to be seen and so to be photographed.

Sunday's primary objectives, however, are archaeological – the ruins of the Roman empire (Augustus's city) – and architectural – the monuments to Christianity (Michelangelo's and Bernini's). These have been scouted and documented on the guided tour; what is interesting is to see them rephotographed and thereby restored to their pre-visualized glory. Warren Langford leaves the First Communion celebrations at the Spanish Steps around 10:20. Has he been to Mass with these people? One hopes so, because he is headed for the ultimate confessional. He crosses the Tiber; his destination is St Peter's, a subject adroitly framed by the Ponte San Angelo, the Castello di San Angelo (Hadrian's Tomb to our steeped-

Figures 55 and 56
Rome, Italy,
May 1963

in-classics photographer), and artfully drooping branches (fig. 54). On St Peter's Square, another site photographed earlier, he has composed his view of the papal apartments and is ready when the ailing pontiff comes to the window to give his blessing (fig. 55). Can our photographer really see this tiny silhouette? It seems unlikely through a viewfinder, but he hears the people around him. He photographs the roar of the faithful and then gets away before he is subjected to the roar of their cars. Time travel waits for no man.

Back across the Tiber, he is destined for ancient Rome, though temporarily detoured through Fascist Italy when he photographs the imposing and ugly Monu-

ment to Vittorio Emanuele II (1911–35), also known as the Altar of the Fatherland, "the typewriter," "the false teeth," or "the wedding cake." One picture should have sufficed, but the structure sneaks into the backgrounds of subsequent frames. He photographs the Forum from two different angles, one virtually replicating his earlier view.[7] Then comes the Colosseum from the southeast corner of the Forum, close by the Arch of Titus, a layered view of Roman triumph and Christian martyrdom glowing under wispy clouds, and with a little red Volkswagen Beetle discreetly included as an emblem of more recent contests (fig. 56). Inexhaustible, he pushes on to the Janiculum Hill, where in Gianicolo Park he watches the puppet show at the

Teatrino di Pulcinella, and then turns back to the hotel via the Trevi Fountain, known to him through two major motion pictures, *Three Coins in a Fountain* (1954) and *La Dolce Vita* (1960). In his first view, the ubiquitous Fiats are creeping into the frame, bottom left and in a courtyard. The second picture closes in on the statuary and the pool, somewhat reduced without Anita Ekberg wading up to the hippocampi in her chiffon gown. English signage on an adjoining building is the only jarring element – for an English-speaking tourist, not jarring at all (fig. 57).

Nothing is surprising in these photographs, except for people who did not know Warren Langford and his ability to walk all day. His attack on the sites, figured in his nervous repetition of images, fits with Rome's long history of feverish tourism: as Richard Wrigley explains, Rome was experienced by newcomers "in a state of hyperactivity and increasing exhaustion."[8] In relation to his Cold Warrior status, there are one or two things to say about his presence in Rome. His Catholicism exerts a calming influence, his pope somehow managing to balance firm anti-Communist views with messages of universal brotherhood.[9] It is all rather optimistic. And sustaining this optimism is evidence, quickly turned into photographic evidence, of the *longue durée* of Western civilization. Rome is the materialization of spiritual and humanist values recognized and shared by the Cold War tourist. After Cairo, it hardly seems foreign at all because the *idea of Rome* as both triumphant and tragic has been forming in his imagination since childhood.

Figure 57
Rome, Italy,
May 1963

When Horace wrote, "I have built a monument more lasting than bronze and higher than the Pharaoh's pyramids," he was praising his *Odes* in contradistinction to Augustus's marble city.[10] The broken columns of material Rome carry grim warnings about the hubris of empire, while on the same site English poets and their readers spin beautiful, melancholic lines, written out by generations of Byronic schoolboys (fig. 58).[11] Warren Langford's photographic notations compose a journal of being there, in company with his "wishful dreams and anxious moments" and, *pace* Walter Benjamin, thrilled by them.[12] He has seized the day. The Eternal

Figure 58
Rome, Italy,
May 1963

City has been confirmed as a parable of contested space and stoic endurance. The Cold War tourist carries this image to Rome in his mental baggage and takes its photographic facsimile away when the tour shifts to northern Italy. There he will be shown things designed to deal with the barbarians threatening the empire of his day.

Prior to their leaving Kingston, the directing staff of the college had been asked to reconfirm that all members of the tour had received top secret clearances. Unlike the relaxed atmosphere of North Bay, our Cold War tourists appear to have been discouraged from photographing any aspect of their visits to the US bases and mis-

Figure 59
Verona, Italy,
May 1963

sile sites in northern Italy. Eight views of Verona represent a brief guided tour, a short diversion for the Cold Warriors, whose actual purpose in being there is to think through the possibilities of turning Europe into a Dantesque Inferno. Accordingly, they pay their respects to the poet's statue at Piazza dei Signori. In successive picturesque views, the not-to-be-missed panoramic prospect from Castel San Pietro includes the Ponte Pietra, recently restored after the departing Nazis tried to blow it to kingdom come (fig. 59). The Basilica of San Zeno, where Shakespeare's Romeo and Juliet tied the knot that was their noose, marks the end of an efficient sightseeing tour: lots of war stories and cultural nuggets to show and tell the family when the Cold Warriors return home.

At military bases near Verona and Vicenza the main focus was on the tactical and defensive nuclear missile weaponry being operated by US and Italian armed forces in support of NATO. Here our Cold War tourists came face to face with key flexible response elements of the nuclear deterrence tool kit. The group first visited the headquarters of NATO's Land Forces Southern Europe (LANDSOUTH) and the US Army's Southern European Task Force (SETAF) in Verona. They were briefed in the latter's underground operational Site A and met with the commanding general. Then by helicopter they visited SETAF's Missile Command site, which by 1963 was staffed jointly by US and Italian troops under the nuclear-sharing strategy adopted by the United States with a number of its NATO allies.[13] The Command's weapons were tactical, mobile, surface-to-surface, atomic missiles. The obsolete 'Corporal' and 'Honest John' missiles were at this point being replaced by 'Sergeant' missiles, which had a somewhat longer range and a substantially bigger nuclear payload and were less complicated and cranky to operate. All three of these battlefield nuclear weapons were deployed across Western Europe and designed, first, to deter the Warsaw Pact nations from attacking and, second, to deny them victory if they did so and threatened to break through NATO's initial defence lines into West Germany, Italy, or southern Europe. A significant part of the defence plan for northern Italy, for instance, involved using atomic munitions to block the mountain passes providing access from Austria and Yugoslavia.

Unfortunately, as their lecturers in Kingston had made clear, the overwhelming preponderance of Warsaw Pact forces made such a breakthrough scenario all but inevitable. Outgunned and outmanned by the Warsaw Pact standing armies and unwilling to pay the cost of matching the East division for division, the Western alliance employed a deterrence strategy in Europe which advertised to the Soviet Union that NATO forces would resort to the nuclear 'sword' if the NATO forward-

deployed conventional troop 'shield' was broken. However, the more thoughtful NDC visitors would have realized that this strategy was in flux, untested, and potentially deeply flawed. If the nuclear response was to be flexible – limited at first to tactical, battlefield nuclear weapons such as the Honest John and Sergeant missiles – heavily populated European battle zones could be laid waste, while the Soviet homeland remained unscathed.

In addition, how the advancing Warsaw Pact armies would react to the use of these weapons as a 'final warning' before the launch of all-out nuclear war was unclear. They might respond with battlefield nuclear weapons of their own (perhaps even targeting nearby cities) or escalate immediately to more powerful intermediate and long-range nuclear weapons targeting more distant military and civilian centres in Europe and the United States. In the early 1960s, simulations of war in Europe in which both sides used battlefield nuclear weapons predicted "the virtual annihilation of European populations," and "such a war seemed all too likely to escalate to general war."[14]

And who was in charge of this dangerous and often unreliable hardware? Despite nuclear sharing, it was not really clear who would ultimately control these weapons in a crisis – the allies (in this case, the Italians) or the Americans. The United States had in the very recent past portrayed its physical control of these shared weapons as nominal. But under the Kennedy administration, emphasis was being placed on tighter US control.[15] While formally part of NATO and working closely with the re-established Italian armed forces, both the US Army and Air Force units in northern Italy and the 6th Fleet, based in Naples, were under the direct control of the American government. Ironically, some NATO allies calculated that this shift in policy might significantly enhance the deterrent value of these weapons, reducing Warsaw Pact expectations that battlefield nuclear weapons would not be used because of the risks to populations close to the battle zone.[16]

It must have been a sobering thought for our Cold War tourists as they visited these sites in northern Italy that the fate of Europe, and possibly the world, might lie in complex decisions to be made about the use of the tactical atomic weapons in the heat of battle by allies uncertain of who ultimately called the shots, how accurately the shots could be fired, and what the response to those shots might be. Our tourists would be reminded of these questions again the next day when the group went by helicopter to Vicenza, where they toured NATO's 5th Allied Tactical Air Force base, met with key personnel, and visited an operational unit of the US Air Force 'Nike' surface-to-air anti-aircraft missile system. There they were able to see both

the older 'Ajax' and the second-generation nuclear-tipped 'Hercules' missile control and launch sites. These missiles were widely deployed around major population centres in the United States and Europe in the 1950s and early 1960s.

At the end of this briefing, the visitors were ferried on to Venice, again by helicopter (fig. 60). The helicopter was a Sikorsky S-58, also known as the CH-34 Choctaw cargo and light tactical transport helicopter (the Wessex in the United Kingdom). It carried sixteen troops and was heavily used by the Marine Corps in Vietnam.[17] Their pilot gave Warren Langford's group of Cold Warriors a beautiful and interesting ride. From the air, they saw a topography of mixed use: first, vineyards and

Figure 60
Northern Italy,
May 1963

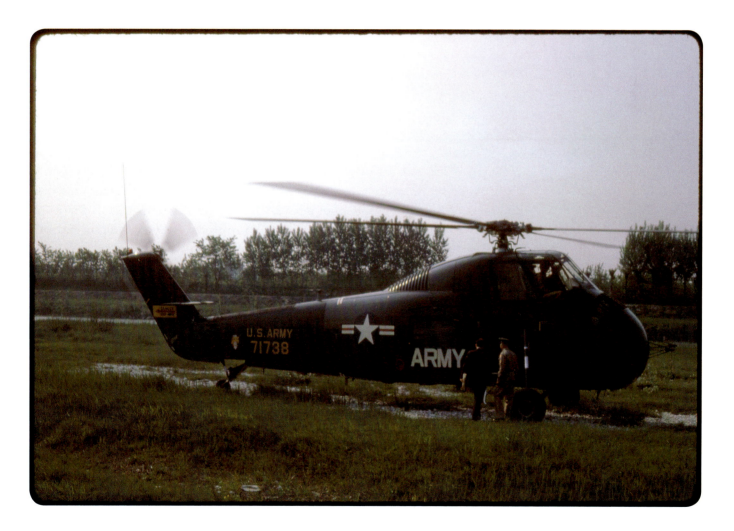

Figure 61
Northern Italy,
May 1963

suburbs (fig. 61) and then the desolate industrial landscape of Mestre and Marghera. Finally, on the approach to Venice (fig. 62), the helicopter inscribed a great circle over the Lagoon and the beach cabanas of the Lido (fig. 63), before landing at the nearby airstrip.

This adventure offered a whole new way of seeing to our photographer – a pure product of modernity. As Kim Sichel explains, aerial photography differs from the conventional landscape in both formal and functional ways: there is "no Renaissance one-point perspective, no horizon, no vanishing point, no human scale

Figure 62
Venice, Italy,
May 1963

Figure 63
The Lido,
Venice, Italy,
May 1963

... few nuances of light and shadow."[18] An aerial view is closer to a map than a conventional landscape; the earliest experiments in aerial photography were conducted with military applications in mind.[19] The same basic technology was still informing military intelligence, as the Cuban missile site photographs had only recently shown.[20] This is God's, or Big Brother's, perspective. So however pretty the pictures, there is something slightly sinister in the bird's-eye views from the big black whirlybird as it transports the Cold War tourists to their next round of

meetings. Their knowledge and prestige are growing apace. From the Lido they will take a launch to their rather grand hotel, the Bauer-Grünwald, where they will be just steps from St Mark's Square, its art, architecture, daily rituals, and social performances.

Bright warm days draw out the tourist-photographer, who combines postcard views of Venetian monuments with everyday images of people strolling and feeding the pigeons (fig. 64). It is hard to make a bad picture under these circumstances and equally hard to achieve the transparency desired. All spontaneity seems staged, like

Figure 64
Venice, Italy,
May 1963

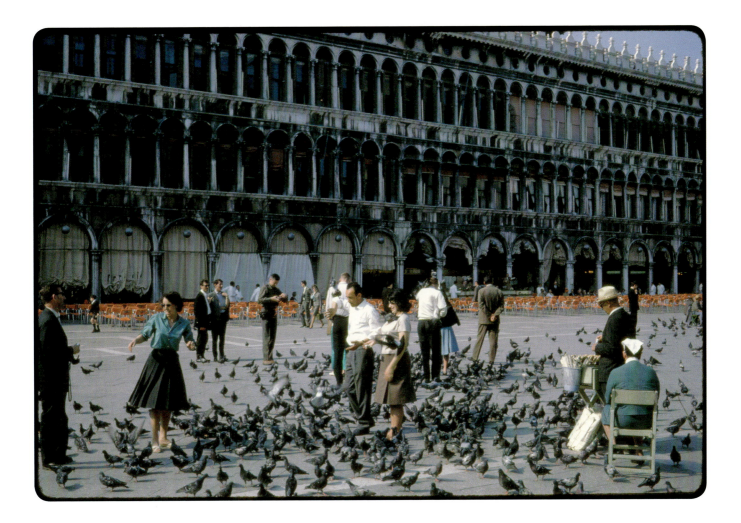

a fashion shoot or a wedding, and somewhat déjà vu, but our photographer is the opposite of jaded: he snaps away at every photo opportunity. Floating in a gondola, Warren Langford represents the tourist-subject's dual experience of being in Venice and being in the way of its authentic representation; his colleague strains his neck to get out of the shot of the nearby gondola's bride and groom (fig. 65). Likewise, his image of the painter who has set up his easel on one of the water bus (vaporetto) jetties to paint the Rialto Bridge. Art for the tourists, one might guess, looking over his shoulder and noting that the tourists lining the bridge – potential buyers of this

Figures 65 and 66
Venice, Italy,
May 1963

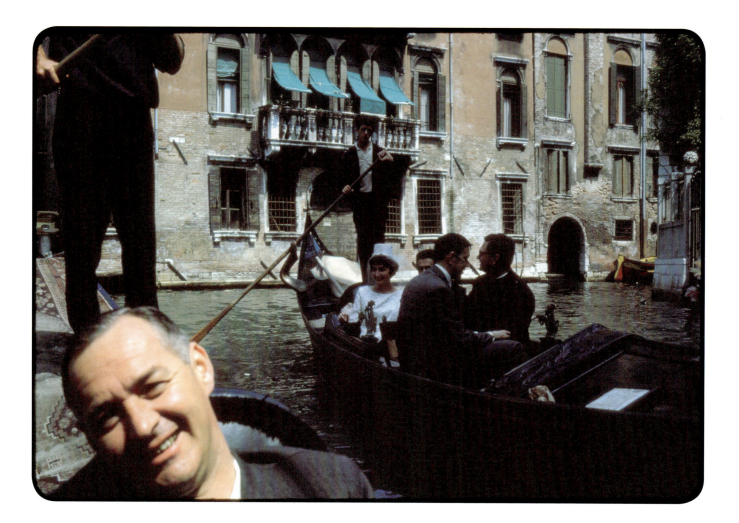

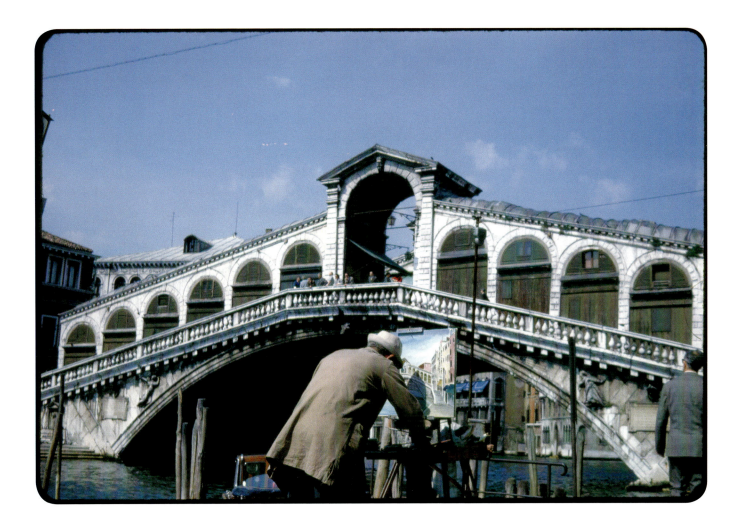

souvenir – have been eliminated from the composition. A vision of timelessness requires that the anecdotal present be systematically suppressed (fig. 66).

Belgrade would be the next stop, a two-day visit before the tour moved on to Bonn, its staging area for Berlin. The notes from a directing staff meeting held after the course ended in July 1963 reported that the Belgrade agenda was "not a very good programme per se, but of good value to the College in that it gave an inside look at a Communist country – an atmosphere visit." The notes went on to suggest that "a visit to Poland might be considered as an alternate if required."[21]

Perhaps, but Yugoslavia and Poland were hardly comparable. With the exception of farming and the Catholic Church, all aspects of Polish life were firmly under Soviet control in the early 1960s. By contrast, Yugoslavia, initially a satellite state of the Soviet Union, broke with Stalin in 1948 and was expelled from the Cominform. Under President Tito's dictatorial direction, the country pursued an independent Communist path and became, like Egypt, a key player in the movement of non-aligned states. This detachment provoked an outpouring of Western aid designed, according to Dean Acheson, then US secretary of state, to make Tito "our son of a bitch."[22] It did not work. Tito moved adroitly between the two sides, shifting some distance away from his initial radical Bolshevism but later repairing his relationship with the Soviet Union and never becoming a solid member of either camp.

We could locate no account of the Belgrade visit. If it fell into the pattern of the previous year, it was largely ceremonial (laying a wreath at a war memorial on Avala Mountain overlooking the city) and bereft of significant briefings by senior officials. And after something of a photographic orgy in Italy, there are no photographs of city or country.

Similarly, there are only three polite efforts, castle views along the Rhine, at the next stop, Bonn. It put them within reach of the RCAF No. 4 Wing at its air base at Baden-Soellingen, which was in the midst of an upgrade from older, now obsolete CF-100 interceptors to the newer CF-104 Starfighters. The latter were designed for a nuclear strike–reconnaissance role but, like their CF-101B Voodoo cousins (visited in North Bay in January), were still bereft of nuclear weapons, a situation that Warren Langford's syndicate had vigorously criticized in its paper on NATO.[23] Our Cold War tourist's photographic engine seems temporarily to have sputtered out. It would be revived by Berlin.

Framing Berlin

What an amazing moment to be in West Berlin, "the outpost of freedom" surrounded by massive concentrations of Russian and East German armed forces and only recently divided, east from west, by the Berlin Wall, the ultimate expression of the Iron Curtain between freedom and oppression, a wealthy market economy and a poor, planned Communist state (fig. 67)! As guests of the British occupation force, our Cold War tourists travelled from Bonn in a Royal Air Force plane that landed at the British base in Gatow. Their itinerary was packed with briefings, as well as social and cultural events. Some members were anticipating an evening of musical

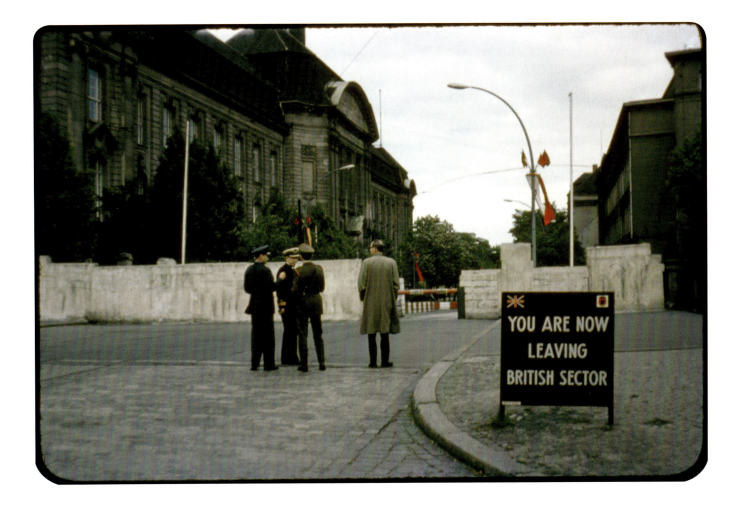

theatre in the West Berlin production of *My Fair Lady*. Its implicit message? British manners and an upper-class English accent will win you the world. Every public moment in the travellers' three-day visit to the city would be freighted with iconic connections to the Cold War and its key players.

Hilton International was again part of the ideological landscape, one piece of an enormous effort – funded by the West German and American governments – to make Berlin a showcase of Western culture and enterprise.[24] The hotel project, financed by the Berlin Senate, had been pushed through, despite opposition from West Berlin's struggling private hoteliers. But the opulence of Cairo was not on

Figure 67
West Berlin,
May 1963

offer: the Berlin hotel was not allowed to be a luxury establishment, only a first-class one. The socialist partners of Hilton International had disallowed many of the chain's most appealing features. There were no balconies, for example, so the hotel's much vaunted views "over the Brandenburg Gate *deep* into East Berlin"[25] had to be contemplated through glass. The physical presence of the building was exerted through its height, compared favourably to a giraffe's, and its surface treatment, which was a hard-edged checkerboard design,[26] a nice touch for a city of checkpoints and checkmates. Its interior decor took its cues from animals in the nearby zoological gardens. As Wharton's descriptions suggest, there was some-

Figure 68
West Berlin,
May 1963

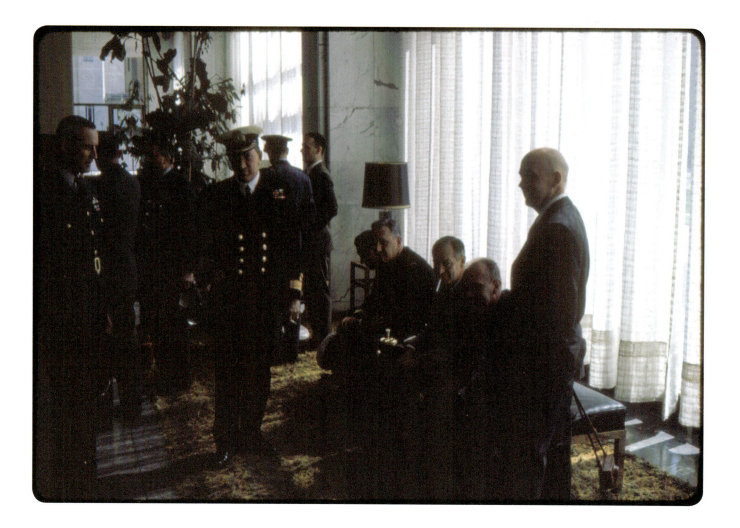

thing of a disconnect between the marble and bronze of the hotel's public rooms and the meaner guest rooms – daily reminders for the Cold War tourists of capitalism's covert operations (fig. 68).

Sprung from their rooms in the Berlin Hilton, the Cold War tourists would be bused around to sites on both sides of Berlin. Photo fever was running high: Warren Langford's Berlin suite includes fourteen images taken by him, as well as six duplicate slides shot by a fellow traveller. Twelve of these twenty photographs focus on the Berlin Wall.

The Wall was an ominous development in the Cold War. The entire 'inner border' between the Soviet-occupied German Democratic Republic and the Western-supported Federal Republic of Germany had been fortified and guarded in progressive steps in the late 1940s and early 1950s. Western propaganda held that East Germany was acting to keep its unhappy citizens from defecting to a better life. The East German version was that the government was protecting its citizens from Western human trafficking.[27] For a time, however, citizens of both East and West Berlin, even those who had essentially defected, were permitted to move relatively freely about the entire city, creating kings and queens for a day, as Westerners spent their much higher earnings on subsidized consumables, services, and entertainment in the East and Easterners found steady, well-paid jobs in the West.[28]

But the economic and political costs of these defections were high. By 1958 the East German government was protesting "the steady haemorrhage of its human resources."[29] Some 2.5 million citizens of the GDR are estimated to have fled through Berlin between 1945 and 1961.[30] Increasing the government's pain, many of the refugees were professionals and skilled workers. Soviet premier Nikita Khrushchev conflated the depopulation issue with one of his own, threatening to abrogate Soviet support for the four-power arrangement in Berlin and pass control over the city to the East German government if the United States proceeded with plans to provide nuclear weapons to the increasingly bellicose West German government. He kept the rhetorical pressure on for three years, alternately threatening nuclear war and appealing to the growing anti-nuclear movement in Europe. In 1961 he indicated his intention to unilaterally withdraw from Berlin, make a separate peace treaty with the East Germans, and leave the other occupying powers to negotiate their status in Berlin with the new owners.[31]

Thus emboldened, the East German government began in June 1961 to impose restrictions on Easterners wanting to cross into West Berlin. This tactic had unintended consequences, immediately increasing the flow of defectors, and it led the

STORY OF THE WEEK

ON THE BRINK
AT BERLIN

RED WATCH ON THE BRANDENBURG GATE

Figure 69
"On the Brink at Berlin,"
LIFE, 25 August 1961, 28–9.
Photos by Hank Walker.
Copyright 1961 Life Inc. Text
reprinted with permission
of Life Inc. All rights
reserved.

Soviets to give the green light to the construction of the Wall. The East German authorities barricaded the border at 1:00 AM on Sunday, 13 August 1961, and began building what they called an "anti-fascist protective wall," using a variety of techniques to seal off the two parts of the city and stop the flood of immigrants to the West. This initiative, long feared by both East and West Berliners, nevertheless came as a shock and was widely reported in the West as a dangerous sign of military escalation. At the end of August, a *LIFE* magazine feature bore the title "On the Brink at Berlin" (fig. 69).[32]

But the explosion never happened, only posturing by both sides. To the intense disappointment of West Germans, the Western allies actually made little fuss about

the creation of the Berlin Wall, having questioned for years why the Russians and East Germans had not built something like it much sooner. This response was precisely what the builders had anticipated, and with good reason. In July 1961 Senator J. William Fulbright, chairman of the US Senate's Foreign Relations Committee, had asked "why the East Germans had not closed their border, which they had 'a perfect right to do.'"[33] *Ex post facto*, the British ambassador to West Germany, Sir Christopher Steel, explained the Wall to authorities in London as an indication that East Germany was content with a divided country and simply wanted to control its citizenry. "I personally have always wondered that East Germans have waited so long to seal this boundary," he wrote. The ambassador's main objective was "to get together with the Americans as soon as possible," ensuring a united front of non-reaction.[34] He had nothing to worry about, because President Kennedy had already decided that the Wall was "the end of the Berlin crisis."[35] The resumption of Soviet nuclear bomb testing in the fall of 1961 and the connections drawn in Washington between the Cuban Missile Crisis and the Soviet Union's Berlin strategy would later lead Kennedy and his Cold Warriors to change their minds.

Confusing to onlookers, and so grist for the propagandists, were the different accords and protocols governing the occupation of Berlin. The famous tank confrontation at Checkpoint Charlie in October 1961 was not really about the Wall at all. The real issue was the attempt by the East German border police, the Grepos, to exercise control over Western access to East Berlin (the deputy leader of the American mission, Allan Lightner, and Mrs Lightner holding tickets to a Czech theatre production in East Berlin on the evening in question). The Americans were not in the habit of producing any documents, least of all to the Grepos, whose authority they did not recognize. Under the occupation agreement, such inspections were the prerogative of the Soviet authorities. When no Russians appeared, and with the curtain rising, Lightner advanced his car into East Berlin, whereupon he was surrounded by armed border guards. The international incident had begun.

The Soviets operated under the rule that the American occupation officials had every right to move freely from the US-controlled sector into theirs. But once this right had been challenged by the East German border guards and General Lucius Clay, the American president's personal representative in Berlin and an intense anti-Communist, had responded militarily, the Soviets were faced with the delicate problem of appearing to support East German head of state Walter Ulbricht by matching their tanks with the Americans' and then backing off with dignity. We will never know what might have happened if this scary piece of Cold War brinks-

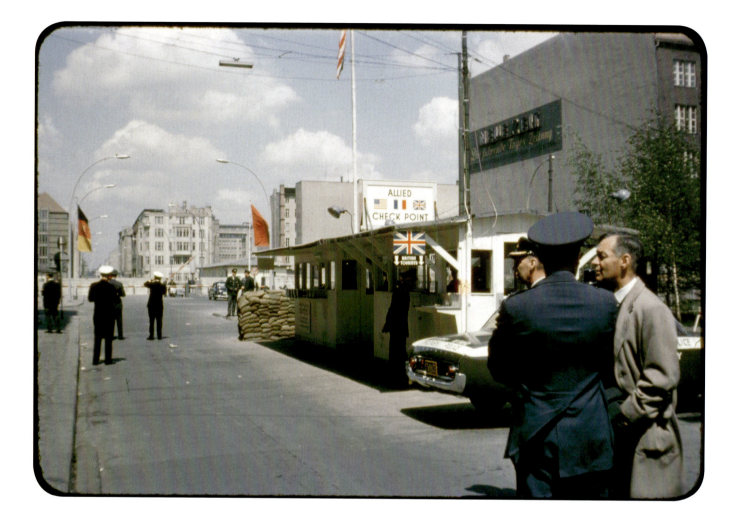

Figures 70 and 71
West Berlin,
May 1963

manship had not been as carefully stage-managed.[36] Images of tanks facing off at the Wall, as well as stories of valiant escapes and violent repercussions, reinforced the popular notion that Berlin was the key flashpoint for nuclear war between the two superpowers.

The word 'wall' appears nowhere in the Cold War tourists' briefing notes. Still, a visit to Checkpoint Charlie was a photo opportunity not to be missed (fig. 70). A colleague's camera records members of Course Sixteen lined up beyond the US sandbag emplacement, aiming *their* cameras at the crossing point from the other

side. A man on a scooter is presenting his papers to the border guard. The mood is sombre. A curious feature of the foreground is the amount of litter scattered across the road: the Americans kept a messy post. Warren Langford was certainly present on this occasion, but he took no pictures of his own. His photographic study of the Wall is of a different order, showing its intrusive, arbitrary presence in the urban fabric, its function, and its incompleteness – the Wall as a work in progress (figs. 71, 72, and 73).[37]

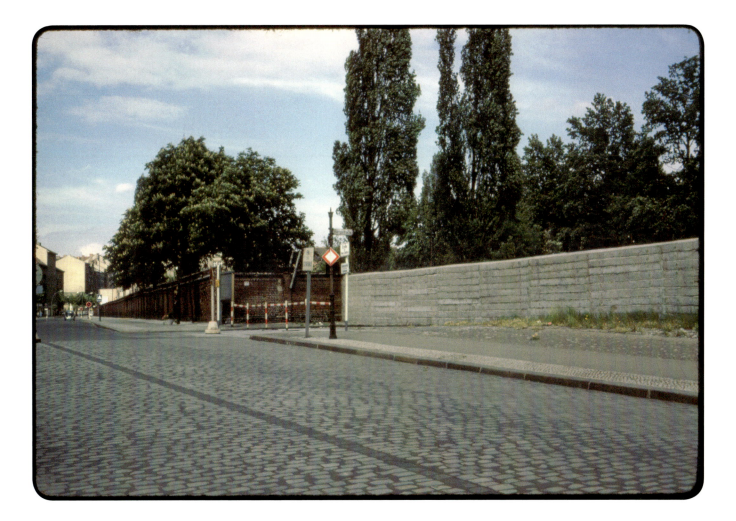

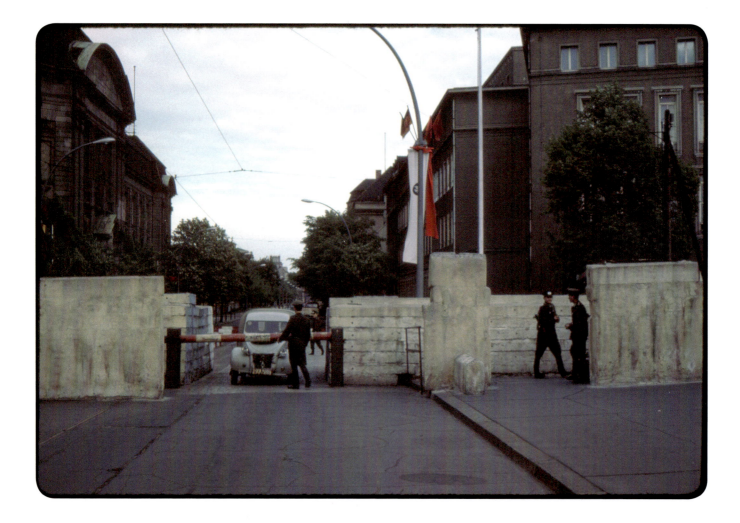

Figures 72 and 73
West Berlin,
May 1963

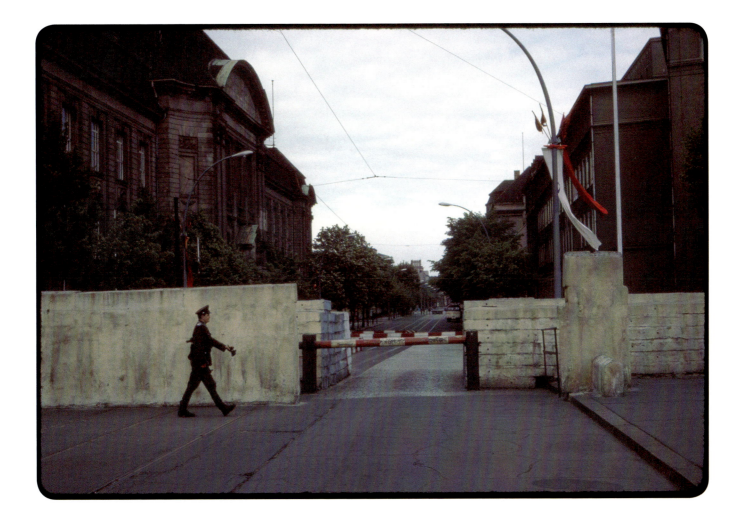

In 1963 there were only a few parts of the city where a proper wall had been built (fig. 74). In many places, east-west streets were simply blocked off by wire, barriers, and devices designed to stop any vehicles. Warren Langford's and Volkmar Wentzel's photographs of Bernauer Strasse, to be considered presently, illustrate the most sinister development, the bricking-up of windows and doorways of buildings that were right on the border (see figs. 80 and 82). In 1963 East Germans were still living and working in some of these buildings. Their homes and offices were systematically emptied of people and their possessions turned into hollow barriers. Later such structures were all knocked down to make room for the 'death strip,' part of a system of high concrete slab walls, spotlights, tripwires, crash barriers,

Figure 74
View of East Berlin,
May 1963

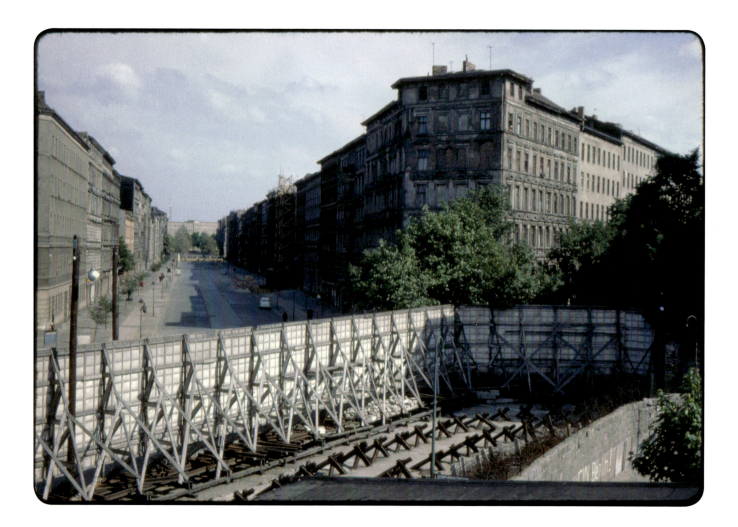

booby traps, patrolling guards (the Grepos and Vopos), and their infamous dogs. These nightmarish images of Berlin fuelled beliefs in the irreconcilability of East and West, conditions in the present creating amnesia about the past.

But the divisions in Berlin, while firmly demarcated for the occupied, could still be porous for the occupiers and their invited guests. A secondary theme of the Berlin photographs is commemoration, including visits to two official World War II monuments and two improvised memorials from the current Cold War. These photographs derive from an itinerary of "dark tourism," a cultural activity theorized by John Lennon and Malcolm Foley and subsequently backformed to photography.[38] The original Lennon-Foley model depends on the concept of "chronological distance": a crash site, for example, cannot become a tourist destination too soon, lest decorum be breached. Battlefields are another matter, however, having historically been readied for visitation quite quickly, their creation often begun before the war was even over.[39] Berlin had been turned into a battlefield at the conclusion of World War II and still wore the scars. Its official memorials were places of remembrance and re-education. At the same time, the Cold War's ongoing battle of wills over the Wall was producing new vernacular monuments.

The Berlin tour was conducted on a Sunday. The itinerary included visits to the two Soviet war memorials, huge monuments to the thousands of Soviet soldiers killed in the final attack on Berlin in April and May 1945. In previous years, this part of the trip had involved the NDC travellers in wreath-laying ceremonies. While their activities in 1963 were intended to be more discreet, views of these monuments made by Warren Langford and his colleague are evidence that they made both pilgrimages.

The Soviet War Memorial in West Berlin – in the British Sector, to be precise – was quite close to their hotel, in the Tiergarten just west of the Brandenburg Gate. This monument was constructed shortly after the war, using stone from the ruined Reich Chancellery. The remains of 2,500 soldiers are interred there. The first Soviet tanks to enter Berlin during the attack on the capital were incorporated into the monument, thereby evoking bitter collective memories of the Battle of Berlin and its aftermath. It was locally referred to as the "tomb of the unknown rapist" or the "tomb of the unknown plunderer."[40] Warren Langford made two views of the monument, the first centring on the curved six-entrance gate, divided by a column surmounted by a bronze statue of a Soviet soldier whose gesture denotes the subjugation of Fascism. His second view, from the side, captures one of the Soviet tanks (fig. 75). A striking feature of both views is the barbed wire surrounding the monument, which was subject to vandalism after the erection of the Wall.

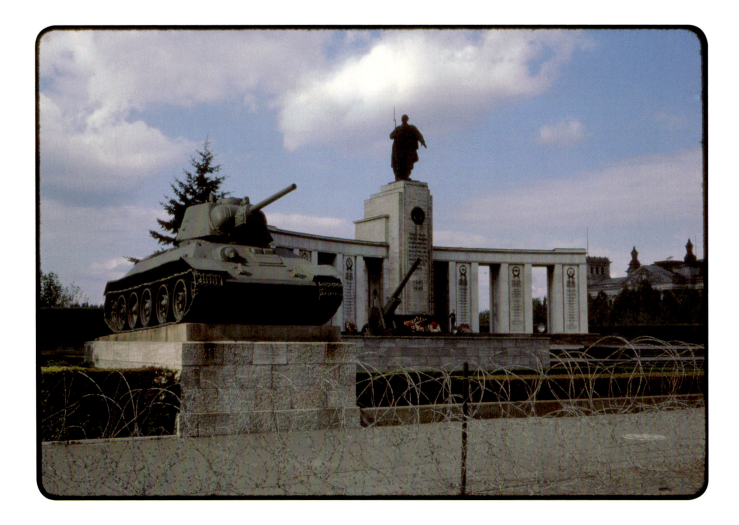

Figure 75
West Berlin,
May 1963

The East Berlin monument is a very large cenotaph in Treptower Park, with burial mounds containing the remains of 5,000 Soviet soldiers. This memorial complex is entered through a triumphal arch that directs the visitors along a ceremonial route honouring the dead for their defeat of Fascism and celebrating the liberation of the people. Accordingly, the figure of the soldier on this monument is smashing a swastika with one arm and cradling a child with the other. The slide given to our father is a long view that sweeps down from the entrance over a Russian- and German-language inscription and rows of floral tributes. Befreiungstag (Liberation

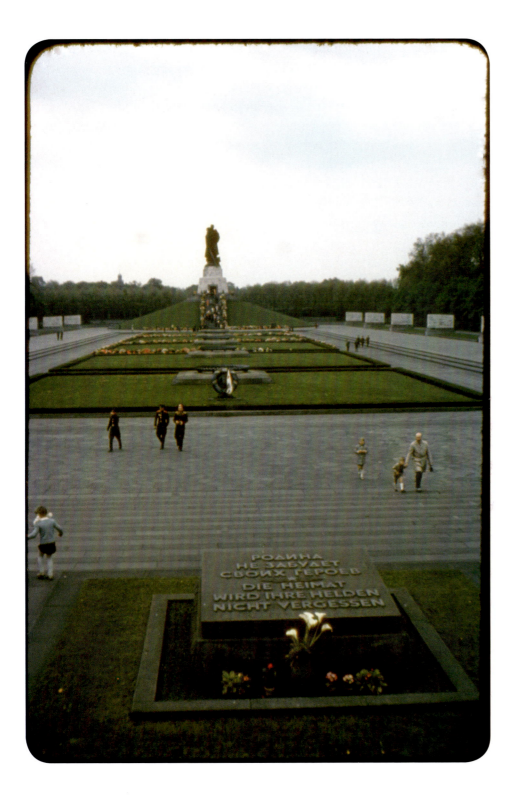

Figure 76
East Berlin,
May 1963

Day), an annual commemoration in the GDR, had been celebrated just eleven days before, on 8 May (fig. 76). But a child carrying flowers and crowds on the distant stairs suggest that commemoration is perpetual and attendance heavy.

Both monuments were staffed by the Soviet army throughout the Cold War and regularly visited as important shrines by bus loads of Soviet soldiers and tourists. The Soviets came not just to grieve: the ritual functions of a Soviet war memorial exceeded those enacted in the West, including personal celebrations such as weddings. As Michael Ignatieff explains, "War memorials are the churches of the Soviet military build-up."[41] When the Soviets eventually withdrew from Berlin, they left on condition that their monuments be maintained in perpetuity.[42]

Figures 77 and 78
East Berlin,
May 1963

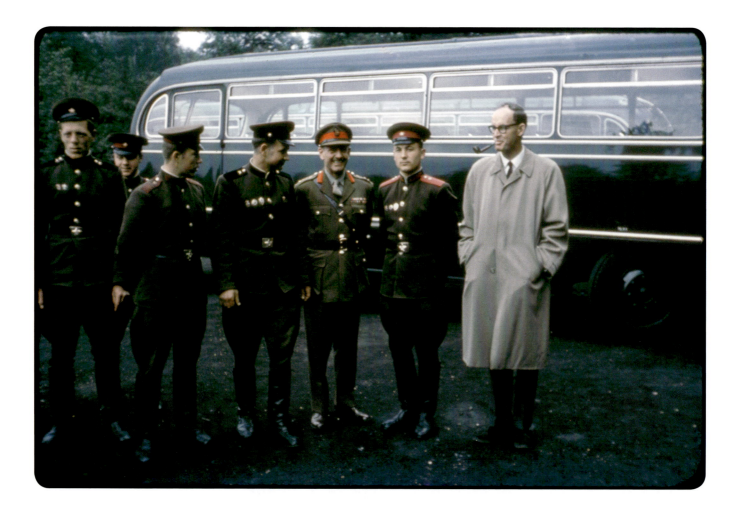

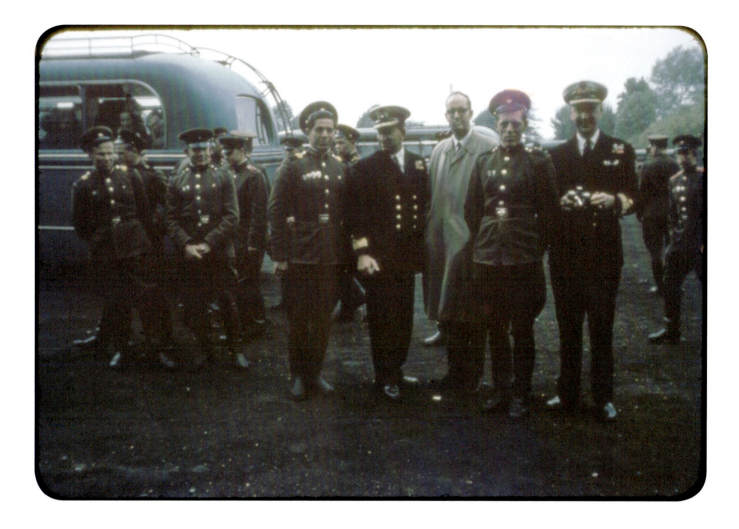

The touristic views of these monuments are impressive and interesting enough within the dynamic of a divided Berlin. But two related photographs, likely taken at the Treptower cenotaph in East Berlin, capture our attention by hinting at the possibility that East-West confrontation in this historic city was more nuanced than the rhetoric and posturing insist. These photographs are part of the duplicated set, taken in one of the monument's parking areas by Warren Langford's colleague. They show our Cold War tourists mingling with some Soviet army visitors (and possibly their spouses in the background). Group portraits are being taken to mark this encounter (fig. 77). Soviet soldiers participate freely, one standing proudly at atten-

tion, some rushing into the frame, others looking on with amusement. The session is fairly protracted and moves around. In one group portrait the buses behind the posing men are empty; in another frame different buses are filling up, and some of the women on board are struggling into position at the rear window to get their own pictures. The line reforms, with a different mix of participants posing in what is literally an east-west crossfire. More cameras on both sides are at the ready (fig. 78).

Warren Langford appears in both these photographs, grinning and smoking his pipe. This is strange territory for a supposedly well-trained Cold Warrior; here, on Soviet sanctified ground, he and his military colleagues are standing peaceably with the enemy in what seems to be a very relaxed moment for everyone. Likewise for the Soviets who are hosting this unofficial fraternization and recording it, visibly from behind and quite possibly from the front, standing shoulder to shoulder with Canadian, British, and American snapshooters. The images are obviously posed, but the occasion seems unplanned, placing it squarely in the category of "event," as opposed to "pseudo-event."[43] Images thus produced carry some credibility.

An early version of the script for the Cold War film classic based on Igor Gouzenko's defection, *The Iron Curtain* (1948), has Gouzenko's superior at the Soviet embassy in Ottawa, Colonel Nicolai Zabotin, declaring that "yesterday we were allies, today we are neighbors, tomorrow we will be enemies." These prescient remarks were assigned to different characters throughout the development of the script but never made it into the film. They were in fact Zabotin's, according to Gouzenko, who repeated them in close variations – minus the notion of "neighbours" – in the royal commission report (1946), his serialized articles in *Cosmopolitan* (1946), and his book, *This Was My Choice* (1948). The Soviet military attaché (and intelligence operative) made the prediction in his remarks to embassy staff at the end of World War II.[44] This photographic meeting in Berlin suggests the possibility that, despite the intense indoctrination, many people of the generation who had fought in World War II only partially bought into the idea that soldiers representing staunch allies during the war were now to be treated as agents of an evil empire.

But Berlin's photographic messages are mixed. Earlier the same day, the group had visited the Ida Siekmann monument, the memorial to the fifty-eight-year-old woman who on 22 August 1961 jumped from the window of her third-floor East Berlin apartment to the West Berlin sidewalk, later to die of her injuries (fig. 79).[45] The monument, which was always evolving, consisted at this point of three wooden posts strung with barbed wire. Siekmann's name and life dates were painted on a plank that had been hammered into the posts at an angle. Two memorial wreaths had been laid, one hanging below her name, the other resting on the ground,

Figure 79
West Berlin,
May 1963

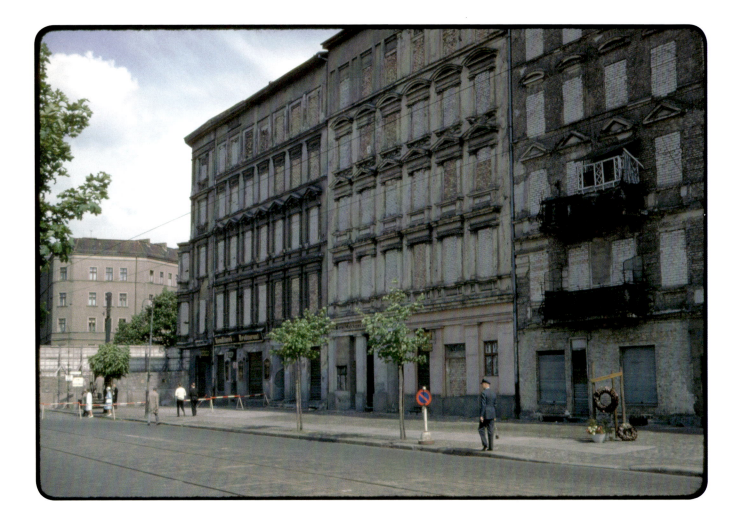

Figure 80
West Berlin,
May 1963

propped up against a post. A planter held pansies, symbols of thought or remembrance, with branches of evergreen symbolizing rebirth. Watering or holding jars were to the side, implying a communal caretaking of the monument. One of these jars had tipped over.

Warren Langford first photographs the Siekmann monument in portrait format, at medium range, including a disused wrought-iron balcony in the background. If he notices the tipped-over jar, he does not right it; he is a scrupulous documentarian. He then backs up to take in the row of bricked-up apartments and businesses, leading to the cinder-block and barbed-wire wall making a dead end of Bernauer

Strasse (fig. 80). Including Ida Siekmann's window brings a second-storey balcony into view, its homey touches of white lattice and striped canopy in sad decrepitude. This view includes several people: a colleague with his camera, walking away from the monument, and a mixed group, tourists and possibly some local residents, dressed for church, who cluster at the end of the street, having breached the cautionary barrier to get closer to the Wall. One man scales the stairway to a viewing platform; the women in their white pumps will not risk it, but gaze up from the pavement. It is a very quiet Sunday morning in Berlin.

LIFE and *National Geographic* would have prepared the Cold War tourists for a different atmosphere, each publication in its way. *LIFE*'s "Report from Berlin" cap-

tures the urgency of the moment: people are challenging the soldiers, pulling each other through holes in the fence, running for their lives. The pictures are bursting with tension and frustration, real-life situations amplified by artful composition and verbal hyperbole. The cover photograph of West Berliners straining at a barrier could easily be mistaken for a scene of containment on the other side of the Wall. The caption is no less misleading: "West Berliners Stand Their Ground," a tacit reminder of the Berlin airlift (fig. 81).

Cold War Berlin produced many canonical images made by photographers with skill, accreditation, and luck. Fortunately, our father was spared the "luck" of witnessing a failed escape or a standoff between soldiers. In quiet contrast, his pictures track the NDC itinerary, pausing on the ruins of World War II, the unfinished Wall, and its ambivalent enforcers. His slide show is infused with a melancholic dailiness, echoing the words even more than the pictures of *National Geographic*'s feature article on the divided city, published in December 1961.[46]

"Life in Walled-off West Berlin" is all about seeing for oneself in a protracted present, not measured in photojournalist's split seconds but in a documentarian's days. Bricklayers, "imported from Saxony," are observed "walling themselves in." They are so near and so impassive that the man seen from the back could be whispering to them through the grille. Likewise unhurried, possibly encouraged by the photographer, West Berliners stand close to the Wall on tiptoe as they peek over the top (fig. 82). The article vividly contrasts the vitality of West Berlin and its booming economy with the other side, "shabby, without heart or soul," much still in ruins, "another world." Photographer Volkmar Wentzel gives an account of his brush with the East German police, concluding: "Back at the Wollankstrasse checkpoint, I saw a scene that has become commonplace – people waving to others a block away, some using field glasses to see their relatives, sweethearts and friends."[47] There are numerous versions of this image taken by professional and amateur photographers in the West. They form a one-way mirror of affection. East Berliners were permitted neither to approach nor to photograph the Wall.[48]

This commonplace of West Berlin is sighted when the tour reaches the intersection of Bernauer and Ruppiner Strassen, near the site of East German soldier Conrad Schumann's famous defection – his leap over the barbed wire into the West on 15 August 1961. The NDC party arrives to find a group gathered on the corner. As if on cue, women wave their handkerchiefs; a man stares bleakly into the distance; an older man fiddles with his camera; a dog twirls at the end of its leash. Warren Langford's empathetic capture of this moment turns a local expression of yearning

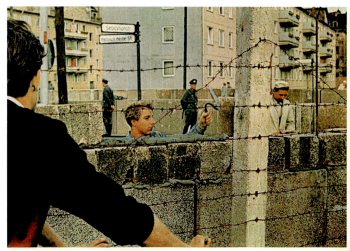

on Humboldt classes, or hold bull sessions with Commie students," Bill told us before the border was closed. "There's a little heat sometimes, but nothing rough."

More than a sixth of the Free University's students used to come from Over There, partly because the East tended until recently to offer college education only to children of workers and farmers, not to those of intellectuals. For the latter there was only the West.

Here again the East suffered a grave wound: Rarely did a graduate of the Free University go back.

When you visit the Free University, you realize that Berlin is still an international cultural center despite its painful history and its present isolation. You realize it also when you go to the concerts of the Berlin Philharmonic Orchestra.

The night before one Philharmonic concert in the Academy of Music auditorium, the rich sounds of a solo violin halted us in Manfred-von-Richthofen Strasse. In an apartment high above the quiet street, someone was practic-

ing parts of the Robert Schumann C-Major Symphony.

We knew then we would hear the work next evening, for this was a fine violinist indeed and must belong to the Philharmonic.

Sure enough, the Schumann was on the program, but we could not pick out our violinist. This great, clear, precise orchestra had a single glorious voice.

"Day of Shame" Shocks Berliners

Such was the city's normal tenor of life until last August 13, known here as "the day of shame." Overnight, without warning, the Communist East Germans sealed off the border between East and West Berlin, first with webs of barbed wire and then with a solid wall of concrete blocks.

The news burst upon Berlin like a bomb, spreading swiftly by word of mouth, by big black headlines in West Berlin's four important daily papers, and by the broadcasts of RIAS. Berliners by the thousands flocked to the barrier, some merely angry or curious,

Under Guard by Vopos, Masons Wall Themselves In

Mistrusting East Berliners, the Communists imported bricklayers from Saxony to build the barrier that stretches for 30 miles across the city. The wall divides families and friends and keeps workers from their jobs. West Berliners sometimes refer to it as "Ulbricht's Chinese wall," after East German boss Walter Ulbricht.

Standing on tiptoe near Friedrichstrasse, West Berliners try to glimpse a relative beyond the wall. Processed rubble forms the blocks. Daring Germans have escaped by crashing through such barricades in trucks.

Sealed and silent, doors and windows of this building on the border no longer open into West Berlin. A family of four and eight relatives escaped from a second-floor apartment on this very street, Bernauerstrasse, by sliding down a rope. But a woman died when she tried to leap to freedom from a third-story window. To bar escapes, the Communists made the border a no man's land of empty buildings and cleared ground.

While taking pictures such as these, GEOGRAPHIC photographer Wentzel was arrested by Vopos (page 764).

Figure 82
Nathaniel T. Kenney and Volkmar Wentzel, "Life in Walled-off West Berlin," *National Geographic*, December 1961, 762–3. Reprinted with permission.

into something infinitely protracted and universal – the broken hearts of the fractured *Family of Man* (fig. 83).

For the dark tourist, Berlin conquered and divided has become a city of vantage points. The Cold War tourist is led to see. As in Rome, certain views are musts, but unlike Rome, variations seem to be limited. Berlin's monuments are seen on a schedule, from predetermined angles. Both Warren Langford and his colleague photograph the Reichstag in ruins. Standing on the border between East and West, the building seems orphaned by the division. In a city of warnings and flags, there is nothing claiming the building – nothing save a chain-link fence to say "Keep out."

Figure 83
West Berlin,
May 1963

Figures 84 and 85
West Berlin,
May 1963

The structure as photographed is nevertheless remote and forbidding. The colleague's image is framed by foliage, suggesting that he is peeking at the monument through the brush (fig. 84). Langford achieves a more objective, timeless quality because he steps free of the natural framing surround (fig. 85). Still, for these visitors, at this historical juncture, in this political climate, there is one right place to stand to see the Reichstag, and this is it. Similarly photogenic and photo-productive, the Brandenburg Gate and the various checkpoints are devices framing fragments of the other side, pictures within pictures, with all the effects of nested memories that the *mise en abyme* implies (fig. 86).[49]

The visuality of Berlin is symbolized at every opportunity, and the rhetoric is photographic. Here again, media reports pave the Cold War tourist's way. Visiting photojournalists such as René Burri, Burt Glinn, and Walter Sanders (1961), Henri Cartier-Bresson and Raymond Depardon (1962), and Thomas Hoepker (1963) have trained the spectatorial gaze over the shoulders of citizens and tourists who seem constantly to be looking at or over the Wall. The *Time* magazine cover story on the Wall on 31 August 1962 (sparked by the public event of Peter Fechter's failed escape and protracted agonies) calls Bernauer Strasse "a standard West German tourist attraction." The same article makes reference to the faded glory of Potsdamer Platz: "Berlin's Time Square before the Wall truncated it, visiting sightseers mount wooden stands to gawk at the bare, dead city beyond. 'In one quick look,' they nod,

Figure 86
West Berlin,
May 1963

'you can see what Communism is like.'"[50] That brief passage seems almost to dictate Warren Langford's paired photographs of a freshly lettered sign and a desolate view from the adjacent platform of "what Communism is like" (figs. 87 and 88). It is grey and almost completely still, the only graphic 'sound' emanating from a two-storey pictogram painted in red, black, and white on a facing wall: a helmeted hand and the single word "HALT."

Suddenly Langford is capturing an event: sign versus sign and, on his side, *fresh* paint, encouraging spectatorial speculation that this fraction of a second on the Cold War battleground is of moment. The photographic billboard in the West, just finished, is declarative, as a monument should be, extolling pre-war, pre-Nazification prosperity and promise – not Tomorrowland but Neverland. Langford's photographs are nevertheless imbued with an acute sense of timeliness, and performatively so; that is, photographically enacted in a way that would otherwise have been impossible to describe. He does so and photographs what the combination of viewing platform and image-sign is designed to do: choreograph a highly mediated "seeing for oneself."

Following the signs, Warren Langford's photographic report implicitly contrasts the poverty and emptiness of the East with the intense economic and social interaction of the West. It is impossible to judge, at this chronological distance, whether his images represent a performative call and response or an honest attempt to describe objectively the ideological apparatus operational in Berlin. In May 1963 these photographs were doing more than reflecting Cold War mythology and propaganda. For two years, not only had East Germans been denied access to jobs and relatives in the West, but West Germans had also been forbidden by their government to cross into East Berlin. Until this latter ban was lifted in late 1963, the Wall really did completely isolate East from West Berlin, both affectively and economically. It was this isolation and the end of emigration by its most talented citizens that, paradoxically, allowed the East German economy to begin a partial recovery and over time put the lie to pictures which contrasted barren streets in the East with vibrant activity in the West.

As for the armed camp that was Berlin, our Cold War tourists cannot have known in the spring of 1963 whether they were witnesses to circumstances that would provoke even more serious superpower confrontations or open the door to better relations between East and West. In fact, the latter was the case. Once the Wall went up, the Soviets stopped pushing for the long-delayed German peace treaty, thus securing West Berlin under the protection of the Western occupying powers for the fore-

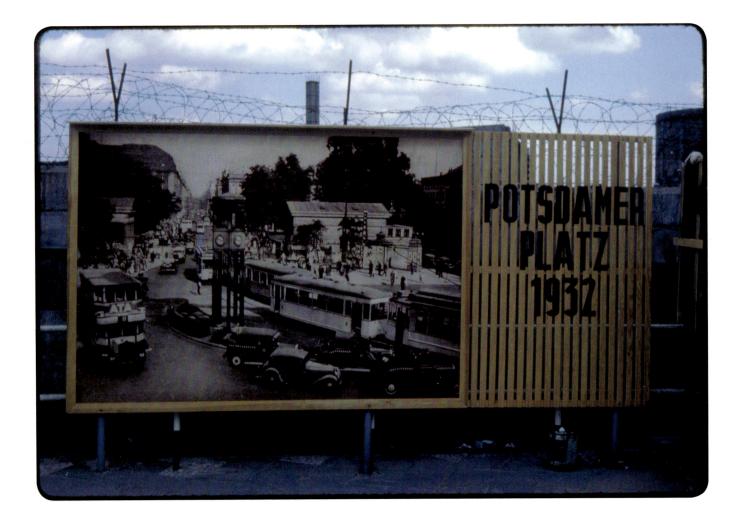

Figure 87
West Berlin,
May 1963

Figure 88
View of East Berlin,
May 1963

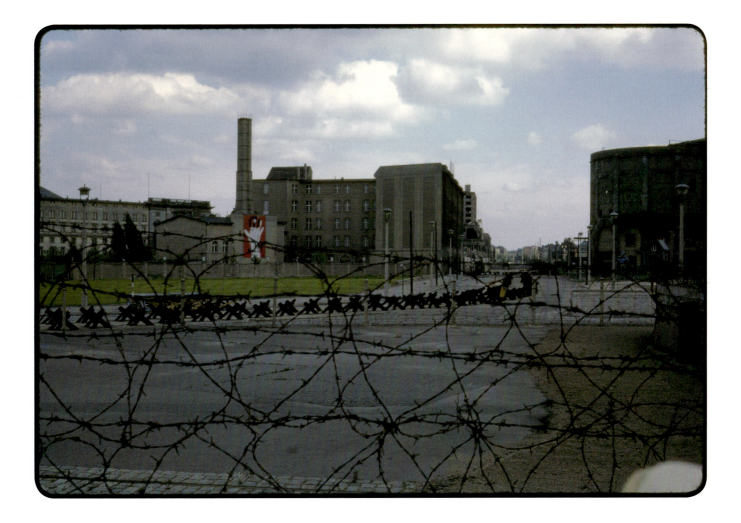

A Cold War Tourist and His Camera

seeable future. President Kennedy calmed West German government fears about long-term US backing with his famous declaration of support for West Berliners in June 1963 and the commitment of a quarter of a million troops to Europe. This commitment in turn damped down West German demands for nuclear weapons. The first significant signs of what would later become known as détente between the superpowers appeared shortly after our Cold War tourist went home. Chastened by the Cuban Missile Crisis and hoping to avoid another round of destructive nuclear weapons testing, the United States, the Soviet Union, and Britain signed a limited test-ban treaty in August 1963. They also began to focus more decisively on a nuclear non-proliferation treaty (eventually completed in 1968) designed to lower the risk of nuclear escalation and confrontation. These initiatives, combined with the much less bellicose approach toward East Germany and other Warsaw Pact countries taken by Willy Brandt when he became German chancellor in 1969, did much to stabilize the Cold War in Europe until it evaporated with the demolition of the Wall in 1989 and the collapse of the Warsaw Pact and the Soviet Union in 1991.

Lights!

CONCLUSION

Warren Langford's images belong to a growing field of photographic investigation called 'the vernacular'; these are product and producers of everyday photographic experience. In this brief examination of a very modest body of work, we have urged the reader to consider such experience in the broadest possible terms. Photographic experience includes, but is not limited to, the multiple perspectives of those photographing, those being photographed, and those watching the photographic act take place. It also includes the backstories of those individuals and institutions that have created or allowed photographic opportunities to occur. Add to these elements the life of the photograph, which is constituted by incalculable variations on photographic dissemination in the seeing, describing, remembering, and misremembering (or reimagining) of the image by a host of contributors. Photographic experience also includes photographic culture, its protocols, and its ethics: situations are coloured by the way they do or do not lend themselves to be photographed. Those that do not have to be remembered in other ways. Invisibilities and potentialities are writ large in contemporary photographic theory; in this aspect alone, analogies with Cold War theory are striking. There is at least, in Wittgensteinian terms, a family resemblance.

Taken at face value, these photographic objects pose the question of their very existence. How did they come into being? Their form and content suggest that

Warren Langford was encouraged by the political rhetoric of National Defence College training and the cultural rhetoric of mass-media publications, tutored and egged on by colleagues to take pictures that marked his passage as a Canadian official on the rise, *seeing things plain, seeing the other for himself.* There are great gaps in his photographic record, and one can only speculate on his reasons for not photographing: decorum, shyness, incompetence, forgetfulness, a greater devotion to his pipe – any one of these factors might have kept his production in check. But when he played the photographer, he played it to the hilt. The resultant images perform both work and tourism, belonging strictly to neither. They are strung between categorical poles: private and public, spontaneous and rehearsed, particular and universal. As work, they are opened up by contextual analysis of Canadian diplomatic and military objectives and the country's relations within the Commonwealth and with its neighbour to the south and Europe. As leisure activity, they break into categories identified by John Taylor in his *A Dream of England* as touristic modes: the traveller's gaze, the tourist's glance, and the day tripper's blink.[1] These ways of seeing are founded in historical patterns and class distinctions. They take the measure of place with both real and fanciful yardsticks.[2] They express degrees of comfort in the presence of strangers, as well as power relations in places other than one's own. There are similar patterns and distinctions in Warren Langford's photographs, evoking both the professional ladder that he was climbing and Canada's colonial ascent through its participation in the Cold War. There is more than photographic mimicry in our Cold War tourist's behaviour.

Examining these images and reconstructing their motives from two disciplinary perspectives has been illuminating, in terms of both public histories and private memories. Snapshot photography poses interesting challenges: its modest intentions, limited audience, formulaic style, and technical incompetence make it somehow authentic and oddly authoritative. We have tried to resist such primitivist notions, seeing these photographs as showings and tellings from the maker's constantly shifting subject positions. The discourse of the Cold War relishes both information and disinformation, events and pseudo-events, as well as the in-betweens of false things taken as truths, truths unrecognized, or, within a group of images, uncomfortable truths unphotographed and therefore suppressed. These pictures are no different. They are freighted with the conventions of their times, social, political, and visual. For us, the children of the photographer, they constitute an intergenerational transmission of knowledge about the Cold War that is naive, partial, sometimes laughable, sometimes terrifying, deeply flawed, and fundamentally true

to the experiences and ambitions of one Cold War traveller. Unpacking this kind of photographic baggage is the cultural work that we have inherited.

Our preparation for this work has often struck us as oddly preordained. In 1962–63 John Langford was already sensitive to his father's views on international affairs, as he was then studying government and international politics at Carleton University. He formed a picture of his father then. Even at the height of the East-West confrontation in the 1950s, Warren Langford was never a bombastic Cold Warrior, and the NDC did not turn him into one. But the year of courses and briefings at the college and the two major tours of various Cold War sites in North America, Africa, and Europe had a strong impact on him. This immersion did not appear to alter his fundamental beliefs about the Cold War or his attitudes toward the various participants and their policies. But it did strengthen his confidence in his own orthodox views by providing him with an enormous amount of 'insider' information and analysis to support them. He suddenly found it easy to respond to skeptical questions about the international ambitions of the Soviet Union and rebut undergraduate arguments about the one-dimensional nature of US foreign and defence policy and the slavish adherence of Canada to the policies of the US-led anti-Communist alliance. Our father was no fanatic, but in our memories, very little of the wider dimension of the things that he heard, saw, wrote about, and photographed during this year rose above the noise level of the Cold War symbols and ideology within which the year was essentially packaged. He was a man of his time.

From Martha Langford's photographic perspective, a particularly interesting aspect of this little private collection is the number of languages that it speaks with sufficient fluency to prompt memories of public images. These Kodachrome copies domesticate a host of public photographies. As trans-parent images (the pun is intentional), they offer her what her parent intended – a transparent view of things that he had been privileged to witness "on the spot." Retakes of public photographs, they prove such pictures to be true because readily obtainable whenever and wherever human beings, animals, or territories are placed under certain kinds of stress. As a child, Martha had her father's *picture* on this, and she still does.

Notes

INTRODUCTION

1 Atkinson, *The Edge of War*, 125. Published in 1960 and listed in the National Defence College reading list, *The Edge of War* argues for replacing the term 'cold war' with "unconventional warfare," introducing the "new pattern of neither peace nor war" as "a sort of ill-defined grey amorphous state," which Atkinson goes on painstakingly to define (123–207). His understanding of Marxist theory and militarism draws on William Kintner, *The Front Is Everywhere: Militant Communism in Action* (1950). Kintner was a National Defence College lecturer. See also Lindsay, "Unconventional Warfare."

2 'Duck and cover,' an exercise designed to train schoolchildren to hide under their desks in case of nuclear attack, was an American phenomenon. The so-called Kitchen Debate occurred in Moscow, between Soviet premier Nikita Khrushchev and then US vice-president Richard Nixon. For a compendium of Canadian canonic images, see Whitaker and Hewitt, *Canada and the Cold War*.

3 Recent books and exhibition catalogues include Cummings, *Cold War Radio*; Jenks, *British Propaganda and News Media in the Cold War*; Masey and Morgan, *Cold War Confrontations*; Shaw, *Hollywood's Cold War*; Crowley et al., *Posters of the Cold War*; Crowley, Pavitt, et al., *Cold War Modern*; and Pavitt et al., *Fear and Fashion in the Cold War*. Kuffert's *A Great Duty* connects Cold War anxiety, Canadian culture, and its institutionalization. See also references to Cavell, *Love, Hate, and Fear in Canada's Cold War*, and Field, *American Cold War Culture*.

4 Such binaries structure the literature. See Whitaker and Hewitt, *Canada and the Cold War*, 6; Field, *American Cold War Culture*, 1–13.

5 Cuban émigré cartoonist Antonio Prohias's *Spy vs Spy* was launched in January 1961 in *Mad Magazine*. Aircraft manufacturer Canadair's mid-fifties Canadian advertising campaign asking, "Do we really know where to face Communism?"

and responding photographically in the negative is examined by James Opp in "Picturing Communism."

6 This list follows background notes published by the NDC in its *National Defence College*. The college's list of comparable institutions includes the Imperial Defence College in London (1927), the National War College in Washington (1946), the Institute for Advanced National Defense Studies (HEDN) in Paris (1949), the National Defense College in Tokyo (renamed in 1954, having evolved from the National Safety College, founded in 1952), and the National Defence College in New Delhi (1960).

7 Representatives of the Onondagas, the Mohawks, the Oneidas, the Cayugas, and the Senecas met with Count Frontenac, newly appointed governor and lieutenant-general of New France, in early July 1673. See Preston and Lamontagne, *Royal Fort Frontenac*, 17–27.

8 This brief history draws on the college's published account of 1967, supplemented by information on the First Nations kindly supplied by Brian S. Osborne and Jeff Thomas in correspondence, 4 October 2009.

9 NDC, *National Defence College*, unpaginated.

10 LAC, RG24-B-8, 1997–98/273, box 4, NDC, "Background, Purpose and Outline of Course," 24 May 1962.

11 LAC, RG25 9918-A-40, vol. 14, 1 September 1960–19 October 1962, NDC, "Some Points to Note in Selection of Candidates," 7 March 1960.

12 LAC, RG24-F-1, vol. 23960, part 1, file 586-36/1, Defence Research Board of Canada file, NDC, "Some Points to Note in the Selection of Candidates," undated.

13 The various branches of the armed forces in Canada, Britain, and the United States were given a set number of places to fill, the quotas varying from year to year.

14 Secretary of State was then charged with all aspects of Canadian culture, a responsibility later transferred to the Department of Communications. Warren Langford was part of that reorganization.

15 Interview with Richard C. Stovel, conducted by John Langford, Victoria, 30 September 2009.

16 LAC, RG24-B-8, 1997–98/273, box 4, "National Defence College, Course XVI – 1962/63, Minutes of DS Meeting No. 16/62–63," 5 March 1963.

17 LAC, RG25 9918-A-40, vol. 14, 1 September 1960–19 October 1962, "National Defence College," typescript of article apparently written by W.T. Warden and approved for publication by the chairman, Chiefs of Staff, and the NDC commandant in the February 1962 issue of *External Affairs Monthly Bulletin*, February 1962.

18 LAC, RG24-B-8, 1997–98/273, box 4, NDC, "Background, Purpose and Outline of Course," 24 May 1962..

19 The camera purchased by Warren Langford was manufactured in the early sixties by Aires Camera Company of Tokyo, a firm soon after extinguished during the intense competition between Japanese companies. For a history of the Aires, see Massimo Bertacchi, "Aires Cameras," http://corsopolaris.net/supercameras/aires/aires.html; posted 6 April 2006. The Aires Viscount M2.8 camera had a 45 mm lens, slightly wider than "normal," and a rather misleading viewfinder that promised more around the edges than it could deliver. Anscochrome was a German slide film, introduced by Agfa during World War II. It was advertised as faster and more subtle than Kodachrome. Another distinct advantage of Anscochrome stock was that it could be processed by any lab. Our father's use of the Aires camera, rather than the ascendant Nikon, and the presence of Anscochrome slides in his photographic hoard have the added advantage of discouraging

anachronistic references to Paul Simon's catchy song "Kodachrome," released 1973.

20 Interview with Richard C. Stovel, Victoria, 30 September 2009.

21 Barthes, *Camera Lucida*; Batchen, "Vernacular Photographies"; Berger, "Uses of Photography"; Bourdieu, *Un Art moyen*; Edwards, *Raw Histories*; Edwards and Hart, eds., *Photographs, Objects, Histories*; Hirsch, *Family Frames* and her edited collection, *The Familial Gaze*; Kuhn, *Family Secrets*; Lamoureux, "L'Album"; O'Brian, "Memory Flash Points"; Simon, ed. *The Zone of Conventional Practice*; Spence and Holland, *Family Snaps*.

22 A primer on photographic formalism is Szarkowski's *The Photographer's Eye*. See also Clement Greenberg, "The Camera's Glass Eye: Review of an Exhibition of Edward Weston," in Greenberg, *Clement Greenberg*, 2: 60–3. Greenberg's comments on the "anecdote" are especially pertinent here. A distinction between artistic culture and photographic culture, as represented by "vernacular, journalistic, or commercial modes," is noted by Kozloff in his *Photography & Fascination*, 124. Basic texts illuminating photographic experience from a Marxist perspective include Buchloh and Wilkie, eds., *Mining Photographs and Other Pictures*; Burgin, ed., *Thinking Photography*; Sekula, *Photography against the Grain*; and Tagg, *The Burden of Representation*. Feminist photographic readings include Hirsch, Kuhn, Martin, Spence, and others listed above, as well as interdisciplinary studies in Close, *Framing Identity*; Wexler, *Tender Violence*; and Williams, *Framing the West*. A psychoanalytical approach to Canadian photography is proposed by Cousineau-Levine in *Faking Death*. To sample the vast literature of subsequent shifts relevant to our discussion, see Rorty, ed., *The Linguistic Turn*; Radstone, ed., *Memory and Methodology*; and Stewart, *On Longing*.

23 Marshall McLuhan, *The Mechanical Bride* (1951). McLuhan's instant notoriety and desirability on the lecture circuit are evidenced in two clippings from Toronto's *Globe and Mail*. His book was unfavourably reviewed by William Arthur Deacon, who begins his review by stating, "Exposures of the appeal of advertising to immature minds is [*sic*] no new thing." The "Social and Personal Notes" column of 12 December 1951 announced that the author of *The Mechanical Bride* would be the special guest and speaker at the Toronto Women's Press Club luncheon. Boorstin's *The Image* (originally published in 1962 under the title *The Image, or What Happened to the American Dream*) was widely reviewed, and little more than a year later, his ideas had sufficiently taken hold to be adapted by Richard R. Rovere for his report on President Kennedy's trip to Europe, an itinerary that included Berlin. See Rovere, "Journal of a Pseudo-event."

24 Boorstin, *The Image*, 109.

25 Jenkins, "Photography and Travel Brochures," 107–8. Albers and James, in "Travel Photography," upgrade this concept to a "hermeneutic circle" (136). There is ample anecdotal and scientific evidence that tourists enjoy taking photographs of places they have already seen in pictures, sometimes inserting themselves or their companions into the iconic view as a form of proof that they were "there."

26 Albers and James, "Travel Photography," 145.

27 Baer, *Spectral Evidence*, 8.

28 Albers and James, "Travel Photography," 145.

29 Burke, "Overture: The New History: Its Past and its Future," in his edited collection, *New Perspectives on Historical Writing*, 6–7.

30 The term 'history from below,' a historical framework for the excavation of ordinary people's

experience, is explained by Jim Sharpe in Burke, *New Perspectives on Historical Writing*, 25–42. In terms of popular visual culture, the work of British historian Raphael Samuel is considered foundational. See Burke, *Eyewitnessing*, 9–13, for a survey of the "pictorial turn," W.J.T. Mitchell's term for the emergence of visual culture studies.

31 Studies of tourism and photography include Osborne, *Travelling Light*; Robinson and Picard, eds., *The Framed World*; and Urry, *The Tourist Gaze*.

32 Constructions and contemporary uses of the "colonial archive" are explored by Pinney and Peterson, *Photography's Other Histories*.

33 Key post-colonial readings, in relation to this project, include Bhabha, "Signs Taken for Wonders" (1985) and "Of Mimicry and Man" (1987), both in his *Location of Culture*; McClintock, *Imperial Leather*; and Phillips and Steiner, eds., *Unpacking Culture*.

34 *Archive Fever: Uses of the Document in Contemporary Art*, organized by Okwui Enwezor for the International Center of Photography, New York, 18 January 2008–4 May 2008. For a critical perspective on appropriative strategies, see Langford, "Strange Bedfellows."

35 For this analysis of the flow of Cold War scholarship, we have drawn on White, "Cold War Historiography."

36 These writers include Kennan (publishing anonymously as "X"), "The Sources of Soviet Conduct"; McNeill, *America, Britain and Russia*; and Herz, *Beginnings of the Cold War*.

37 See, for example, Lafeber, *America, Russia and the Cold War*.

38 A good example is Gaddis, *The United States and the Origins of the Cold War, 1941–1947*.

39 Fukuyama, *The End of History and the Last Man*; Powalski, *The Cold War*; Gaddis, *The Cold War*.

40 This conversational approach to family photographs builds on Martha Langford's previous work on the oral-photographic framework, as developed in *Suspended Conversations*, "An Excursion into the Amateur Grotesque," and "Speaking the Album."

41 Based on a conversation between Warren Langford and Martha Langford in late August 1997.

42 Kennan, "The Sources of Soviet Conduct"; Field, "Introduction," in *American Cold War Culture*, 2–3.

43 Bothwell, *The Big Chill*, 25–7.

44 Albright and Kunstell, *Bombshell*.

45 See Thompson, *The Hawk and the Dove*. And for precious insights into efforts by behavioural psychologists to get into the Cold War game, see Dunlap, "Psychologists and the Cold War"; Price, "Applying Wargaming to the Cold War"; Waskow, "Civil Defense, Democracy, and the Self-Destroying Prophecy"; and (saving the best for last) Burg, "Sex and Statism in Russia."

46 Whitaker, "'We Know They're There,'" 45. Cavell's edited collection, *Love, Hate, and Fear in Canada's Cold War*, in which Whitaker's essay appears, explores Canadian Cold War "cultural production" in relation to Britain and the United States. See also Field, ed., *American Cold War Culture*; Cobb, *Native Activism in Cold War America*; and Saunders, *Who Paid the Piper?*

47 Knight, *How the Cold War Began*, 98–150. The Gouzenko defection was also culturally productive, inspiring the film that Daniel J. Leab calls "Hollywood's first shot in the Cold War," *The Iron Curtain* (William A. Wellman, 1948). See Leab, "'The Iron Curtain' (1948)."

48 Wenger, *Living with Peril*, especially chapter 3; and Bloomfield, Clemens, and Griffiths, *Khrushchev and the Arms Race*, especially parts 1 and 2.

49 Phayer, *Pius XII, the Holocaust, and the Cold War*, especially chapter 6.

50 LAC, RG25 9918-A-40, vol. 14, 1 September 1960–19 October 1962, NDC, "Some Points to Note in the Selection of Candidates," 7 March 1960.

51 Simpson, "New Ways of Thinking about Nuclear Weapons and Canada's Defence Policy."

52 LAC, RG24-B-8, 1997–98/273, box 4, NDC, Syndicate No. 5, "The Western Alliance: NATO – How Goes NATO?" 5 November 1962, 1.

53 Defence spending absorbed 21 per cent of the federal budget in 1963. See Royal Military College, *Report 2*, 52.

54 In 1963 it was estimated that the RCMP's Directorate of Security and Intelligence had five hundred employees. See Kinsman and Gentile, *The Canadian War on Queers*, 158

55 See Lyon, *Canada in World Affairs, 1961–1963*, for a full contemporary account of contending political and bureaucratic attitudes toward the relationship with the United States.

56 See Conant, *The Long Polar Watch*.

57 Such ideas received a momentary setback – again at the political level – when Walter Gordon was named finance minister in the new Liberal government in April 1963. See Anastakis, *Auto Pact*, chapter 2; and Azzi, *Walter Gordon and the Rise of Canadian Nationalism*, especially chapter 4.

58 Canada, Royal Commission on Aboriginal Peoples, *Report*, 1: 55 and 67.

59 See Spicer, *The Samaritan State*; and Morrison, *Aid and Ebb Tide*.

60 See Johnson, *The Lavender Scare*; and Robinson and Kimmel, "The Queer Career of Homosexual Security Vetting in Cold War Canada." The chilling effect on freedom of expression in Canada and its nation-building cultural agencies, a "censorship-intelligence-propaganda complex" fuelled by Cold War paranoia, is examined in Kristmanson, *Plateaus of Freedom*.

61 Whitaker, "Cold War Alchemy."

62 LAC, RG25 9918-A-40, vol. 14, 1 September 1960–19 October 1962, J.B.C. Watkins, "The National Defence College," memorandum to the undersecretary of state for External Affairs, 18 July 1961. John Watkins had been ambassador to

the Soviet Union, where he had been the object of a failed KGB homosexual blackmail scheme. He was cleared by the RCMP of any wrongdoing, but died in 1964 while being interrogated by the RCMP in a Montreal-area hotel. See the introduction by Beeby and Kaplan in Watkins, *Moscow Despatches*.

63 LAC, RG24-F-1, vol. 23960, Part 1, file 586-36/1, "The National Defence College – A Reappraisal," 1. The authors of this report, dated 17 July 1967, were members of Course Twenty.

64 More skeptical views were expressed by Prime Minister Diefenbaker, Howard Green, the secretary of state for External Affairs, and his close bureaucratic advisers Norman Robertson and George Ignatieff. See Simpson, *NATO and the Bomb*, chapter 5.

65 Revisionist views were put forward by journalists, however. See Minifie, *Peacemaker or Powdermonkey*.

66 Lyon, "Problems of Canadian Independence," 250.

67 Rostow, "The Third Round," 9.

68 Saxon, "W.R. Kintner, 81, Dies."

69 A critical assessment of Lasswell as progenitor of the US military-academic-industrial complex is offered by Robin, *The Making of the Cold War Enemy*, here cited from page 64.

70 See Stairs, "Intellectual on Watch," 223–4; and Eayrs, *Northern Approaches* and *Canada in World Affairs*.

71 The text in Bromke's Carleton course was a later edition of the Cold Warrior's *realpolitik* classic *Politics among Nations,* by Hans J. Morgenthau.

72 Sutherland, "Canada's Long Term Strategic Situation."

73 LAC, RG25 9918-A-40, vol. 14, 1 September 1960–19 October 1962, J.B.C. Watkins, "The National Defence College," memorandum to the undersecretary of state for External Affairs, 18 July 1961.

74 Ibid. Holmes elaborates the necessity for Canadians to adopt more mature and complex approaches to international affairs in "Canada and the United States in World Politics" and "Canada in Search of Its Role," both published in *Foreign Affairs*. Wry, somewhat snobbish humour enlivens the first piece: "The fact that we worship at the same supermarkets leads to unwarranted conclusions about the identity of our political lives" (108). Canada is a young middle power, he argues, whose greatest strides toward adulthood have been made through diplomacy.

75 Interview with Richard C. Stovel, Victoria, 30 September 2009.

76 LAC, RG24-B-8, 1997–98/273, box 4, NDC, "National Defence College Overseas Tour: Personal Information Brochures," 20 November 1962.

77 Anthropologist Richard Chalfen reports some rare instances of "extreme restriction," specifically citing prohibitions on photography in Cairo. See Chalfen, "Photography's Role in Tourism," 443. We return to this point in chapter 2.

78 Slides of later trips, still in our father's trays, corroborate this impression. They are generally loaded in numerical order.

79 Urry, *The Tourist Gaze*, was first published in 1990. This study refers to the second edition of 2002.

80 Lanfant, "The Purloined Eye." See also Jenkins, "Photography and Travel Brochures," 309–11.

81 Carol Crawshaw and John Urry, "Tourism and the Photographic Eye," in Rojek and Urry, eds., *Touring Cultures*, 176–95; citation, 184.

82 Leiper, "An Etymology of 'Tourism,'" 277. Leiper traces both neutral and pejorative usages of the word, while speculating on its derivation from a sixteenth-century French family's monopoly on English travellers' arrangements on the Continent. The English word 'tourist' might have referred to the de la Tour family, just as nineteenth-century clients of Thomas Cook were derisively called "Cookites."

83 Chalfen, "Photography's Role in Tourism," 437; Jenkins, "Photography and Travel Brochures," 315; citation from Urry, *The Tourist Gaze*, 3.

84 MacCannell, *The Tourist*, 57–76, 91–107. Urry's concise review of theoretical approaches to the study of tourism in *The Tourist Gaze*, 7–15, includes MacCannell's *The Tourist*, whose application of Erving Goffman's *Presentation of Self in Everyday Life* (1956) bolsters an attack on Boorstin's critique of tourism as a "pseudo-event." In *The Image* Boorstin expresses particular disdain for photography's shaping of tourist attractions (108–9) and for the "environmental bubble" of American-style international hotels (98–9). We will enter that bubble in chapter 3 when our tourists register at the Cairo Hilton.

85 Culler, "The Semiotics of Tourism," 155, 159.

86 Bruner, "Transformation of Self in Tourism," 248. See also Graburn, "The Anthropology of Tourism."

87 Bruner, "Transformation of Self in Tourism," 243–4.

88 See, for example, Albers and James, "Tourism and the Changing Photographic Image of the Great Lakes Indian," and Mellinger, "Toward a Critical Analysis of Tourism Representations."

89 Chalfen, citing Willis A. Sutton Jr's *Travel and Understanding: Notes on the Social Structure of Tourism* (1967), introduces the possibility of "encounters" and "interactions," though he refrains from siding with either Boorstin or MacCannell, tactfully suggesting that there are "different types of tourists." See Chalfen, "Photography's Role in Tourism," 437–9.

90 Urry's definition is a useful starting point for visual analysis based on intended function rather than form, but it can never hold, as photographic travelogues are frequently multi-purpose documents, or documents easily repurposed by makers

and their audiences. See, for example, Langford's "An Engineer's Progress" in *Suspended Conversations*, 83–8. Colonial and missionary albums are also fascinating as they oscillate between realms and functions. See Murray, "Frocks and Bangles." A related concept is explored in Cohen and Manspeizer, "The Accidental Tourist."

91 Horner, "Tourist Arts in Africa before Tourism," 59.

92 Towner, "The Grand Tour."

93 LAC, RG24-B-8, 1997–98/273, box 4, Weston, ed., "It was said on Course Sixteen (Lines from the NDC Line Book collected, edited, refined and expurgated by Group Commodore Ralph Weston). Trip Lines: Afro-European Division."

94 Morin, *The Cinema*, 18–19. This theme is later taken up by Susan Sontag in *On Photography*, 8–10.

95 Lanfant's phenomenological enrichment of Urry's concept into a complex encounter between "gazer" and "gazed-upon," complicated by speculations on the understandings and expectations of subjects on both sides of the camera, as well as the subjects formed by encounter with the photographic object, is illustrated by this corpus. See Lanfant, "The Purloined Eye."

96 Warren Langford was forty-three on joining, and he celebrated his forty-fourth birthday on 12 March 1963, just prior to the Overseas Tour.

97 LAC, RG24-B-8, 1997–98/273, box 4, Major General C.B. Ware, commandant, NDC, letter to undersecretary of state for External Affairs, 6 December 1962.

98 Ibid. An appended list of points to be considered is short on specifics about these sorts of excursions. The closest in kind is a request for briefings from Canadians associated with aid programs – another form of Western industry, to be sure.

99 National Gallery of Canada, "Exhibitions 1950–1959." The National Gallery hosted other touring photographic exhibitions in the late 1950s that might have heightened Warren Langford's appreciation, but we can recall no mention. See Kunard, "The Role of Photography Exhibitions at the National Gallery of Canada (1934–1960)," 48.

100 Barthes, "The Great Family of Man," in his *Mythologies*, 100–2. For a fairly balanced review of responses to *The Family of Man*, see Berlier, "*The Family of Man*."

101 Lutz and Collins, *Reading National Geographic*, 24, 28–9.

102 Ibid., 59, 60. The authors' comparison between decisive and random moments draws on Susan Moeller, *Shooting War: Photography and the American Experience of Combat* (1989).

103 Moore, "Progress and Pageantry in Changing Nigeria."

104 Photographs taken by W. Robert Moore, then chief of the Foreign Editorial Staff, *National Geographic*, are subtly combined with images of the British royal tour taken on assignment to *National Geographic* by Brian Brake of Magnum, stock photographs credited to George Rodger (Magnum) and Camera Press-Pix, and a picture by another "Cold War tourist," J. Wayne Fredericks, then deputy assistant secretary of state for African affairs in the US State Department. See Herskovits, "Remembrance: J. Wayne Fredericks," 23 August 2004.

105 Elisofon and *LIFE* staff, "The Hopeful Launching of a Proud and Free Nigeria,"

106 Hariman and Lucaites, *No Caption Needed*, 5–7.

107 Lutz and Collins, *Reading National Geographic*, 33–4. See also Bryan, *The National Geographic Society*.

108 Hutchison and Fletcher, "Exploring Ottawa," 566, 568.

109 LAC, RG25 9918-E-40, vol. 19, March 1963– 23 July 1963, "NDC Visit to Berlin – Question of Publicity," memorandum from K.B. Williamson,

Canadian Military Mission, Berlin, to undersecretary of state for External Affairs, 30 April 1963.

110 The term "dark tourism," coined by Foley and Lennon, captures the presentation and consumption of sites made famous by death or disaster. Their work characterizes such newsworthy sites and explains their transformation into tourist destinations. "Thanatourism," as defined by Seaton in "Guided by the Dark," is a pattern of human behaviour driven by the desire to travel to and experience places of individual or mass death, whether through visitation of sites and monuments or through spectacles such as public executions or theatrical forms of re-enactment. The concurrent development of these theories (circa 1996) is traced by Richard Sharpley in Sharpley and Stone, eds., *The Darker Side of Travel*, 3–22. Key titles by Foley and Lennon, Lennon and Foley, Seaton, and Stone and Sharpley are listed in the bibliography.

111 Foley and Lennon, "The Spectacularization of Dark Tourism," 211.

CHAPTER ONE

1 LAC, RG24-B-8, 1997–98/273, box 4, NDC, "North American Tour Problem," 2 January 1963.

2 Ibid., R.T.B. (Colonel R.T. Bennett), "'Twas the Week before Christmas," December 1962.

3 The parallel had already been made by *Globe and Mail* editorial cartoonist Jack Boothe as a response to the bombing of Hiroshima. His cartoon entitled "Avenging Genii" was published on 9 August 1945. It is reproduced in Teigrob, *Warming Up to the Cold War*, following page 120.

4 LAC, RG24-B-8, 1997–98/273, box 4, "The Role of the Army in National Survival," produced at Army Headquarters, Ottawa, September 1962, bemoaned the "apathy and defeatism in respect of civil defence" and, criticizing Neville (*sic*) Shute's

novel *On the Beach* (1957) for spreading "incorrect information," concluded that fallout shelters "could save millions of lives in Canada alone," while "adequate plans" and "a disciplined rescue force" could save hundreds of thousands more (13).

5 Ibid., Weston, ed., "It was said on Course Sixteen," both "Lecture Lines" dated 8 January 1963.

6 Ibid., NDC, "North American Tour Problem," 2 January 1963.

7 The agreement to integrate US and Canadian continental air defence forces under the joint command of both countries was announced in 1957. NORAD became the North American Aerospace Defense Command in 1981, reflecting the focus on attack by missiles rather than bombers.

8 See Maloney, *Learning to Love the Bomb*, 271.

9 When they were eventually equipped with nuclear weapons, the Bomarcs were under the joint control of Canada and the United States. The AIR-2A Genie nuclear air-to-air rockets for the Voodoos were held by US detachments at Canadian air bases, to be fitted to the aircraft for use if need arose. Similar arrangements were established for the battlefield nuclear missiles and nuclear bombs for Canadian ground and air forces in Europe. For a comprehensive analysis of this issue, see Jockel, *Canada in NORAD, 1957–2007*, especially chapters 1 and 2. For a sense of the practical uncertainties that surrounded some of these sharing arrangements, see Trachtenberg, *A Constructed Peace*, especially chapters 5 and 6.

10 LAC, RG24-B-8, 1997–98/273, box 4, NDC, Syndicate No. 5, "The Western Alliance: NATO – How Goes NATO?" 5 November 1962, 9.

11 Ibid., Weston, ed., "It was said on Course Sixteen (Lines from the NDC Line Book collected, edited, refined and expurgated by Group Commodore Ralph Weston). Trip Lines – North American

Division." The comment is attributed to Keith Butler of the British Foreign Office.

12 History and Heritage of Canada's Air Force, "Avro Canada Canuck CF-100."

13 "de Havilland Comet."

14 Card posted at Edmonton, 20 January 1963.

15 Taylor, "Exploring Northern Skies."

16 LAC, RG24-B-8, 1997–98/273, box 4, NDC, "North American Tour Problem," 2.

17 "Imperial Landscape" is the title of W.J.T. Mitchell's essay in his influential collection *Landscape and Power*, 5–34.

18 Glenn Gould, "To Kitty Gvozdeva, September 6, 1965," in Roberts and Guertin, eds., *Glenn Gould*, 80–3.

19 Mowat, *Lost in the Barrens*.

20 Grace, *Canada and the Idea of North*, 16; Mitchell, *Landscape and Power*, 1–4.

21 For an in-depth study of the influence of northern experience, real and imagined, on the Canadian psyche, see Hulan, *Northern Experience and the Myths of Canadian Culture*.

22 Michael Goodyear, executive director, Churchill Northern Studies Centre, was immensely helpful in establishing the exact location of the Churchill pictures.

23 Taylor, "Exploring Northern Skies."

24 This effect may be somewhat exaggerated by fading; Anscochrome stock is noted for this problem.

25 LAC, RG24-B-8, 1997–98/273, box 4, NDC, "North American Tour Problem," 2.

26 One forty-nine-year-old Inuit man, pondering the RCMP's extermination of the dogs, wondered if the Inuit people would be next. See Yatsushiro, "The Changing Eskimo," 22. For a contemporary analysis of the technology's impoverishment of pre-industrialized societies, as exemplified by the "Eskimo," see Mead, "The Underdeveloped and the Overdeveloped," 79–80.

27 Lutz and Collins, *Reading National Geographic*, 110–11.

28 Hulan, "Literary Field Notes"; see also van Wyck, "An Emphatic Geography."

29 Harrington, *The Face of the Arctic* and *The Inuit: Life as It Was*.

30 OMI Information, "FRANCE: 'Pôle et tropiques' Closes."

31 Lord, "The Silent Eloquence of Things," 206.

32 Harrington, *The Face of the Arctic*, 166.

33 LAC, RG24-B-8, 1997–98/273, box 4, NDC, "North American Tour Problem," 1.

34 Coates, Lackenbauer, Morrison, and Poelzer, *Arctic Front*, 66.

35 The Broadmoor's archivist, Beth Davis, solved the mystery of this photograph.

36 Warren Langford, card postmarked Colorado Springs, 23 January 1963.

37 The Voodoos had been "previously driven" by US National Guard units. See Morton, *A Military History of Canada*, 244.

38 See Lyon, *Canada in World Affairs*, 530.

39 See Orvik, "The Basic Issue in Canadian National Security."

40 See Sutherland, "Canada's Long Term Strategic Situation."

41 LAC, RG24-B-8, 1997–98/273, box 4, Weston, ed., "It was said on Course Sixteen (Lines from the NDC Line Book collected, edited, refined and expurgated by Group Commodore Ralph Weston). Trip Lines: North American Division."

CHAPTER TWO

1 LAC, RG24-B-8, 1997–98/273, box 4, NDC, "Confidential Aide Memoire: Aircraft – Overseas Tour," 13 September 1962.

2 Ibid., "The case for NDC Visits to Africa," section
II of internal briefing note prepared by NDC direc-
tion and inscribed: "Notes for Commandant prior
to, and for any meeting which CCOS may call.
15 Sep. 62." Section I is entitled "The Case for a
West-about Tour including Japan."

3 Ibid., NDC, "Confidential Aide Memoire:
Aircraft – Overseas Tour," 13 September 1962.

4 Ibid.

5 History and Heritage of Canada's Air Force,
"Canadair C-5."

6 LAC, RG25 9918-E-40, vol. 19, March 1963–23 July
1963, undersecretary of state for External Affairs,
Ottawa, "National Defence College Tour,"
memorandum to the Canadian embassy, Madrid,
4 April 1963.

7 American Consulate, Ponta Delgada, Azores,
"History of Air Base 4."

8 LAC, RG24-B-8, 1997–98/273, box 4, NDC,
"Course XVI, 1962/3: Countries of Asia, Africa
and Latin America, 5 February–1 March 1963,"
topics listed on the agenda circulated for discus-
sion on 28 February–1 March.

9 See Canada, Department of Foreign Affairs
and International Trade, "Movement for
Independence of African Territories."

10 Anglin, "Towards a Canadian Policy on Africa."

11 Rivkin, "Lost Goals in Africa," 111.

12 Mwakikagile, *Africa and America in the Sixties*.

13 Renato Rosaldo attributes "imperialist nostalgia"
to "agents of colonialism" who "long for the very
forms of life they intentionally altered or de-
stroyed." Accompanying "a peculiar sense of mis-
sion, the white man's burden … [t]he relatively
benign character of most nostalgia" paradoxically
increases its effectiveness by blinding the agent to
his or her own complicity. Rosaldo's character-
ization describes our gaping tourists to a T. See
Rosaldo, "Imperialist Nostalgia," 107–8.

14 Gershovich, *French Military Rule in Morocco*.

15 LAC, RG25 9918-E-40, vol. 19, March 1963–23 July
1963, undersecretary of state for External Affairs,
Ottawa, "National Defence College Tour,"
memorandum to the Canadian embassy, Madrid,
4 April 1963.

16 Ibid.

17 LAC, RG25 9918-E-40, vol. 19, March 1963–23 July
1963, Ambassade du Canada, "A travers le Maroc
(15–30 avril 1963)," memorandum to the under-
secretary of state for External Affairs and signed
by the ambassador to Spain, Jean Bruchési,
19 May 1963. We draw freely on the ambassador's
lively and detailed travel report. Translation by
Martha Langford.

18 Ibid.

19 LAC, RG25 9918-E-40, vol. 18, August 1961–28
February 1963, "Country Topics for National
Defence College Tour," memorandum
from African and Middle Eastern Division,
Department of External Affairs, 28 January 1963,
including appended report "Recent Political
Developments in Nigeria," 17 January 1963.

20 Ibid.

21 LAC, RG25 9918-E-40, vol. 19, March 1963–23 July
1963, Agence France Press, Lagos, 22 April 1963,
"Nous sommes contre le système des blocs …"
The federal prime minister's views were hardly
newsworthy, having been published just months
before in *Foreign Affairs*. See Balewa, "Nigeria
Looks Ahead," 139.

22 LAC, RG24-B-8, 1997–98/273, box 4, NDC,
"Course XVI – Overseas Tours 1963: Points to be
Considered on Overseas Tours, Part II. Afro-
European Section," 6 December 1962.

23 LAC, RG25 9918-E-40, vol. 18, August 1961–28
February 1963, "Country Topics for National
Defence College Tour," memorandum from
African and Middle Eastern Division, Department
of External Affairs, 28 January 1963. The terms of
Canada's participation in SCAAP are outlined in

a telegram from the Canadian high commissioner to the secretary of state for External Affairs, 22 September 1960, http://www.international.gc.ca/department/ history-histoire/dcer/details-en.asp?intRefid=12984; accessed 21 November 2009. Another SCAAP project, left off the NDC briefing, placed Canadian meteorologists and their data-processing equipment in Lagos, while offering training to Nigerian staff at the Canadian Meteorology Service in Toronto. See Rogalsky, "Weather Knows No Boundaries," 25.

24 Anglin, "Nigeria," especially 258–60.

25 Macmillan, "Africa," 191, 193.

26 Ehrhardt, "Authoritative Voices," 55–60.

27 Melvin, "Native Urbanism in West Africa."

28 Boorstin, *The Image*, 92.

29 Muhammad, "Development of Hospitality and Tourism Industry in Kano."

30 Comments made by Dr Iyorwuese Hagher, Nigerian high commissioner to Canada, interviewed in Ottawa, 1 March 2010. On this occasion Dr Hagher, Mrs Nancy Hagher, and Ms Rita Iorbo of the Nigeria High Commission generously offered many valuable observations and corrections to the authors' readings of the images.

31 Our visitors were in Kano from 22 to 24 April. This productive agricultural region's dry season lasts from October to May. See McDonell, "The Dynamics of Geographic Change," 357.

32 Lutz and Collins specifically cite Moore's "Progress and Pageantry in Changing Nigeria" as exemplifying *National Geographic*'s "two world" theme: "the traditional and the modern." See their *Reading National Geographic*, 110–11. In addition to the binary oppositions of modern/primitive, civilized/wild, and so forth, tropes such as "Afro-Romanticism" and "Afro-Pessimism" are elaborated by Cohen and Manspeizer in "The Accidental Tourist," 86–90.

33 Fayola and Heaton, *A History of Nigeria*, 161.

34 Moore, "Progress and Pageantry in Changing Nigeria," 358. Benedict Anderson's influential notion of print culture as an instrument of nation-building is being evoked here. See Anderson, *Imagined Communities*.

35 Lutz and Collins, *Reading National Geographic*, 178.

36 Interview with Iyorwuese Hagher, conducted by Martha Langford, 1 March 2010.

37 Lutz and Collins, *Reading National Geographic*, 40. The presence of Westerners in non-Western settings is graphed (figure 2.2), showing a precipitous decline in the late 1960s.

38 Interview with Iyorwuese Hagher, conducted by Martha Langford, 1 March 2010.

39 The phrase is borrowed from the title of Whittlesey's 1937 survey of the colonial city.

40 Elisofon et al., "The Hopeful Launching of a Proud and Free Nigeria."

41 Moore, "Progress and Pageantry in Changing Nigeria," 351.

42 Anderson, *Imagined Communities*, 120.

43 LAC, RG25 9918-E-40, vol. 18, August 1961–28 February 1963, "Nigeria," in "Country Topics for Nigeria and Kenya," memorandum from Africa and Middle Eastern Division, Department of External Affairs, to Defence Liaison (1) Division, 28 January 1963.

44 Macdona, "The African Scene – 1963," citation, 228.

45 Macmillan, "Africa," 195.

46 LAC, RG24-B-8, 1997-98/273, box 4, "The Case for NDC Visits to Africa," internal briefing note prepared by NDC direction and inscribed: "Notes for Commandant prior to, and for any meeting which CCOS may call. 15 Sep. 62."

47 Ibid., box 3, "NDC Course XV – 1961–62, Minutes of DS Meeting, Overseas Tour, 1962 – Post Mortem," 20 June 1962.

48 Percox, *Britain, Kenya and the Cold War*, 21.

49 Ibid., 192.

50 Ibid., chapter 5.

51 Percox cites Philip Darby's point in *British Defence Policy East of Suez, 1947–1968,* that when the decision was taken to station British troops in Kenya, independence seemed many years away. See Percox, *Britain, Kenya and the Cold War,* 85–6.

52 LAC, RG25 9918-E-40, vol. 18, August 1961–28 February 1963, "Country Topics for National Defence College Tour," memorandum from African and Middle Eastern Division, Department of External Affairs, 28 January 1963.

53 Andrew, *The Defence of the Realm,* 466.

54 Ibid.

55 LAC, RG25 9918-E-40, vol. 18, August 1961–28 February 1963, "Country Topics for National Defence College Tour," memorandum from African and Middle Eastern Division, Department of External Affairs, 28 January 1963.

56 Percox, *Britain, Kenya and the Cold War,* 164.

57 "*Kenya:* Charles Trieschman," in Museum of Modern Art, *The Family of Man,* 60.

58 Andrew, *The Defence of the Realm,* 458.

59 Ibid., 454.

60 Such careful avoidances of car tracks, commercial campsites, and other sources of resentment by travellers seeking authentic experience are recalled by Wilfred Thesiger in his memoir *My Kenya Days* (1995), 68, 75, 77, 90–1; cited in Youngs, "'Why Is That White Man Pointing That Thing at Me?'" 440.

61 Rodger and Rodger, "Where Elephants Have Right of Way," 371.

62 Rosaldo, "Imperialist Nostalgia," 107–10.

63 Percox, *Britain, Kenya and the Cold War,* 185–226.

64 See the well-documented account in Halabi, *US Foreign Policy in the Middle East,* chapter 3.

65 Warren Langford, card postmarked Rome, 3 May 1963. The image on the card, taken by Italian photographer Giovanni Trimboli, is of a modern sculpture by Mahmoud Mokhtar, *Egypt Awakening* or *Egypt's Renaissance* (1919–28), which has been interpreted as an expression of essentialist nationalism by Mokhtar, whose precocious native talent earned him a scholarship to the École des Beaux-Arts in Paris. To situate this work, see Haikal, "Egypt's Past Regenerated by Its Own People," 134.

66 LAC, RG25 9918-E-40, vol. 18, August 1961–28 February 1963, "Country Topics for National Defence College Tour," memorandum from African and Middle Eastern Division, Department of External Affairs, on or before 28 January 1963.

67 See Lyon, "The Loyalties of E. Herbert Norman," 227–8.

68 The estimated number of displaced Nubians on both sides of the border was 100,000, with the Sudanese facing the most severe cultural and climatic challenges. See Kirwan, "Land of Abu Simbel," 264.

69 See Burke et al., "A Heritage in Need of Help," 62, 64. The feature is divided in sections. Alexander Eliot is credited with "The Storied World of Ramses," but the rest of the text, including titles and subheads, appears to have been produced by staff writers.

70 Frankfurter, "Is Abu Simbel Lost?" 25–6, 62–5.

71 "Let Abu Simbel Drown, NYU Professor Says," 196.

72 Adams, "Organizational Problems in International Salvage Archaeology," 113.

73 Excerpt from the message of President Kennedy to Congress, appendixed to Brew, "The Threat to Nubia," 272–3.

74 R. Komer quoted in Halabi, *US Foreign Policy in the Middle East,* 39.

75 Raafat, "Ramses Returns Home."

76 MacCannell, *The Tourist*, 6.

77 Steegmuler, *Flaubert in Egypt*, 101.

78 The epic film *Lawrence of Arabia*, directed by the David Lean and starring Peter O'Toole, was released in Canada in January 1963.

79 The 1964 program specifies a nighttime visit to the High Dam. See LAC, RG24-B-8, 1997–98/273, box 5, "Overseas Tour 1964, Tentative Outline Program, Afro-European Section, United Arab Republic," 3 March 1964.

80 Louis Turner and John Ash, *The Golden Hordes: International Tourism and the Pleasure Periphery* (1976), 241; cited in Chalfen, "Photography's Role in Tourism," 443.

81 Wharton, *Building the Cold War*. See also Wharton, "Economy, Architecture and Politics."

82 "The President's Corner," *Hiltonitems*, May 1958, 1; cited in Wharton, *Building the Cold War*, 8.

83 Boorstin, *The Image*, 98.

84 MacCannell, *The Tourist*, 106–7.

85 For the post–World War II shift from British economic imperialism, through an Anglo-American coalition, to US president Kennedy's "New Frontier," see Louis and Robinson, "The Imperialism of Decolonization."

86 Wharton, *Building the Cold War*, 47.

87 Wharton, "Economy, Architecture and Politics," 296.

88 Ibid., 295.

89 This nuanced reading of the square is indebted to social scientist Hanae El-Alfy, Europeanist Amr Sabbour, and artist Soad El-Alfy, whose kitchen debate, held in Toronto with cross-continental telephone communication, was skilfully moderated and reported by Tammer El-Sheikh; personal communication with Martha Langford, 17–18 December 2009.

90 Graburn, "The Anthropology of Tourism," 25.

91 Kanet, "The Evolution of Soviet Policy toward the Third World," 4.

92 Kovner, "Soviet Trade and Aid," 233–4.

93 Hourani, "Near Eastern Nationalism Yesterday and Today," 131–6.

CHAPTER THREE

1 The subsequent discussion largely ignores non-European dimensions of the Cold War in favour of the issues that our Cold War tourists were concentrating on during this trip.

2 For a perceptive and literate analysis of the evolution and frailties of nuclear strategy in the 1950s and 1960s, see Malcolmson, *Beyond Nuclear Thinking*, especially chapters 1 and 2.

3 See Judt, *Postwar*, 170–4.

4 LAC, RG24-B-8, 1997–98/273, box 4, NDC, "Minutes of DS Meeting, 4 July 1963."

5 Victor Turner and Edith Turner, *Image and Pilgrimage in Christian Culture* (1978), 20; cited in Graburn, "The Anthropology of Tourism," 17.

6 Warren Langford, card postmarked Rome, 8 May 1963.

7 The repetition of images might have been prompted by fears that his earlier roll had been damaged. The roll with the guided tour ends on frame 9.

8 Wrigley, "Infectious Enthusiasms," 81.

9 Pope John XXIII's encyclical *Pacem in Terris* (Peace on Earth), issued on 11 April 1963, was warmly received on both sides of the Iron Curtain and by Communist parties in Italy, Belgium, and France, whose responses were hastily contextualized by Vatican radio. The encyclical was explained by *Time* as a "bold stroke of diplomacy intended to remind men of both East and West that a new era is dawning, requiring new policies." See "Roman Catholics: What We Are For."

10 Edwards, *Writing Rome*, 7.

11 Ibid., 10–15.

12 Boyer, *The City of Collective Memory*, 135. The literature arising from Walter Benjamin's and Siegfried Kracauer's discouragement with modern tourism is rehearsed in Rojek and Urry, *Touring Cultures*, 5–10.

13 The complex evolution of the US nuclear-sharing policy is well documented in Trachtenberg, *A Constructed Peace*, especially in chapters 5, 6, and 8.

14 Steinbruner, *The Cybernetic Theory of Decision*, 164.

15 See Trachtenberg, *A Constructed Peace*, chapter 8.

16 See Sokolsky, *Seapower in the Nuclear Age*, 32–3.

17 See "Historic U.S. Army Helicopters." The group flew in two CH-34s, each configured for VIP transport.

18 Sichel, *To Fly*, 11. See also Kozloff, "Moholy-Nagy, the Aerialist," in his *Photography & Fascination*, 119–35.

19 Sichel, *To Fly*, 10–12.

20 Aerial photographs taken in the name of progress might eventually serve different purposes. Course Fourteen's briefing notes for the Asian section tour include reference to the Mekong Delta aerial survey, co-conducted in the early sixties by Canada, Thailand, Laos, and South Vietnam "to assist eventually in flood control, irrigation, hydro electric power development and improved navigation." See LAC, RG24-C-1-c, 1983–84/167, box 5008, Office of the High Commissioner for Canada, Kuala Lumpur, Malaya, "Visit of the National Defence College of Canada to Malaya – April 22–26, 1961," memorandum dated 4 May 1961, in Department of National Defence, "Training Courses at National Defence College."

21 LAC, RG24-B-8, 1997–98/273, box 4, NDC, "Minutes of DS Meeting, 4 July 1963." Later that same month, the plan for Poland was quashed by the chairman of the Chiefs of Staff, as reported by the commandant in "Minutes of DS Meeting, 30 July 1963."

22 Gaddis, *The Cold War*, 33.

23 LAC, RG24-B-8, 1997–98/273, box 4, NDC, Syndicate No. 5, "The Western Alliance: NATO – How Goes NATO?" 5 November 1962.

24 For a full and incisive analysis of the Berlin Hilton, see Wharton, *Building the Cold War*, 77–88.

25 Ibid., 85.

26 Ibid., 80–5.

27 Phrases adopted by the propaganda arm of the SED, the Communist party, were "trade in human beings" or "head-hunting." See Taylor, *The Berlin Wall*, 135–6.

28 Ibid., 125.

29 Judt, *Postwar*, 250.

30 Taylor, *The Berlin Wall*, xviii.

31 Judt, *Postwar*, 251.

32 *LIFE* Staff, "On the Brink at Berlin," is a compendium of staff, correspondents', and wire-service images by photographers such as Edo Koenig, Klaus Lemnartz, Edwin Reichert, Walter Sanders, Dr Peter Senzen, Hank Walker, and Stan Wayman.

33 Taylor, *The Berlin Wall*, 145.

34 Ibid., 220.

35 Ibid.

36 For a clear statement of General Clay's readiness to deal with the Communists by force, see Clay, "Berlin."

37 The NDC tour of the Wall was necessarily selective. Still, a number of key sites were visited, including sections that would be preserved as monuments after 1989, such as the stretch along Bernauer Strasse, between Ackerstrasse and Bergstrasse (see fig. 71).

38 See Foley and Lennon, "The Spectacularization of Dark Tourism."

39 Vance, *Death So Noble*, 57.

40 Cochrane, "Making Up Meanings in a Capital City," 12.

41 Ignatieff, "Soviet War Memorials," 161.

42 Cochrane, "Making Up Meanings in a Capital City," 12.

43 Boorstin, *The Image*. For comparison with the American presidential visit to Berlin, which took place a few weeks later, see Rovere, "Journal of a Pseudo-event."

44 Leah, "'The Iron Curtain,'" 163–4.

45 Tusa, *The Last Division*, 314–15. Tusa gives Siekmann's age as fifty-nine; it was in fact the day before her fifty-ninth birthday.

46 Lutz and Collins virtually ignore the text in *Reading National Geographic,* and their book has been criticized for that neglect in a review by historian Joan Shelley Rubin.

47 Kenney and Wentzel, "Life in Walled-off West Berlin," 756–7, 767.

48 Kuehn, *Caught*, 75.

49 For an elaboration of the memory-effect of pictures nested within pictures, see Langford, *Scissors, Paper, Stone*, 212–15.

50 "Wall of Shame."

CONCLUSION

1 Taylor, *A Dream of England*, 14.

2 See Chard and Langdon, *Transports*; and Schwartz and Ryan, *Picturing Place*.

Bibliography

ARCHIVAL SOURCES

Library and Archives Canada (LAC)

RG 24, National Defence College (NDC) files
RG 25, Department of External Affairs files

OTHER SOURCES

Abrahamson, David. *Magazine-Made America: The Cultural Transformation of the Postwar Periodical*. Cresskill, NJ: Hampton Press, 1996

Adams, William Y. "Organizational Problems in International Salvage Archaeology." *Anthropological Quarterly* 41, no. 3 (July 1968): 110–21

Albers, Patricia C., and William R. James. "Tourism and the Changing Photographic Image of the Great Lakes Indian." *Annals of Tourism Research* 10 (1983): 123–48

– "Travel Photography: A Methodological Approach." *Annals of Tourism Research* 15 (1988): 134–58

Albright, Joseph, and Marcia Kunstel. *Bombshell: The Secret Story of America's Unknown Atomic Spy Conspiracy*. New York: Times Books, 1997

American Consulate, Ponta Delgada, Azores. "History of Air Base 4." http://www.usconsulateazores.pt/ LajesField.html. Accessed 3 January 2010

Anastakis, Dimitri. *Auto Pact: Creating a Borderless North American Auto Industry, 1950–1971*. Toronto: University of Toronto Press, 2005

Anderson, Benedict. *Imagined Communities: Reflections on the Origin and Spread of Nationalism*. Rev. ed. London: Verso, 1991

Andrew, Christopher. *The Defence of the Realm: The Authorized History of MI5*. Toronto: Penguin Group, 2009

Anglin, Douglas G. "Nigeria: Political Non-Alignment and Economic Alignment." *Journal of Modern African Studies* 2, no. 2 (July 1964): 247–63

– "Towards a Canadian Policy on Africa." *International Journal* 15, no. 4 (Autumn 1960): 290–310

Atkinson, James David. *The Edge of War.* Chicago: Henry Regnery Co., 1960

Avery, Donald, and Roger Hall. *Coming of Age: Readings in Canadian History since World War II.* Toronto: Harcourt Brace Canada, 1996

Azzi, Stephen. *Walter Gordon and the Rise of Canadian Nationalism.* Montreal and Kingston: McGill-Queen's University Press, 1999

Baer, Ulrich. *Spectral Evidence: The Photography of Trauma.* Cambridge, Mass., and London: The MIT Press, 2002

Balewa, Abubakar Tafawa. "Nigeria Looks Ahead." *Foreign Affairs* 41, no. 1 (October 1962): 131–40

Barthes, Roland. *Camera Lucida: Reflections on Photography.* Trans. Richard Howard. New York: Hill and Wang, 1982

– *Mythologies.* New York: Farrar, Straus and Giroux, 1972

Batchen, Geoffrey. "Vernacular Photographies." In his *Each Wild Idea: Writing, Photography, History.* Cambridge, Mass., and London: The MIT Press, 1991

Berger, John. "Uses of Photography." In his *About Looking.* New York: Pantheon Books, 1980

Berlier, Monique. "*The Family of Man*: Readings of an Exhibition." In Bonnie Brennen and Hanno Hardt, eds., *Picturing the Past: Media, History, and Photography,* 206–41. Urbana and Chicago: University of Illinois Press, 1999

Bertacchi, Massimo. "Aires Cameras." Posted 6 April 2006. http://corsopolaris.net/supercameras/aires/aires.html. Accessed 30 December 2009

Betts, Raymond F. *Decolonization.* 2nd ed. New York and London: Routledge, 2004

Bhabha, Homi. *The Location of Culture.* London and New York: Routledge, 1994

Bloomfield, Lincoln P., Walter C. Clemens Jr, and Franklyn Griffiths. *Khrushchev and the Arms Race: Soviet Interests in Arms Control and Disarmament, 1954–1964.* Cambridge, Mass.: MIT Press, 1966

Boorstin, Daniel J. *The Image: A Guide to Pseudo-events in America.* New York: Harper & Row, 1964

Bothwell, Robert. *The Big Chill: Canada and the Cold War.* Toronto: Canadian Institute of International Affairs, 1998

Bourdieu, Pierre. *Un Art moyen: essai sur les usages sociaux de la photographie.* Paris: Les Éditions de Minuit, 1965

Boyer, M. Christine. *The City of Collective Memory: Its Historical Imagery and Architectural Entertainments.* Cambridge, Mass.: MIT Press, 1996

Boyle, Peter G. "The Cold War Revisited." *Journal of Contemporary History* 35, no. 3 (2000): 479–89

Brew, John Otis. "The Threat to Nubia." *Archaeology* 14, no. 4 (December 1961): 268–76

Brune, Lester H., and Richard Dean Burns. *Chronology of the Cold War, 1917–1992.* New York: Routledge, 2006

Bruner, Edward M. "Transformation of Self in Tourism." *Annals of Tourism Research* 18 (1991): 238–50

Bryan, C.D.B. *The National Geographic Society: 100 Years of Adventure and Discovery.* New York: Abradale Press, 1997

Buchloh, Benjamin H.D., and Robert Wilkie. *Mining Photographs and Other Pictures, 1948–*

1968: A Selection from the Negative Archives of Shedden Studio, Glace Bay, Cape Breton. Halifax and Sydney: Press of the Nova Scotia College of Art and Design and the University College of Cape Breton Press, 1983

Burg, David. "Sex and Statism in Russia." *American Behavioral Scientist* 4, no. 5 (January 1961): 16–17

Burgin, Victor, ed. *Thinking Photography.* London: Macmillan Publishers, 1982

Burke, James, with Alexander Eliot and *LIFE* staff. "A Heritage in Need of Help: New Nile Dam Will Drown Fabled Monuments." *LIFE* 50, no. 12 (24 March 1961): 62–82

Burke, Peter. *Eyewitnessing: The Uses of Images as Historical Evidence.* Ithaca, NY: Cornell University Press, 2001

– ed. *New Perspectives on Historical Writing.* 2nd ed. University Park: Pennsylvania State University Press, 2001

Canada. Department of Foreign Affairs and International Trade. Documents on Canadian External Relations. "Movement for Independence of African Territories." Paper by European Division for discussion at European Heads of Mission Meeting, Paris, 26–29 October 1959. http://www.international.gc.ca/department/history-histoire/dcer/details-en.asp?intRefid=11272. Accessed 9 November 2009

Canada. Royal Commission on Aboriginal Peoples. *Report.* Vol. 1. Ottawa: Queen's Printer, 1996

Cavell, Richard. *Love, Hate, and Fear in Canada's Cold War.* Toronto: University of Toronto Press, 2004

Chalfen, Richard M. "Photography's Role in Tourism: Some Unexplored Relationships." *Annals of Tourism Research,* October/December 1979, 435–47

Chard, Chloe, and Helen Langdon, eds. *Transports: Travel, Pleasure, and Imaginative Geography.* New Haven and London: Yale University Press, 1996

Clay, Lucius D. "Berlin." *Foreign Affairs* 41, no. 1 (October 1962): 47–58

Close, Susan. *Framing Identity: Social Practices of Photography in Canada (1880–1920).* Winnipeg: Arbeiter Ring Pub., 2007

Coates, Ken S., P. Whitney Lackenbauer, William R. Morrison, and Greg Poelzer. *Arctic Front: Defending Canada in the Far North.* Toronto: Thomas Allen Publishers, 2008

Cobb, Daniel M. *Native Activism in Cold War America: The Struggle for Sovereignty.* Lawrence: University Press of Kansas, 2008

Cochrane, Allan. "Making Up Meanings in a Capital City: Power, Memory and Monuments in Berlin." *European Urban and Regional Studies* 13, no. 1 (2006): 5–24

Cohen, Brian, and Ilyssa Manspeizer. "The Accidental Tourist: NGOs, Photography, and the Idea of Africa." In Robinson and Picard, eds., *The Framed World.*

Coleman, Peter. *The Liberal Conspiracy: The Congress for Cultural Freedom and the Struggle for the Mind of Postwar Europe.* New York: Collier Macmillan, 1989

Collins, Anne. *In the Sleep Room: The Story of the CIA Brainwashing Experiments in Canada.* Toronto: Lester and Orpen Dennys, 1988

Conant, Melvin. *Canadian Foreign Policy: Old Habits and New Directions.* Toronto: Musson Book Co., 1962

– *The Long Polar Watch: Canada and the Defence of North America.* New York: Council on Foreign Relations, 1962

Cooper, Andrew F. *Canadian Foreign Policy: Old Habits and New Directions.* Scarborough: Prentice-Hall Allyn and Bacon Canada, 1997

Cousineau-Levine, Penny. *Faking Death: Canadian Art Photography and the Canadian Imagination*. Montreal and Kingston: McGill-Queen's University Press, 2003

Cronin, James E. *The World the Cold War Made: Order, Chaos and the Return of History*. New York: Routledge, 1996

Crowley, David, Jane Pavitt, and the Victoria and Albert Museum. *Cold War Modern: Design, 1945–1970*. London: V&A Publishing, 2008

Crowley, David, and the Victoria and Albert Museum. *Posters of the Cold War*. London: V&A Publishing, 2008

Culler, Jonathan D. "The Semiotics of Tourism." In his *Framing the Sign: Criticism and Its Institutions*, 153–67. Norman: University of Oklahoma Press, 1990

Cummings, Richard H. *Cold War Radio: The Dangerous History of American Broadcasting in Europe, 1950–1989*. Jefferson, NC: McFarland & Co., 2009

Daugherty, William E. *A Psychological Warfare Casebook*. Baltimore: The Johns Hopkins University Press, 1958

Deacon, William Arthur. "Saturday Review of Books: Psychoanalysis Salesmanship and Sneers." *Globe and Mail*, 27 October 1951, 14

"de Havilland Comet." http://en.wikipedia.org/wiki/De_Havilland_Comet#Comet_4. Accessed 3 January 2010

Donaghy, Greg. *Tolerant Allies: Canada and the United States, 1963–1968*. Montreal and Kingston: McGill-Queen's University Press, 2002

Dunlap, Jack W. "Psychologists and the Cold War." *American Psychologist* 10, no. 3 (1955): 107–9

Eayrs, James George. *The Art of the Possible: Government and Foreign Policy in Canada*. Toronto: University of Toronto Press, 1961

– *Canada in World Affairs, October 1955 to June 1957*. Toronto: Oxford University Press, 1959

– *Northern Approaches: Canada and the Search for Peace*. Toronto: Macmillan, 1961

Edwards, Catharine. *Writing Rome: Textual Approaches to the City*. Cambridge: Cambridge University Press, 1996

Edwards, Elizabeth. *Raw Histories: Photographs, Anthropology and Museums*. Oxford and New York: Berg, 2001

Edwards, Elizabeth, and Janice Hart, eds. *Photographs, Objects, Histories: On the Materiality of Images*. London and New York: Routledge, 2004

Ehrhardt, David. "Authoritative Voices: Informal Authorities and Conflict Resolution in Kano, Nigeria." Doctoral thesis, University of Oxford, 2007. http://oxford.academia.edu/DavidEhrhardt/Papers. Accessed 29 March 2010

Elisofon, Eliot, and *LIFE* staff. "The Hopeful Launching of a Proud and Free Nigeria." *LIFE* 49, no. 13 (26 September 1960): 54–74

Engel, Jeffrey A. *Local Consequences of the Global Cold War*. Washington, DC: Woodrow Wilson Center Press, 2007

Fayola, Toyin, and Matthew H. Heaton. *A History of Nigeria*. Cambridge: Cambridge University Press, 2008

Field, Douglas. *American Cold War Culture*. Edinburgh: Edinburgh University Press, 2005

Foley, Malcolm, and J. John Lennon. "The Spectacularization of Dark Tourism: Photojournalism, Deontology and Commemoration in the Visitation of Sites of Mass Disaster." In Vincent Lavoie, ed., *Maintenant/Now: Images du temps présent/Images of Present Time*, 205–23. Montreal: Le Mois de la Photo à Montréal, 2005

Frankfurter, Alfred. "Is Abu Simbel Lost?" *Art News*, Summer 1962, 25–6, 62–5

Fukuyama, Francis. *The End of History and the Last Man.* New York: Free Press, 1992

Gaddis, John Lewis. *The Cold War: A New History.* New York: Penguin Press, 2005

– *The United States and the Origins of the Cold War, 1941–1947.* New York: Columbia University Press, 1972; repub. with new preface, 2000

– *We Now Know: Rethinking Cold War History.* Oxford: Clarendon Press, 1997

Gershovich, Moshe. *French Military Rule in Morocco: Colonialism and Its Consequences.* London: F. Cass, 2000

Graburn, Nelson H.H. "The Anthropology of Tourism." *Annals of Tourism Research* 10 (1983): 9–33

Grace, Sherrill E. *Canada and the Idea of North.* Montreal and Kingston: McGill-Queen's University Press, 2001

Granatstein, J.L., and David Stafford. *Spy Wars: Espionage and Canada from Gouzenko to Glasnost.* Toronto: Key Porter, 1990

Greenberg, Clement. *Clement Greenberg: The Collected Essays and Criticism.* Ed. John O'Brian. Vol. 2, *Arrogant Purpose, 1945–1949.* Chicago: University of Chicago Press, 1986

Haikal, Fayza. "Egypt's Past Regenerated by Its Own People." In Sally MacDonald and Michael Rice, eds. *Consuming Ancient Egypt*, 123–38. London: UCL Press, 2003

Halabi, Yakub. *US Foreign Policy in the Middle East: From Crisis to Change.* Aldershot, Eng.; Burlington, Vt: Ashgate Publishing, 2009

Hanhimäki, Jussi M., and Odd Arne Westad, eds. *The Cold War: A History in Documents and Eyewitness Accounts.* Oxford: Oxford University Press, 2004

Hariman, Robert, and John Louis Lucaites. *No Caption Needed: Iconic Photographs, Public Culture, and Liberal Democracy.* Chicago: University of Chicago Press, 2007

Harrington, Richard. *The Face of the Arctic: A Cameraman's Story in Words and Pictures of Five Journeys into the Far North.* London: Hodder and Stoughton, 1954

– *The Inuit: Life as It Was.* Edmonton: Hurtig Publishers, 1981

Hatzivassiliou, Evanthis. "Images of the Adversary: NATO Assessments of the Soviet Union, 1953–1964." *Journal of Cold War Studies* 11, no. 2 (2009): 89–116

Herskovits, Jean. "Remembrance: J. Wayne Fredericks." 23 August 2004. http://allafrica.com/stories/200408230214.html. Accessed 31 December 2009

Herz, Martin. *Beginnings of the Cold War.* Bloomington: University of Indiana Press, 1966

Hirsch, Marianne. *Family Frames: Photography, Narrative, and Postmemory.* Cambridge, Mass.: Harvard University Press, 1991

– ed. *The Familial Gaze.* Hanover: University Press of New England, 1999

"Historic U.S. Army Helicopters." http://tri.army.mil/LC/CS/csa/aahist.htm#Igor. Accessed 3 January 2010

History and Heritage of Canada's Air Force. "Avro Canada Canuck CF-100." http://www.rcaf.com/Aircraft/ aircraftDetail.php?CANUCK-8. Accessed 3 January 2010

– "Canadair C-5." http://www.rcaf.com/aircraft/ transports/c5/index.php?name=C-5. Accessed 3 January 2010

Holmes, John W. "Canada and the United States in World Politics." *Foreign Affairs* 40, no. 1 (October 1961): 105–17

- "Canada in Search of Its Role." *Foreign Affairs* 41, no. 4 (July 1963): 659–72
- *The Shaping of Peace: Canada and the Search for World Order 1943–1957.* Vol. 2. Toronto: University of Toronto Press, 1982

Horner, Alice E. "Tourist Arts in Africa before Tourism." *Annals of Tourism Research* 20 (1993): 52–63

Hourani, Albert. "Near Eastern Nationalism Yesterday and Today." *Foreign Affairs* 42 (October 1963): 123–36

Hulan, Renée. "Literary Field Notes: The Influence of Ethnography on Representations of the North." *Essays on Canadian Writing* 59 (1996): 147–63
- *Northern Experience and the Myths of Canadian Culture.* Montreal and Kingston: McGill-Queen's University Press, 2002

Hutchison, Bruce, and John E. Fletcher, "Exploring Ottawa." *National Geographic Magazine* 92, no. 5 (November 1947): 565–96

Ignatieff, Michael. "Soviet War Memorials." *History Workshop Journal* 17 (1984): 157–63

Jenkins, Olivia H. "Photography and Travel Brochures: The Circle of Representation." *Tourism Geographies* 5, no. 3 (2003): 305–28

Jenks, John. *British Propaganda and News Media in the Cold War.* Edinburgh: Edinburgh University Press, 2006

Jockel, Joseph. *Canada in NORAD, 1957–2007.* Montreal and Kingston: McGill-Queen's University Press, 2007

Johnson, David. *The Lavender Scare: Cold War Persecution of Gays and Lesbians by the Federal Government.* Chicago: University of Chicago Press, 2006

Judt, Tony. *Postwar: A History of Europe since 1945.* New York: Penguin, 2005
- *Reappraisals: Reflections on the Forgotten Twentieth Century.* London: William Heinemann, 2008

Kanet, Roger E. "The Evolution of Soviet Policy toward the Third World." In Carol R. Saivetz, ed., *The Soviet Union in the Third World,* 1–20. Boulder: Westview Press, 1989

Kennan, George ("X"). "The Sources of Soviet Conduct." *Foreign Affairs* 25, no. 4 (1947): 556–82

Kenney, Nathaniel T., and Volkmar Wentzel. "Life in Walled-Off West Berlin." *National Geographic* 120, no. 6 (December 1961): 735–67

Khalidi, Rashid. *Sowing Crisis: The Cold War and American Dominance in the Middle East.* Boston: Beacon Press, 2009

Killen, Linda. *The Soviet Union and the United States: A New Look at the Cold War.* Boston: Twayne Publishers, 1988; 1989

Kinsman, Gary, and Patrizia Gentile. *The Canadian War on Queers: National Security as Sexual Regulation.* Vancouver: UBC Press, 2010

Kintner, William. *The Front Is Everywhere: Militant Communism in Action.* Norman: University of Oklahoma Press, 1950

Kirwan, L.P. "Land of Abu Simbel." *Geographical Journal* 129, no. 13 (September 1963): 261–73

Knight, Amy W. *How the Cold War Began: The Gouzenko Affair and the Hunt for Soviet Spies.* Toronto: McClelland & Stewart, 2005

Kort, Michael. *The Columbia Guide to the Cold War.* New York: Columbia University Press, 1998

Kovner, Milton. "Soviet Aid and Trade." *Current History* 49, no. 290 (October 1965): 227–34

Kozloff, Max. *Photography & Fascination.* Danbury, NH: Addison House, 1979

Kristmanson, Mark. *Plateaus of Freedom: Nationality, Culture, and State Security in Canada, 1940–1960.* Don Mills: Oxford University Press, 2003

Kuehn, Karl Gernot. *Caught: The Art of Photography in the German Democratic Republic.* Berkeley: University of California Press, 1997

Kuffert, L.B. *A Great Duty: Canadian Responses to Modern Life and Mass Culture, 1939–1967.* Montreal and Kingston: McGill-Queen's University Press, 2003

Kuhn, Annette. *Family Secrets: Acts of Memory and Imagination.* London and New York: Verso, 1995

Kuhn, Annette, and Kirsten Emiko McAllister, eds. *Locating Memory: Photographic Acts.* New York and Oxford: Berghahn Books, 2006

Kunard, Andrea. "The Role of Photography Exhibitions at the National Gallery of Canada (1934–1960)." *Journal of Canadian Art History* 30 (2009): 28–56

Lafeber, Walter. *America, Russia and the Cold War.* New York: Wiley, 1966

Lamoureux, Johanne. "L'Album ou la photographie corrigée par son lieu." *Trois* 6, nos. 2–3 (Winter–Spring 1991): 185–91

Lanfant, Marie-Françoise. "The Purloined Eye: Revisiting the Tourist Gaze from a Phenomenological Perspective." In Robinson and Picard, eds., *The Framed World*, 239–56

Langford, Martha. "An Excursion into the Amateur Grotesque." In Ian H. Angus, ed., *Anarcho-Modernism: Toward New Critical Theory: In Honour of Jerry Zaslove.* Vancouver: Talon Books, 2001

– *Scissors, Paper, Stone: Expressions of Memory in Contemporary Photographic Art.* Montreal and Kingston: McGill-Queen's University Press, 2007

– "Speaking the Album: An Application of the Oral-Photographic Framework." In Kuhn and McAllister, eds., *Locating Memory*, 223–46

– "Strange Bedfellows: Appropriations of the Vernacular by Photographic Artists."
Photography & Culture 1, no. 1 (July 2008): 73–94

– *Suspended Conversations: The Afterlife of Memory in Photographic Albums.* Montreal and Kingston: McGill-Queen's University Press, 2001

Larson, Deborah Welch. *Anatomy of Mistrust: U.S.-Soviet Relations during the Cold War.* Ithaca, NY: Cornell University Press, 1997

Leab, Daniel J. "'The Iron Curtain' (1948): Hollywood's First Cold War Movie." *Historical Journal of Film, Radio, and Television* 8, no. 2 (1988): 153–88

Leiper, Neil. "An Etymology of 'Tourism.'" *Annals of Tourism Research* 10 (1983): 277–81

Lennon, John, and Malcolm Foley. *Dark Tourism: The Attraction of Death and Disaster.* London: Thomson, 2007

"Let Abu Simbel Drown, NYU Professor Says." *Science News Letter* 81, no. 13 (31 March 1962): 196

LIFE staff, with correspondent Eric Pace. "On the Brink at Berlin." *LIFE* 51, no. 8 (25 August 1961): 28–37

Lindsay, Franklin A. "Unconventional Warfare." *Foreign Affairs* 40, no. 2 (January 1962): 264–74

Lloyd, Trevor. *Canada in World Affairs, 1957–59.* Toronto: Oxford University Press, 1968

Lord, France. "The Silent Eloquence of Things: The Missionary Collections and Exhibitions of the Society of Jesus in Quebec, 1843–1946." In Alvyn Austin and Jamie S. Scott, eds., *Canadian Missionaries, Indigenous Peoples: Representing Religion at Home and Abroad*, 205–34. Toronto: University of Toronto Press, 2005

Louis, William Roger, and Ronald Robinson. "The Imperialism of Decolonization." In James D. Le Sueur, ed., *The Decolonization Reader*, 49–79. London: Routledge, 2001

Lutz, Catherine, and Jane L. Collins. *Reading National Geographic*. Chicago: University of Chicago Press, 1993

Lyon, Peyton V. *Canada in World Affairs, 1961–1963*. Toronto: Oxford University Press, 1968

– "The Loyalties of E. Herbert Norman." *Labour/Le Travail* 28 (Fall 1991): 219–59

– *The Policy Question: A Critical Appraisal of Canada's Role in World Affairs*. Toronto: McClelland & Stewart, 1963

– "Problems of Canadian Independence." *International Journal* 16, no. 3 (Summer 1961): 250–9

MacCannell, Dean. *The Tourist: A New Theory of the Leisure Class*. New York: Schocken Books, 1976

Macdona, Brian F. "The African Scene – 1963." *African Affairs* 62, no. 248 (July 1963): 224–35

Macmillan, Harold. "Africa." *African Affairs* 59, no. 236 (July 1960): 191–200

Malcolmson, Robert. *Beyond Nuclear Thinking*. Montreal and Kingston: McGill-Queen's University Press, 1990

Maloney, Sean M. *Learning to Love the Bomb: Canada's Nuclear Weapons during the Cold War*. Washington, DC: Potomac Books, 2007

Marcus, Alan R. *Relocating Eden: The Image and Politics of Inuit Exile in the Canadian Arctic*. Hanover, NH: Dartmouth College, 1995

Masey, Jack, and Conway Lloyd Morgan. *Cold War Confrontations: U.S. Exhibitions and Their Role in the Cultural Cold War*. Baden: Lars Muller, 2008

Matthews, Harry G., and Linda K. Richter, "Political Science and Tourism." *Annals of Tourism Research* 18 (1991): 120–35

McCalla, Robert B. *Uncertain Perceptions: U.S. Cold War Crisis Decision Making*. Ann Arbor: University of Michigan Press, 1992

McCauley, Martin. *Russia, America, and the Cold War, 1949–1991*. London and New York: Longman, 1998

McClintock, Anne. *Imperial Leather: Race, Gender and Sexuality in the Colonial Context*. New York and London: Routledge, 1995

McDonnell, Gavan. "The Dynamics of Geographic Change: The Case of Kano." *Annals of the Association of American Geographers* 54, no. 3 (September 1964): 355–71

McLuhan, Marshall. *The Mechanical Bride: Folklore of Industrial Man*. New York: Vanguard Press, 1951

McNeill, William Hardy. *America, Britain and Russia: Their Cooperation and Conflict*. New York: Oxford University Press, 1957

Mead, Margaret. "The Underdeveloped and the Overdeveloped." *Foreign Affairs* 41, no. 1 (October 1962): 78–89

Mellinger, Wayne Martin. "Toward a Critical Analysis of Tourism Representations." *Annals of Tourism Research* 21, no. 4 (1994): 756–79

Melvin, Ernest E. "Native Urbanism in West Africa." *Journal of Geography* 60, no. 1 (1961): 9–16

Minifie, James. *Peacemaker or Powdermonkey: Canada's Role in a Revolutionary World*. Toronto: McClelland & Stewart, 1960

Mitchell, W.J.T. *Landscape and Power*. Chicago: University of Chicago Press, 1994

Moore, Robert W. "Progress and Pageantry in Changing Nigeria." *National Geographic*, September 1956, 325–65

Morgenthau, Hans J. *Politics among Nations: The Struggle for Power and Peace*. New York: Alfred Knopf, 1948

Morin, Edgar. *The Cinema, or the Imaginary Man*. Trans. Lorraine Mortimer. Minneapolis: University of Minnesota Press, 2005

Morrison, David. *Aid and Ebb Tide: A History of CIDA and Canadian Development Assistance.* Waterloo: Wilfrid Laurier University Press, 1998

Morton, Desmond. *A Military History of Canada: From Champlain to Kosovo.* 4th ed. Toronto: McClelland & Stewart, 1999

Moughtin, J.C. "The Traditional Settlements of the Hausa People." *Town Planning Review* 35, no. 1 (April 1964): 21–34

Mowat, Farley. *Lost in the Barrens.* Boston, Toronto: Little, Brown and Co., 1956

Muhammad, Sabo. "Development of Hospitality and Tourism Industry in Kano." *Sunday Triumph* (Kano), 4 January 2009

Murphy, Francis X. *Pope John XXIII Comes to the Vatican.* New York: Robert M. McBride, 1959

Murray, Sharon. "Frocks and Bangles: The Photographic Conversion of Two Indian Girls." In Loren Lerner, ed., *Depicting Canada's Children,* 233–57. Waterloo: Wilfrid Laurier University Press, 2009

Museum of Modern Art. *The Family of Man.* Exhibition catalogue by Edward Steichen. New York: MACO Magazine Corporation, 1955

Mwakikagile, Godfrey. *Africa and America in the Sixties: A Decade That Changed the Nation and the Destiny of a Continent.* Dar Es Salaam: New Africa Press, 2006

National Defence College. *National Defence College, Canada.* Kingston, Ont., 1967

National Gallery of Canada. "Exhibitions 1950–1959." EX0815B. *The Family of Man.* http://www.gallery.ca/english/496.htm. Accessed 18 November 2009

Nelson, Robert S., and Margaret Olin, eds. *Monuments and Memory, Made and Unmade.* Chicago: Chicago University Press, 2003

O'Brian, John. "Editing Armageddon." In Mark A. Cheetham, Elizabeth Legge, and Catherine M. Soussloff, eds., *Editing the Image: Strategies in the Production and Reception of the Visual.* Toronto: University of Toronto Press, 2008

– "Memory Flash Points." In Allan Sekula, ed., *Geography Lessons: Canadian Notes,* 74–91. Vancouver and Cambridge, Mass.: Vancouver Art Gallery and MIT Press, 1997

Olympio, Sylvanus E. "African Problems and the Cold War." *Foreign Affairs* 40, no. 1 (October 1961): 50–7

OMI Information. "FRANCE: 'Pôle et tropiques' Closes." *OMI Information* 417 (December 2002). http://www.omiworld.org/Informazioni.asp?L=1&I=35#10. Accessed 31 December 2009

Opp, James. "Picturing Communism: Yousuf Karsh, Canadair, and Cold War Advertising." In Carol Payne and Andrea Kunard, eds., *The Cultural Work of Photography in Canada.* Montreal: McGill-Queen's University Press, forthcoming

Orvik, Nils. "The Basic Issue in Canadian National Security: Defence against Help/Defence to Help Others." *Canadian Defence Quarterly* 11, no. 1 (1981): 8–15

Osborne, Peter D. *Travelling Light: Photography, Travel, and Visual Culture.* Manchester: Manchester University Press, 2000

Pavitt, Jane, and the Victoria and Albert Museum. *Fear and Fashion in the Cold War.* London: V&A Publishing, 2008

Percox, David A. *Britain, Kenya and the Cold War: Imperial Defence, Colonial Security and Decolonisation.* London and New York: I.B. Tauris Academic Studies, 2004

Phayer, Michael. *Pius XII, the Holocaust, and the Cold War.* Bloomington: Indiana University Press, 2008

Phillips, Ruth B., and Christopher B. Steiner, eds. *Unpacking Culture: Art and Commodity*

in Colonial and Postcolonial Worlds. Berkeley: University of California Press, 1999

Pinney, Christopher, and Nicolas Peterson, eds. *Photography's Other Histories.* Durham and London: Duke University Press, 2003

Powaski, Ronald E. *The Cold War: The United States and the Soviet Union, 1917–1991.* New York: Oxford University Press, 1998

Preston, Richard A., and Leopold Lamontagne. *Royal Fort Frontenac.* Toronto: The Champlain Society for the Government of Ontario; University of Toronto Press, 1958

Price, Maurice T. "Applying Wargaming to the Cold War." *Political Research, Organization and Design (PROD)* 3, no. 3 (November 1959): 3–6

Raafat, Samir. "Ramses Returns Home." *Cairo Times,* 7 August 1997. http://www.egy.com/landmarks/97-08-07.shtml. Accessed 1 January 2010

Radstone, Susannah, ed. *Memory and Methodology.* London: Berg, 2000

Rivkin, Arnold. "Lost Goals in Africa." *Foreign Affairs* 44, no. 1 (October 1965): 111–26

Roberts, John P.L., and Ghyslaine Guertin, eds. *Glenn Gould: Selected Letters.* Toronto: Oxford University Press, 1992

Robertson, Gordon. *Memoirs of a Very Civil Servant: Mackenzie King to Pierre Trudeau.* Toronto: University of Toronto Press, 2000

Robin, Ron. *The Making of the Cold War Enemy: Culture and Politics in the Military Intellectual Complex.* Princeton and Oxford: Princeton University Press, 2001

Robinson, Daniel J., and David Kimmel. "The Queer Career of Homosexual Security Vetting in Cold War Canada." *Canadian Historical Review* 75, no. 3 (September 1994): 319–45

Robinson, Mike, and David Picard, eds. *The Framed World: Tourism, Tourists and Photography.* Farnham, Eng., and Burlington, Vt: Ashgate, 2009

Rodger, George, and Jinx Rodger. "Where Elephants Have Right of Way." *National Geographic* 118, no. 3 (1960): 363–89

Rogalsky, J. "Weather Knows No Boundaries." *Transport* 20, no. 5 (September–October 1969): 25

Rojek, Chris, and John Urry, eds. *Touring Cultures: Transformations of Travel and Theory.* London and New York: Routledge, 1997

"Roman Catholics: What We Are For." *Time,* 19 April 1963. http://www.time.com/time/printout/0,8816,830133,00.html. Accessed 3 January 2010

Rorty, Richard M., ed. *The Linguistic Turn: Essays in Philosophical Method.* Chicago: University of Chicago Press, 1992

Rosaldo, Renato. "Imperialist Nostalgia." In "Memory and Counter-Memory." Special issue, *Representations* 26 (Spring 1989): 107–22

Rostow, W.W. "The Third Round." *Foreign Affairs* 42, no. 1 (1963): 1–10

Rovere, Richard H. "Journal of a Pseudo-event." *New Yorker,* 13 July 1963, 76–88

Royal Military College. Centre for Studies in Defence Resources Management. *Report 2: The Economic Impact of Canadian Defence Expenditures.* Kingston, 1983

Rubin, Joan Shelley. "Review [Untitled]: Reading National Geographic." *Journal of American History* 81, no. 4 (1995): 18–22

Saull, Richard. *Rethinking Theory and History in the Cold War: The State, Military Power, and Social Revolution.* London: F. Cass, 2001

Saunders, Frances S. *Who Paid the Piper? The CIA and the Cultural Cold War.* London: Granta, 1999

Saxon, Wolfgang. "W.R. Kintner, 81, Dies; World Affairs Expert." *New York Times*, 9 February 1997. http://www.nytimes.com/1997/02/09/world/wr-kintner-81-dies-world-affairs-expert.html. Accessed 14 April 2010

Schwartz, Joan M., and James R. Ryan, eds. *Picturing Place: Photography and the Geographical Imagination.* London: I.B. Tauris, 2003

Schwartz, Richard Alan. *Cold War Culture: Media and the Arts, 1945–1950.* New York: Facts on File, 1998

Seaton, A.V. "Guided by the Dark: From Thanatopsis to Thanatourism." *International Journal of Heritage Studies* 2, no. 4 (1996): 234–44

Sekula, Allan. *Photography against the Grain: Essays and Photo Works, 1973–1983.* Halifax: The Press of the Nova Scotia College of Art and Design, 1984

Sharpley, Richard, and Philip R. Stone. *The Darker Side of Tourism: The Theory and Practice of Dark Tourism.* Bristol: Channel View Publications, 2009

Shaw, Tony. *Hollywood's Cold War.* Edinburgh: Edinburgh University Press, 2007

Sichel, Kim. *To Fly: Contemporary Aerial Photography.* Boston: Boston University Art Gallery, 2007

Simon, Cheryl, ed. *The Zone of Conventional Practice and Other Real Stories.* Montreal: Galerie Optica, 1989

Simpson, Erika. *NATO and the Bomb: Canadian Defenders Confront Critics.* Montreal and Kingston: McGill-Queen's University Press, 2001

– "New Ways of Thinking about Nuclear Weapons and Canada's Defence Policy." In D.C. Story and R.B. Shepard, eds., *Diefenbaker's Legacy*, 27–41. Regina: Canadian Plains Research Centre, 1998

"Social and Personal Notes." *Globe and Mail*, 12 December 1951, 10

Sokolsky, J.J. *Seapower in the Nuclear Age: the United States Navy and NATO, 1949–80.* London: Routledge, 1991

Sontag, Susan. *On Photography.* New York: Farrar, Straus and Giroux, 1977

Spence, Jo, and Patricia Holland. *Family Snaps: The Meanings of Domestic Photography.* London: Virago Press, 1991

Spicer, Keith. *The Samaritan State: External Aid in Canadian Foreign Policy.* Toronto: University of Toronto Press, 1966

Stairs, Denis. "Intellectual on Watch: James Eayrs and the Study of Foreign Policy and International Affairs." *International Journal* 62, no. 2 (Spring 2007): 215–40

Steege, Paul. *Black Market, Cold War: Everyday Life in Berlin, 1946–1949.* New York: Cambridge University Press, 2007

Steegmuler, Francis, trans. and ed. *Flaubert in Egypt: A Sensibility on Tour.* Chicago: Academy Chicago, 1979

Steinbruner, John D. *The Cybernetic Theory of Decision: New Dimensions of Political Analysis.* Princeton: Princeton University Press, 1974

Stewart, Susan. *On Longing: Narratives of the Miniature, the Gigantic, the Souvenir, the Collection.* Durham and London: Duke University Press, 1993

Stone, Philip, and Richard Sharpley. "Consuming Dark Tourism: A Thanatological Perspective." *Annals of Tourism Research* 35, no. 2 (2008): 574–95

Sutherland, Robert J. "Canada's Long Term Strategic Situation." *International Journal* 17, no. 3 (1962): 199–223

– "The Strategic Significance of the Canadian Arctic." In R.St.J. Macdonald, ed., *The Arctic Frontier*, 256–78. Toronto: University of Toronto Press, 1966

Szarkowski, John. *The Photographer's Eye*. New York: Museum of Modern Art, 1966

Tagg, John. *The Burden of Representation: Essays on Photographies and Histories*. Minneapolis: University of Minnesota Press, 1993

Taylor, C.J. "Exploring Northern Skies: The Churchill Research Range." *Manitoba History* 44 (Autumn/Winter 2002–3). http://www.mhs.mb.ca/docs/mb_history/44/exploringnorthernskies.shtml. Accessed 31 December 2009

Taylor, Frederick. *The Berlin Wall: A World Divided, 1961–1989*. New York: HarperCollins, 2006

Taylor, John. *A Dream of England: Landscape, Photography, and the Tourist's Imagination*. Manchester: Manchester University Press, 1994

Teigrob, Robert. *Warming Up to the Cold War: Canada and the United States' Coalition of the Willing, from Hiroshima to Korea*. Toronto: University of Toronto Press, 2009

Thompson, Nicholas. *The Hawk and the Dove: Paul Nitze, George Kennan and the History of the Cold War*. New York: Henry Holt, 2009

Towner, John. "The Grand Tour: A Key Phase in the History of Tourism." *Annals of Tourism Research* 12 (1985): 297–333

Trachtenberg, Marc. *A Constructed Peace: The Making of the European Settlement, 1945–1963*. Princeton: Princeton University Press, 1999

Tucker, Spencer, and Priscilla Mary Roberts. *The Encyclopedia of the Cold War: A Political, Social, and Military History*. Santa Barbara, Calif.: ABC-CLIO, 2008

Tusa, Ann. *The Last Division: A History of Berlin, 1945–1989*. Reading, Mass.: Addison-Wesley, 1997

Urry, John. *The Tourist Gaze*. 2nd ed. London and Thousand Oaks, Calif.: Sage, 2002

Vance, Jonathan F. *Death So Noble: Memory, Meaning, and the First World War*. Vancouver: UBC Press, 1997

van Wyck, Peter C. "An Emphatic Geography: Notes on the Ethical Itinerary of Landscape." *Canadian Journal of Communication* 33 (2008): 171–91

"Wall of Shame." *Time*, 31 August 1962. http://www.time.com/time/printout/0,8816,938872,00.html. Accessed 1 January 2010

Waskow, Arthur I. "Civil Defense, Democracy, and the Self-Destroying Prophecy." *American Behavioral Scientist* 6, no. 2 (October 1962): 3–6

Watkins, John. *Moscow Despatches: Inside Cold War Russia*. Ed. and with an introd. by Dean Beeby and William Kaplan. Toronto: Lorimer, 1987

Wenger, Andreas. *Living with Peril: Eisenhower, Kennedy and Nuclear Weapons*. Lanham: Rowman and Littlefield, 1997

Westad, Odd Arne. *The Global Cold War: Third World Interventions and the Making of Our Times*. Cambridge: Cambridge University Press, 2005

Wexler, Laura. *Tender Violence: Domestic Visions in an Age of U.S. Imperialism*. Chapel Hill: University of North Carolina Press, 2000

Wharton, Annabel. *Building the Cold War: Hilton International Hotels and Modern Architecture*. Chicago and London: Chicago University Press, 2001

– "Economy, Architecture and Politics: Colonialist and Cold War Hotels." *History of Political Economy* 31 (1999): 285–300

Whitaker, Reginald. "Cold War Alchemy: How America, Britain and Canada Transformed Espionage into Subversion." *Intelligence and National Security* 15, no. 2 (2000): 177–210

– "'We Know They're There': Canada and Its Others, with or without the Cold War." In Cavell, ed., *Love, Hate, and Fear in Canada's Cold War*, 35–55

Whitaker, Reginald, and Steve Hewitt. *Canada and the Cold War.* Toronto: Lorimer, 2003

Whitaker, Reginald, and Gary Marcuse. *Cold War Canada: The Making of a National Insecurity State, 1945–1957.* Toronto: University of Toronto Press, 1994

White, T.J. "Cold War Historiography: New Evidence behind Traditional Typographies." *International Social Science Review* 75, no. 3/4 (2000): 35–46

Whitfield, Stephen J. *The Culture of the Cold War.* Baltimore: Johns Hopkins University Press, 1991

Whittlesey, Derwent. "Kano: A Sudanese Metropolis." *Geographical Review* 27, no. 2 (April 1937): 177–99

Williams, Carol J. *Framing the West: Race, Gender, and the Photographic Frontier in the Pacific Northwest.* Oxford: Oxford University Press, 2003

Wilson, Thomas W., Jr. *Cold War and Common Sense: A Close Look at the Record of Communist Gains and Failures and of Freedom's Fortunes in the Mid-Twentieth Century.* Greenwich, Conn.: New York Graphic Society, 1962

Winsberg, Morton P. "Overseas Travel by American Civilians since World War II." *Journal of Geography* 65, no. 2 (February 1966): 73–9

Wright, A. Craig, "Philosophical and Methodological Praxes in Dark Tourism: Controversy, Contention and the Evolving Paradigm." *Journal of Vacation Marketing* 12 (2006): 119–29

Wrigley, Richard. "Infectious Enthusiasms: Influence, Contagion, and the Experience of Rome." In Chloe Chard and Helen Langdon, eds., *Transports: Travel, Pleasure, and Imaginative Geography, 1600–1830*, 75–116. New Haven and London: Yale University Press, 1996

Yatsushiro, Toshio. "The Changing Eskimo." *Beaver,* Summer 1962, 19–26

Youngs, Tim. "'Why Is That White Man Pointing That Thing at Me?': Representing the Maasai." *History in Africa* 26 (1999): 427-47

Index